MIKE AND DOUG STARN

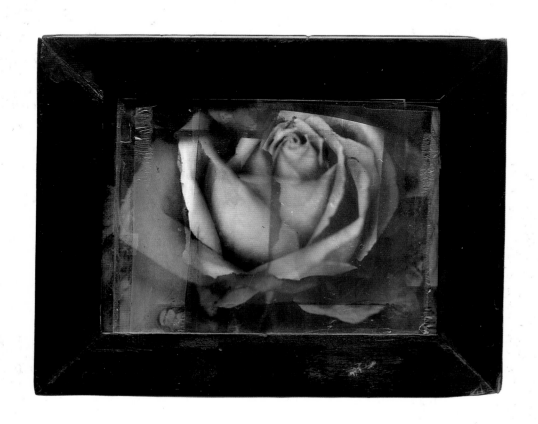

BLUE ROSE. 1982–88

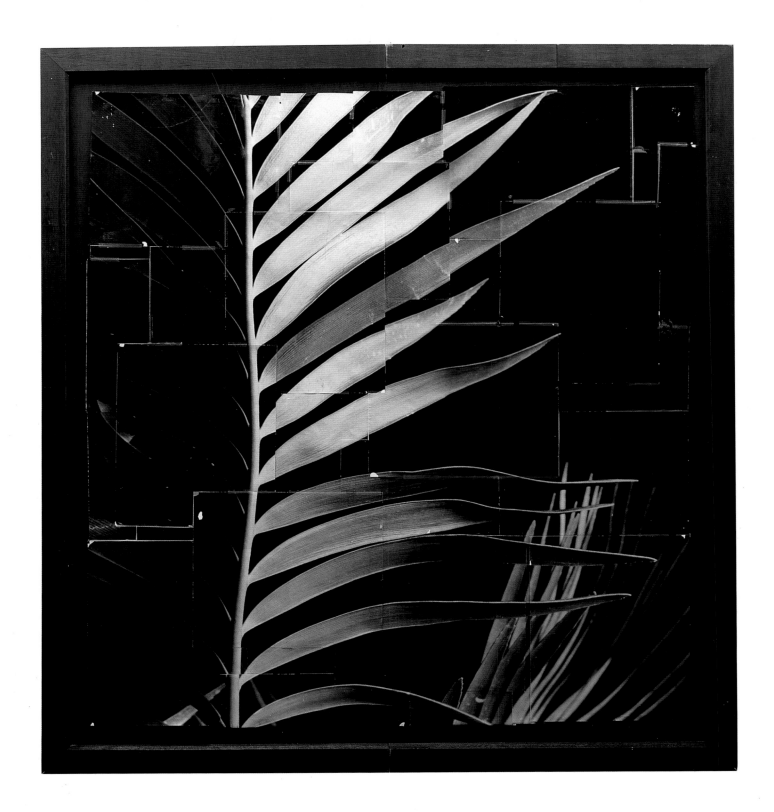

LARGE FERN. 1988

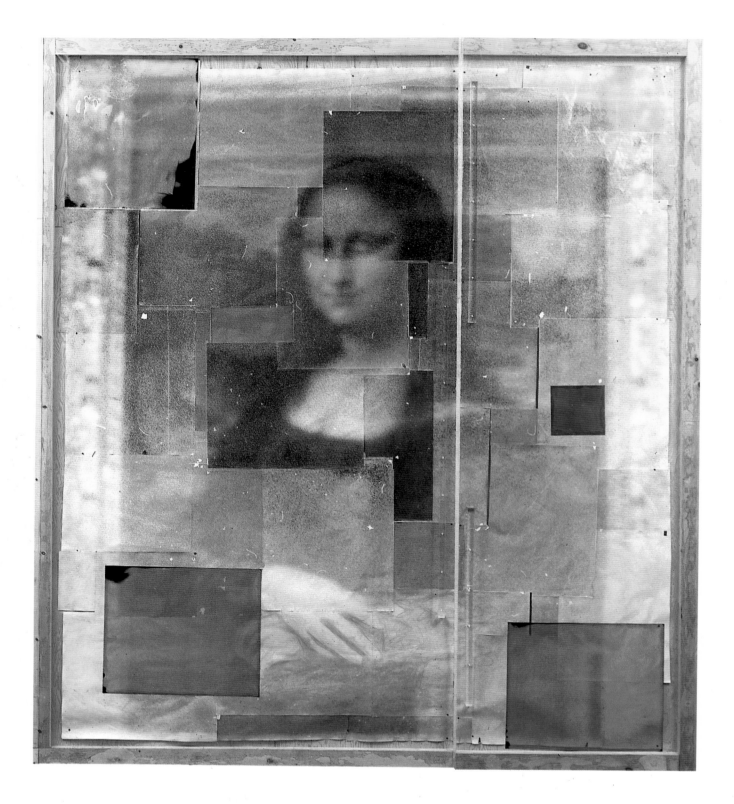

LARGE MONA WITH PLEXI. 1985–88

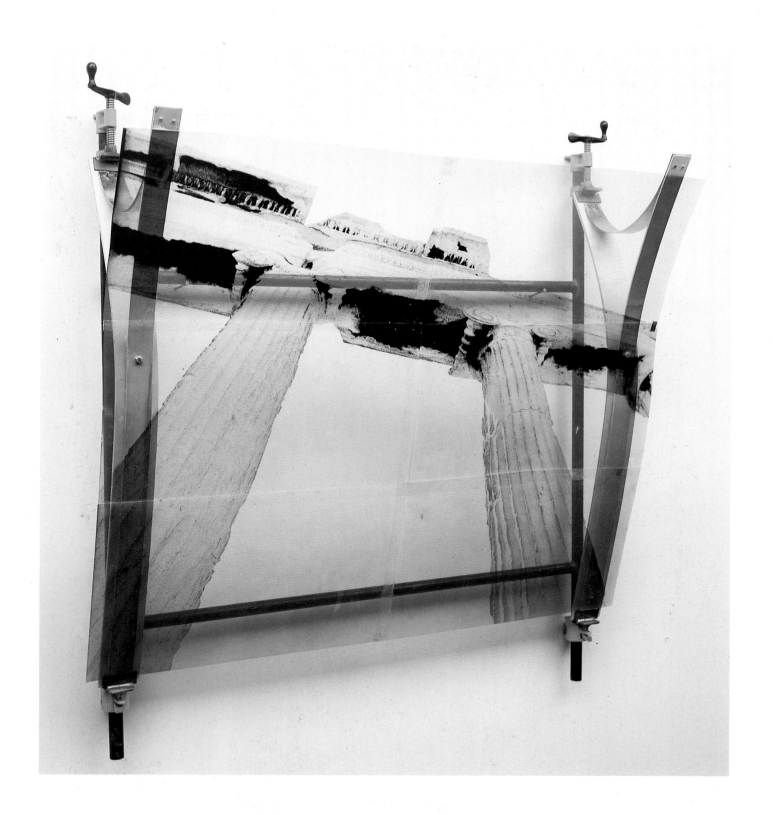

FILM ACROPOLIS WITH PIPE CLAMPS. 1989

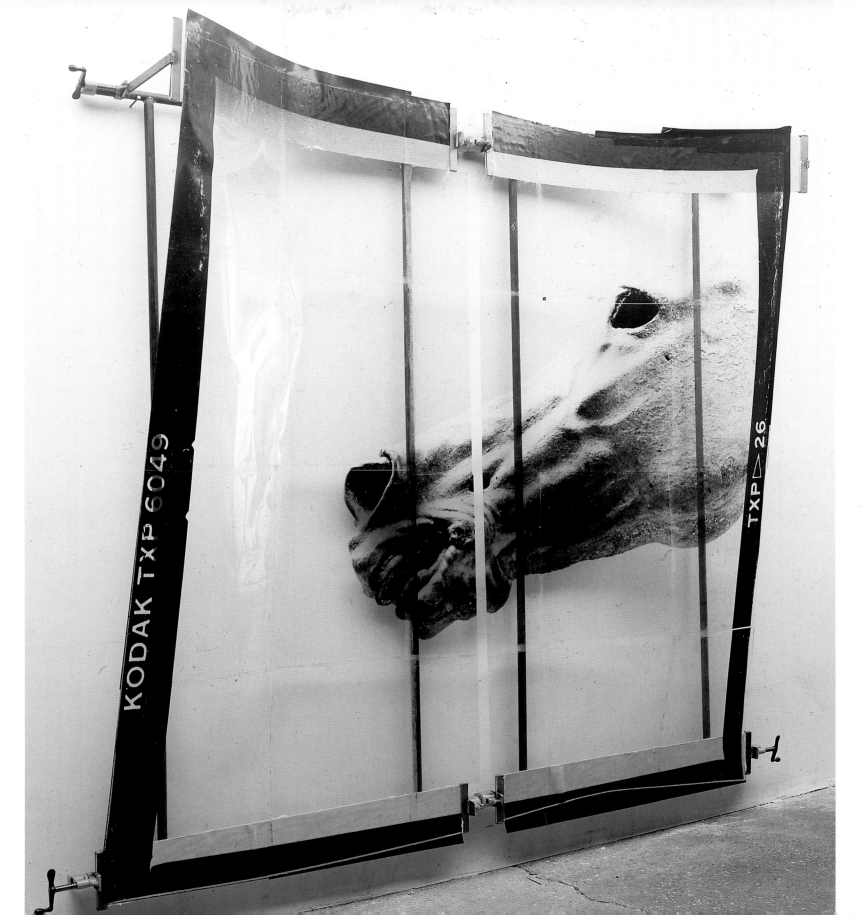

HALF CONCAVE ATHENIAN HORSE HEAD · 1989

MIKE AND DOUG
STARN

ANDY GRUNDBERG

INTRODUCTION ROBERT ROSENBLUM

HARRY N. ABRAMS, INC., PUBLISHERS, NEW YORK

For our parents, Bob and Cee Starn.

D. S. / M. S.

And for my wife, Anne Pasternak.

M. S.

TR
647
S73
1990

Editor: Ruth Peltason
Designer: Dana Sloan

(*Pages 8–9*) In the studio, Boston, 1988

Library of Congress Cataloging-in-Publication Data

Grundberg, Andy.
 Mike and Doug Starn / Andy Grundberg: introduction, Robert
Rosenblum.
 p. cm.
 Includes bibliographical references.
 ISBN 0–8109–3815–4
 1. Photography, Artistic—Exhibitions. 2. Starn, Mike—
Exhibitions. 3. Starn, Doug—Exhibitions. I. Starn, Mike.
II. Starn, Doug. III. Title.
TR647.S73 1990
779′092′2—dc20 90-31665
ISBN 0–917562–55–0 (C.A.C.) CIP

Published in 1990 by Harry N. Abrams, Incorporated, New York
A Times Mirror Company

Printed and bound in Japan

CONTENTS

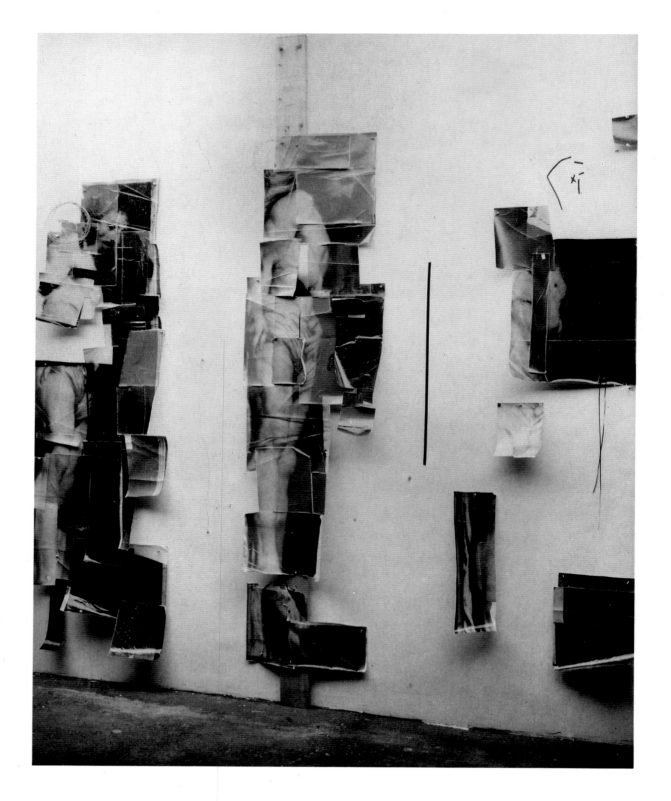

CRUCIFIXION. 1985–88

Despite its now venerable history — 150 years old in 1989 — the medium of photography still arouses many of the same expectations it held at its birth. We intuit, for one thing, that a photograph tells us the truth about an instant in time and a fragment in space, flash-freezing for posterity sights as dramatic as the ruins of Richmond, Virginia, in 1865 or as prosaic as a family gathering in Absecon, New Jersey, in 1961, the place and the year of the birth of Mike and Doug Starn. And we expect, too, that a photograph, in its role as a time-capsule document of our communal and individual lives on earth, should be preserved for the future in as pristine a form as possible, an unchanging image fixed on paper that might survive the ravages of time and death. Many photographers, of course, have challenged some of these stubborn assumptions, creating, for example, montages and dreamworlds that subvert the initially objective premises of photography; but few, if any, have mounted so personal yet so full-scale an attack upon the conventions and restrictions of the medium as Mike and Doug Starn. For them, photography, which usually delivers its messages in the present tense, could be opened to a vast new range of temporal experiences that include the slow and layered accumulation of memory and history, and the melancholy decay of flesh and matter. It is no accident that many of their works, like those of Cézanne that were painted and repainted over months and years, are often left looking as if they were still in a state of becoming.

The haunting and at times even ectoplasmic environment created by the Starns suggests a hermetic world, the stuff of a Gothic novel, a uniqueness of vision surely fostered, too, by our awareness of the uncommon phenomenon of their being identical twins who work as one artist. Indeed, their twinning creates resonant psychological dimensions that are clearly reflected in their preferred configurations. For instance, paired or mirrored motifs recur throughout their work, often creating surrogate double portraits. At times, as in one of their variations on a Rembrandt in Chicago (a portrait presumably of the artist's father), the head is reflected upside down, playing-card fashion, in a Narcissus-like pattern that is also used for the twins' self-portraits as well as for less personal images. And insofar as their work often evokes an archaic mood from the history of photography, their frequent use of stereoscopic double formats is one that intersects both their private identity and the technological history of their medium. Such a magnetic attraction to doubled imagery can even be found in many of their choices from earlier art. It is telling that when they selected a painting by Picasso for photographic inspiration, they originally considered the 1921 trio of Neoclassic women at the Museum of Modern Art, but then dropped it for an earlier, lesser-known version of the painting in Düsseldorf in which this monumental trio is only a duo. And startlingly, in one of their variations upon a seventeenth-century Dutch painting of a huge, threatened swan by Jan Asselijn, the bird's neck suddenly bifurcates in a mirror-like sprouting of not one, but two, hissing heads.

The strange intimacy of their work is further borne out by its way of making us feel like intruders, unexpectedly discovering these precious, aging relics in an attic that was locked up decades ago. Although their images may range from Hawaii to the Tuileries, from the Crucifixion to Anne Frank, from a Minoan ivory bull-jumper to a portrait of the late photographer Mark Morrisroe, one of their few early influences, these facts of the public domain are transformed into records of private responses that almost seem like mirages, withdrawing from view as we look at them. What, in fact, may at first be most disconcerting about the Starns' work, in both an obvious and a subliminal way, is their insistence on the material life span of their medium, images on paper; for they are determined to undo the scientific look usually associated with photography's techniques of laboratory precision, cleanliness, and impersonality. The fact and the illusion of accident and of the handmade are everywhere. Fragments are scotch-taped together; edges are furled and torn; black tape defaces images; photographic surfaces are crumpled or, at times, seen through the transparency of ortho film; push pins pierce ragged holes into paper and wall; frames look haphazardly chosen in shape or style. We sometimes feel that we have stumbled upon the rubble of both public history and intimate journals, deteriorating fragments for some future archaeologist who would reconstruct our past from what looks like a site unearthed after the apocalypse.

But even odder, a pulse of life and memory continues to beat in these withering ruins, which blur the distinction between the quick and the dead, between things once alive and embalmed and those which never lived at all but are now coming to life. Typical is the recurrent motif of a horse's head, frozen in movement. In an early appearance, this doubled image was that of a pair of real horses belonging to the Starns' sister, descendants of the kind documented in Muybridge's photographic studies of animal locomotion; but the literal premises of such a factual document were thoroughly undermined by the strange way in which it was mutilated, recomposed, veiled by extended exposure, or even tinted in the colors of old-fashioned photographs—smoky sepias, otherworldly blues, bleaching yellows. Already transformed into wisps of memory that both congeal and evaporate, this horse head was later to be reincarnated as a detail of a late classical sculpture, a bronze actually observed on a visit to Greece, but one that now looks like the petrified, yet once living version of its modern kin. The boundaries between these two animals, one preserved by the lens of a camera, the other by the hand of an ancient sculptor, were melted by the Starns in a terrain of photographic phantoms where time could be as fluid as the difference between sentient beings and lifeless matter.

The Starns' ability to resuscitate as well as to distance photographic images is uncanny, verging on hallucination. Like many artists of the 1980s, they are often concerned with quoting earlier works of art, but they do so in an eerie way that explores the potential life and death of what are literally only photographic reproductions of inert objects in museums. They can work their magic, for instance, on a Neoclassic painting by Picasso, whose sculptural nudity already conjures up the archaic ghosts of a lost Mediterranean past but whose remoteness is made still more layered by their re-creation of the painting as fragmented, recomposed, tattered, and tinted photographic images that seem to have survived from an epoch equally remote from the present.

Even more ambitious are their astounding variations on a lesser-known seventeenth-century painting in the Louvre, a fleshy, totally supine dead Christ by Philippe de Champaigne. Printing a photograph of this painting under their usual conditions of lengthy exposure already began to complicate the image, which seemed to exist in a shadowy territory somewhere between the record of a real oil painting on canvas and a photograph of the no less real hair, flesh, and muscle of a full-bodied male corpse who might well have been Christ. The effects were like a modern version of Veronica's veil or the Holy Shroud of Turin: muffled, impalpable, sacred records and memories of a painful, palpable, secular truth. But from this motif they proceeded to a further reincarnation, wrenching the supine body upward at a full ninety degrees, in order to evoke the Crucifixion itself. This bramble of wood, photographs, and coiling wires inspired by the crown of thorns in the original painting connects the repeated details of Christ's body left and right, discharging shock waves of suffering that also make us feel we are watching a real crucifixion in progress. Since the debut of Francis Bacon, it would be hard to think of any late twentieth-century artists who have tackled this archetypal tragedy with such harrowing immediacy.

Within only a matter of five years, in fact, the Starn twins seem to have mastered their private imagination sufficiently to take on the most relentless specters of public history, including the holocaust itself. Their 1989 memorials to Anne Frank on the occasion of the sixtieth anniversary of her birth in 1929 are records of individual history, scaled to what recall heartbreaking souvenirs from the scrapbooks of a doomed family; but these reminders of unbearable facts can also be amplified to global dimensions in the Starns' history of martyrdom, titled *The Lack of Compassion* and destined for the Israel Museum in Jerusalem. The open-ended history of human suffering, ranging from individual martyrs, like Christ or Martin Luther King, to collective victims, like those from the concentration camps or Tiananmen Square, are compiled here in an encyclopedic inventory of death, where memorials in the form of wooden planks that bear the photographs of the deceased create the litter of a mass grave, poignantly incomplete and ready to accommodate the next chapter in this narrative.

Given the seeming privacy of the Starns' world, which in literary terms might be the equivalent of intimate, unpublished diaries, it is startling to realize that they can create work of such epic and universal dimensions. And it is no less surprising that what begins as the most eccentric, personal art ends up occupying an ever more central position in any international community of art culled from the last decades. Their concern with the traumas of the Third Reich, for example, may be relatively alien to their artist compatriots in America; but their contributions to this theme of bottomless terror join forces with the gloom-ridden, elegiac visions of the Nazi era offered by such Europeans as Anselm Kiefer and Christian Boltanski. Yet their art belongs to an American milieu as well. It would be difficult to think of their mix of photographs and art reproductions within an environmental poetry of disorder and disintegration without summoning up the spirit of Rauschenberg in the 1950s; and as for Warhol, his ever-lengthening shadow is cast throughout their work, whether we look at their early attraction to repetitive photo patterns or their pervasive sense of death, which can range from a traditional skull still life and

images of corpses and public tragedies to the rendering of photographic portraits as ghostly afterimages. Moreover, any consideration of the historicizing character of the 1980s would have to take the Starns into account, not only in terms of their remembrance of things past, but in terms of their constant scrutiny of earlier works of art as grist for their image mill. Much as David Salle might offer fragmentary quotations from a surprisingly diverse repertory of artists, from Watteau to Kuniyoshi, so, too, will the Starns seize details from painting and sculpture that range from classical gravestones to paintings by Bouts, Leonardo, Copley, works that at times come to life like spirits from a museum tomb or at times serve to recall the displacements of travel experience, as in the jolting juxtaposition of a detail from a Rembrandt in the Art Institute of Chicago against one of the city's classic skyscrapers, The Rookery. And even on the level of twinning, their art has echoes on both sides of the ocean in other examples of couples who, though not twins, also share their life and art. In London, Gilbert & George provide a parallel in their double portraits and double vision of a vast panorama of experience that would document both their personal history and the public world outside their door; and closer to home, in New York, Peter McGough and David McDermott offer, like the Starn twins, a willful recall of the historical past, whether the 1890s or the 1940s, which, in their paintings as well as in their tinted photographs, they would resurrect as period reconstructions capable of transporting them from an alien present to an earlier decade. Initially as lonely and peripheral as the most personal of family albums, the work of Mike and Doug Starn is becoming unexpectedly central to the history of contemporary art. That this has happened in less than five years opens vistas for their future that only they could begin to imagine.

Robert Rosenblum
January 1990

SELF-PORTRAIT WITH METAL AND RIBBON, 1985–89

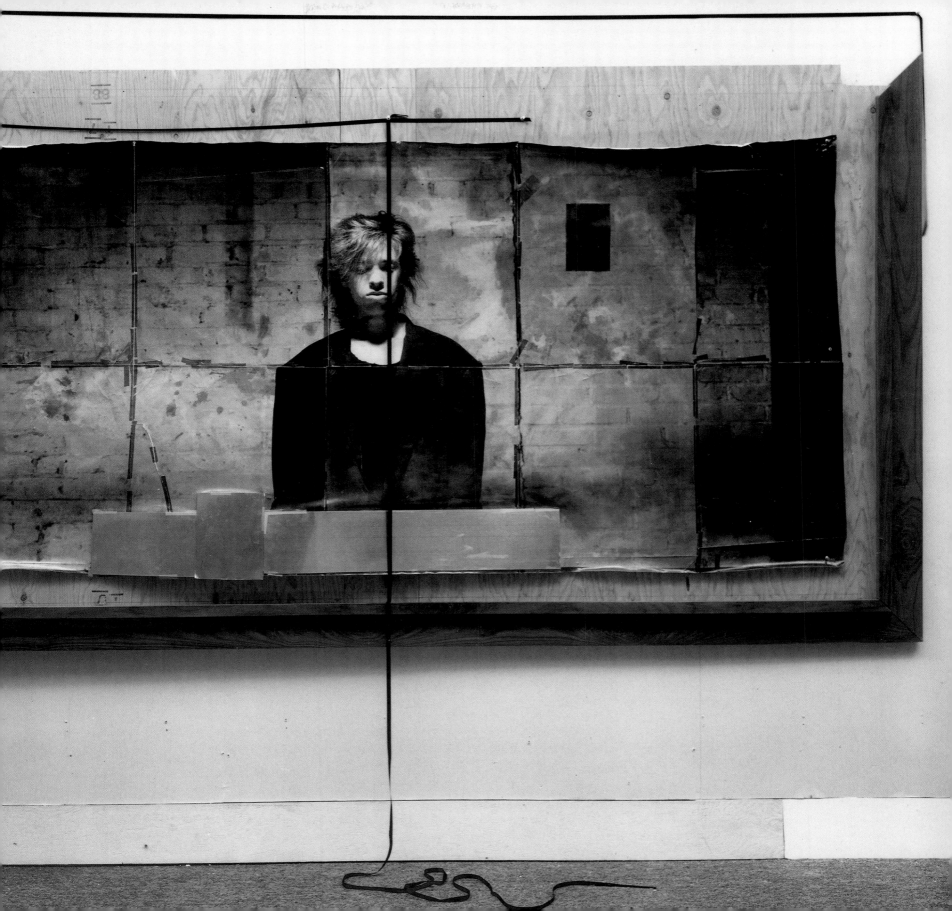

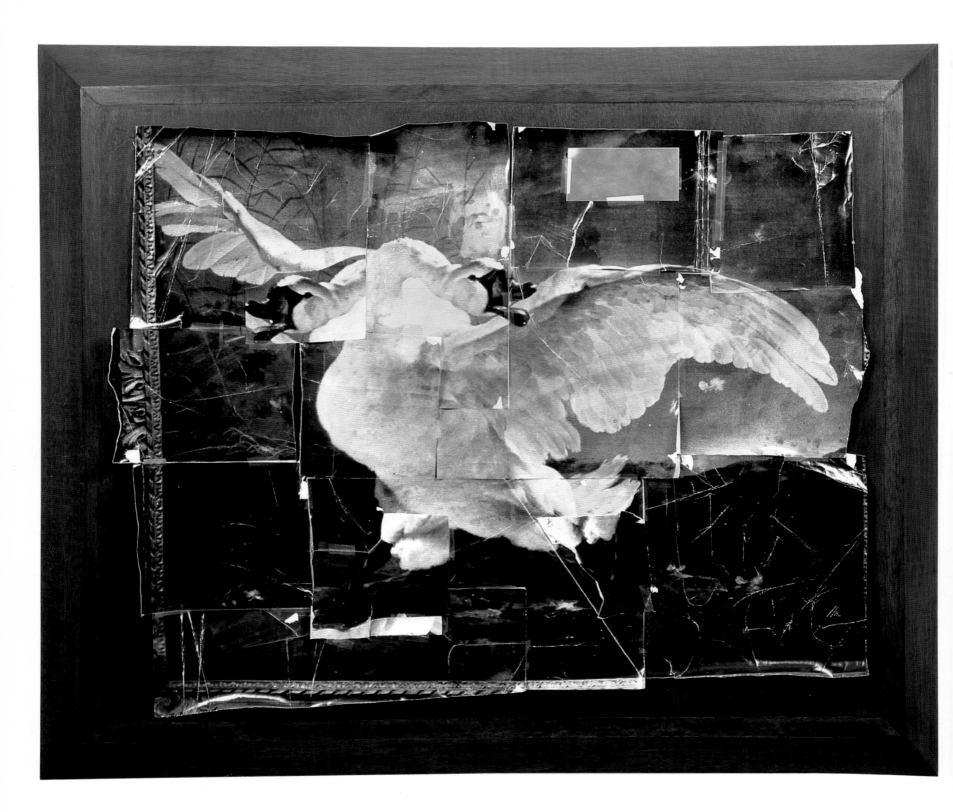

TWO-HEADED SWAN. 1988–89

MIKE AND DOUG STARN

ANDY GRUNDBERG

I. MILLENNIUM

To the unaided eye, the art world of the late twentieth century does not appear particularly inviting, even if only to visit. Riven by competing territorial claims, it often seems on the brink of splitting into medieval-style fiefdoms. The diverse movements that define these fiefdoms tend to have names preceded by Neo or Post, a choice of language that suggests the aesthetic polarities at stake.

Artists at the Neo end of the scale subscribe, at least implicitly, to the idea of renewal. Like Picasso, Pound, and Gropius in the early decades of the century, they believe in the possibility of "making it new." They may choose to make it new by remaking it—hence the Neo prefix—but nonetheless they believe in the limitless possibilities of visual expression and, of equal import, in the vitality of self-expression as an antidote to the numbing quality of contemporary culture.

Post artists, on the other hand, take an end-game position. For them, the idea of "the new" is merely a convenient crutch of twentieth-century art, used to prop up the flagging aesthetic known as Modernism and—an even more radical thought—the exhausted tradition of Western art itself. Cultures construct their own myths, and one of ours has been the idea of a "high culture" distinct from, and ruling over, the commonplace experience of everyday life. In the Post world, however, all experience is equally available to the realm of art, and art itself is simply an extension of the information and entertainment industry. Self-expression? Another cultural myth, one that convinces us that we can control our own destinies in the face of a media-induced, consumerist conformity.

In the 1980s, the forces of Neo and Post created a dialectical discourse that defined the reception for that

decade's art. Neo-Expressionism, Neo-Geo, and Neo-Abstraction, all of which involved painting, were aligned against Post-modernist, Post-Pop, and Post-Conceptual practices, which tended to use nonpainterly means. A Neo-Expressionist painter like Julian Schnabel was seen as a healthy response to Post-modernist artists like Sherrie Levine and Robert Longo, or else as a retrograde effort to restore the creative aura of painting. Levine, with her photographic copies of Modernist classics, and Longo, with his polished sculptures that were fabricated by others, were viewed either as avatars of a new era in art-making or as the worst examples of aesthetic skepticism and market-conscious cynicism. Within this divisive discourse, photography has played a significant role and achieved a special status. As a mechanical and chemical medium, it seems an ideal instrument for suggesting, as Levine did in the works *After Walker Evans* and *After Edward Weston*, that all art is copied from other art—or, as Cindy Sherman suggested in her *Untitled Film Stills*, that our individual identities are copied from stereotypical models provided by the culture. In both cases, photographs are essential to making the point: they are signs of both mass reproduction and mass culture.

But photographs also have a paradoxical relationship to art. Because they seem so mechanical in origin and transparent in their description, they raise questions about the nature of creativity. They challenge artists to find ways to undercut their superficial neutrality and to trespass their seemingly inviolate surfaces. As a Cinderella to painting for one hundred and fifty years, photography mirrors the yearnings of renegade and naive artists who stand outside the art marketplace. In the decade of the 80s—as it had in the late 60s and early 70s—photography acquired a kind of reverse chic: it was unexplored territory at a time when painting and sculpture seemed resigned to recycling the empty containers of their glorious pasts.

The foregoing account has the virtue of simplicity, but its simplicity necessarily elides some of the contradictions that make the art of our time, and photography in particular, so captivating. The division between Post and Neo factions has never been absolute, for example. Schnabel, a Neo-Expressionist, recycled elements of pop culture as freely as a Post-modernist like Longo, what with his antlers, dishware, and velvet grounds. A Neo-Geo painter such as Peter Halley could negotiate the territory of both genuine geometric abstraction and its ironic, recycled imitation, just as James Welling, with his photographs of crumpled aluminum foil and sagging drapery, could present both the emptied-out, simulated container of twentieth-century abstraction and, in a purely visual sense, the promise of abstraction's renewal. Indeed, much of the most intriguing art of the 1980s conflated the dichotomy of Neo and Post, making Post-modernism seem less the antagonist of Modernism than its inevitable companion or double.

It was into this climate that Doug and Mike Starn, also known as the Starn Twins, introduced their doubly radical version of photographic art, starting in the mid-1980s. As recent arrivals in the art world, they were

acutely aware of how disputatious and uninviting it seemed when seen from the outside. They were also resolved to do something about it. They wanted to make art that leaped over the Neo/Post divide, that would appeal to the best instincts of a broad audience.

Their vision was doubly radical because it rejected the two prevailing models available to them at the time. Unlike so-called art photography, which by and large kept the print intact as an object, the Starns' work treated the printed paper as merely a piece of paper, albeit one holding an image; they creased, tore, taped, and glued their prints with an unrestrained abandon that bordered on vehemence. Unlike what has come to be called photo art—that is, photographs in service to an artist's ulterior motives—the Starns' work did not come tethered to conceptual subtexts, ideological labels, or critical theories. Consequently, it first attracted an audience that was rooted outside of photography; its most enthusiastic supporters were (and, it seems fair to say, still are) from the world of painting and sculpture. For some, the Starns represented the long-awaited renewal of genuine expression and a reaffirmation of the potentials of uncalculated beauty. They were the saviors of twentieth-century fin de siècle art.

Since 1985, the Starns have been making pictures formed with from one to several dozen pieces of printing paper. After being exposed, developed, and treated in toners that give them hues of blue, yellow, and a rich range of browns, the pieces of paper are taped together to form a single, or at least contiguous, image. The images are so bold and theatrical as to be iconic: self-portraits and portraits of friends, horses' heads, flowers, paintings of the dead Christ, a Rembrandt portrait, Leonardo's Mona Lisa. Occasionally the image disappears, leaving only the glossy surface of photographic paper in its wake. The Starns often show their work in what is called the salon style—the pictures are scattered about the gallery or museum walls at various levels, looking as casually assembled in sum as they do individually.

The Starns' critical reception has been remarkable for its adamancy. Their work, wrote the art critic Robert Pincus-Witten, "reaffirms the bohemian, estheticized outlaw status of artmaking."[1] Other critics noted its "sheer beauty"[2] and "naive joy,"[3] while still others spoke of the pictures as "large, beautiful and romantic"[4] and "puzzling and fresh."[5] Klaus Ottmann, a writer for *Flash Art*, one of the art world's more vogueish magazines, went so far as to declare the Starns "among the pre-eminent talents of our time."[6] This was in early 1988, less than three years after they left art school.

Other reactions, however, were less sanguine. "Sentimentality . . . taken to . . . a suffocating extreme,"[7] "imbued with melancholia for a fabricated romantic past that feeds illusions of self-aggrandizement,"[8] "products of the unengaged and cynical late 80s."[9] Clearly for some the Starns represented not the saviors of contemporary art but its antichrist. However, in the strength of their reactions both the proponents and opponents of the Starns' work showed that it represented something crucially important for contemporary art. One could even say that it serves as a watershed, marking the closure or synthesis of the Neo/Post dialectic that characterized most of the art of the 80s.

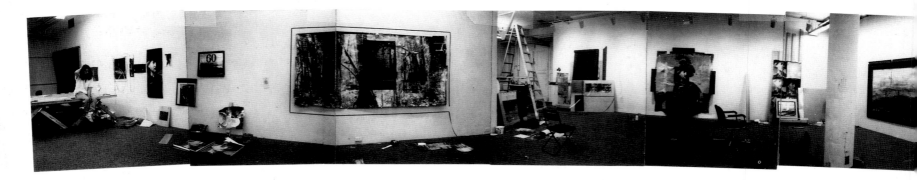

The Starns' work provokes not only a wide variety of opinions but also an amazingly diverse range of interpretations—some of them patently contradictory. What does the Starns' work look like? Even on this simple subject there is no agreement. Some have characterized it as Romantic,[10] others as Victorian.[11] Joe Jacobs, who organized a 1987 exhibition of the Starns' work at the Ringling Museum in Sarasota, Florida, called it "a photographic version of Cubism," but went on to find it reminiscent of "19th century photographs that have suffered the ravages of time."[12]

To the critic Joseph Masheck, the Starns' work has "the surf-like sweep of big Abstract-Expressionist canvases by Robert Motherwell."[13] Others have compared them to Sol LeWitt and Robert Ryman,[14] Eugene Atget and Robert Rauschenberg,[15] William Henry Fox Talbot and Robert Mapplethorpe,[16] Gilbert and George, Henri LeSecq, F. Holland Day and Man Ray,[17] Richard Prince, Barbara Kruger, Cindy Sherman and, perhaps inevitably, Joel Peter Witkin.[18] Clearly, any artist who manages to evoke nineteenth-century photography, fin de siècle Pictorialism, Surrealism, Abstract Expressionism, Minimalism, and Post-modernism is an artist of an impressive, even unimaginable range. One might suspect that more than one sensibility was at work—which, in the Starns' case, is literally true.

During the course of their as-yet brief career, much attention has been focused on the Starns' many-faceted investigation of the formal possibilities of photography. "The Starns challenge the tendency of contemporary photographers to rely on straight printing techniques to ensure maximum image sharpness and tonal fidelity," according to Francine A. Koslow, in a 1986 article on the Starns in *The Print Collectors Newsletter.*[19] Their art also has been called "part of the contemporary co-optation, or rescue, of photographic media by artists"[20] and "virtually a dictionary for the new photography."[21]

Such assessments, however, betray a certain lack of historical consciousness, not to mention an ignorance of twentieth-century photographic practice. After all, the yen to disrupt, transgress, and recompose the visual information supplied by the camera goes directly back to the European experimental Modernists of the 1920s and 30s. Photomontage, photocollage, and a whole repertory of interventions in "straight" photographic practice have been standard fare in art photography ever since. Technical innovation is surely present in the Starns'

work—even if their discoveries are only rediscoveries, born out of a dissatisfaction with the present—but it does not account for the work's meaning, or for its remarkable reception. For that, one has to recognize an aesthetic value that, for much of the 80s, remained largely repressed: beauty.

Beauty is a word the Starns use often in talking about art. It is both an instrument and an aim of their work, and it inspires them to invent new processes and procedures. Doug says, "The image means nothing to us, in a sense. It's just exciting to look at."[22] In other words, their art is located resolutely in the realm of the ocular. At its best, it derives its meaning and appeal from its surface, not from any underlying concept, and it defies conventional analysis. This is not to say that it is superficial, but that any formal similarities to nineteenth-century art photography, or to movements in twentieth-century art such as Cubism, are largely fortuitous and extraneous. Unlike, say, Sherrie Levine, the Starns operate intuitively, without a great deal of art-historical calculation.

This stance—of the intuitive, self-generating artist, working apart from the critical dialogue of the time—is not without dangers. It risks seeming purposefully naive, old-fashioned, labored. It ignores the Post-modernist critique of cultural values, which holds that all supposedly autonomous production is actually determined by the culture from which it comes. But these risks, in the Starns' case, seem well worth taking, for they give the work its contemporary charge. It is precisely the Starns' unapologetic insistence on visual pleasure and their provocative manipulations performed in the name of beauty that make them such provocative artists for these times.

IN THE STUDIO, NEW YORK, 1989

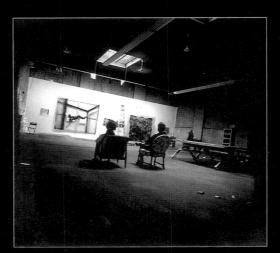

The response to the Starns' work has been so widespread and rapid that one tends to forget that their public career is only a few years old, and that as of this writing they are still shy of thirty. This not only makes their achievements seem precocious, but it also gives their lives a mythic quality. That they are twins only adds to the aura that has surrounded them from the start. But for most of their lives they have had the same aspirations and doubts as anyone embarking on a creative life.

Doug and Mike Starn were born in 1961 and raised in Absecon, New Jersey, a small town nestled between the honky-tonk shore resort of Atlantic City and the desolate splendor of the Jersey Pine Barrens. By and large, they had an uneventful, middle-class upbringing. Their father, Paul Robert Starn, who is known as Bob, was one of fifteen children of Charles and Sophie Starn, who had transformed a produce market into a successful chain of supermarkets. Bob Starn had wanted to be an architect but, like most of his brothers and sisters, he joined the family business.[23]

Their father's architectural yearnings did not go entirely unfulfilled, however. He designed and built the house in which they grew up, as well as several of the Starns' markets, and he had a wood-working shop at home. His interest in structural design and wood-working rubbed off on his two sons; they now devote part of their studio space to a wood shop, complete with table saw, radial-arm saw, and planer, where their increasingly complex frames and supports are fabricated.

Other than their father's interest in architecture, there was little artistic activity in the Starns' immediate family. Their sister, Linda, three years their senior, liked to draw as a youngster, and her brothers remember trying to match their talents against hers—sometimes successfully, they recall. But the main exposure the Starns had to art while growing up was on visits to the Philadelphia Museum of Art. There, they saw some of the classic masterpieces of Western painting, as well as medieval armor, tapestries, and antique furniture. They might even have encountered Marcel Duchamp's "large glass," but they have no memory of seeing it until they were grown. In contemporary art, they remember being impressed by Robert Rauschenberg's combines and Andy Warhol's multiple-image silkscreens.

At age thirteen they became interested in photography. A year later, in 1975, they enrolled in a photography class at Stockton State College, an experimental, arts-oriented school located some ten miles west of Absecon. It was an evening course in the school's continuing education department—most of the other students were in their forties, Mike recalls—and it was taught by a local photographer, Steve Roberts.

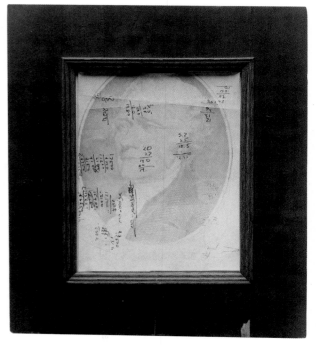

LITTLE MONEY. 1988

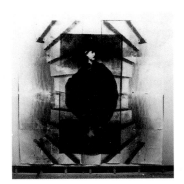

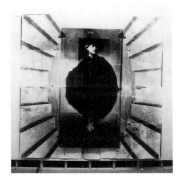

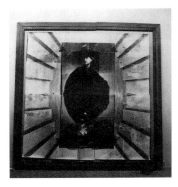

DOUBLE REMBRANDT WITH STEPS,
WORK IN PROGRESS, BOSTON, 1988

Roberts, who has since left New Jersey for Vermont and the teaching of photography for a career selling insurance, remembers having the Starns in two or three of his classes. To him, they seemed introverted and unsure of themselves. "They didn't fit into any world at the time," he recalls. "They were like social outcasts at high school, because they were twins, they were quiet, and they wore their hair down the middle of their backs. They certainly needed something in their life."

Photography turned out to be that something. "As far as photography goes, they didn't know what they were getting into," Roberts says, remembering their first efforts as being "like any beginner's work." But he gave them extra attention because they worked so hard and took the class so seriously. "They had a hard time expressing their feelings and emotions," he says. "With photography they were able to form an identity."

The Starns remember Roberts as "the best teacher we ever had," largely because he confounded and inspired them. He would point out pictures on their contact sheets that he thought were good but offer no explanation, leaving the Starns to puzzle over why he had chosen them. His most memorable remark was one that set the Starns in the direction they have pursued, with amazing energy and zeal, ever since: unhappy with the thin white borders they left on the edges of their prints, he told them, "Think about your paper."

Roberts's approach to the medium was happily open-ended—his work at the time was experimental and process-oriented, involved old-fashioned printing techniques like cyanotype, collage, and such surface additions as press-on type and hand-stitched thread—so his admonition may have been intended to challenge the Starns' idea about what a photograph could be. They remember it as a more conventional appeal for wider borders, in the "fine-print" style of the time. (Roberts doesn't remember this exchange—"As a teacher, you say so many things.") In either case, the Starns began to think about the paper as more than a support for the image; they began to think of it as an integral part of the image.

Although brought up in the Methodist faith, the twins followed their sister's path and attended Holy Spirit High School, a Roman Catholic school in Absecon. They quickly became aware that they were not comfortable with the strictures of parochial-school discipline, at least as it was defined by the nuns who were their teachers. They were continually reprimanded for behavioral breaches, which apparently only escalated their desire to rebel. By their senior year of high school they were living in nearby Ocean City with their sister, who had been appointed their guardian so that they could attend Ocean City High. All this time they were pursuing their photography, each taking his own pictures but working together in the darkroom.

If the Starns got their interest in architectonic presentation from their father and their urge to violate the norms of self-expression from their experience in parochial school, they may also have acquired some of their subject matter from the same early childhood experiences. The stairs in *Double Stairs* (page 78), the steps in *Double Rembrandt with Steps* (page 81), and the floor pattern in *Yellow and Blue Louvre Floor* (pages 90–91) show a debt to their father's avocation. Their use of religious subjects from the history of art—most obviously, their *Stretched Christ* of 1985–86—and their attempt to create "moral" art in a work such as the *Lack of*

Compassion series testify to the influence of their Protestant upbringing and brief encounter with Roman Catholicism. So does their aspiration to create an art that transcends the material existence of the photographic image.

Their subject matter also bears traces of the natural environment of southern New Jersey. To the east, the ocean was a constant presence and, for the Starns, not always a benign one. In pieces like *Yellow Seascape with Film and Wood Blocks* (page 98) and *Film Seascape* (pages 100–101, formerly titled *Film Seascape with Woman*), they use the ocean to suggest endless, infinite space, conveying a calm, spiritual realm. But in these same works the sea registers as imposing and remote, a sign of nature's ultimate indifference to human mortality.

To the west, the Starns faced the Pine Barrens, a landscape most remarkable for its lack of prominent geological features. Like the open sea, it is flat, disorienting, and occasionally hypnotic; the major elements on the horizon are pine trees and the open sky. In winter, the ground is colored with shades of sepia and umber — the same colors that the Starns deploy in their black-and-white photographs, by use of chemical toners. In their abstract pieces, which consist only of toned photo paper (*Sol* or *Corona*, for example), the Starns create works that seem to emulate this dusky, nearly featureless landscape. The generally muted colors of all their works to date suggest it as well.

By their senior year in high school, the Starns knew they wanted to go to art school. Although "it seemed a stupid idea" to them at the time, they packed their portfolios and traveled to Philadelphia, where a consortium of art schools was having a day-long recruiting and interviewing session. Of the schools they considered that day, they preferred the School of the Museum of Fine Arts in Boston — commonly known as the Boston museum school — because, they remember, "it seemed the loosest" in terms of curriculum. They applied to it and several other schools and, to their surprise, were accepted by all of them.

They were still searching for identities as photographers, but they were obviously eager and ambitious. Their models at the time were Duane Michals and Jerry Uelsmann, two photographers who in the 1960s broke with the modernist conventions of their medium. Michals, who is well known both as an artist and as a fashion and portrait photographer, dispensed with the idea of the single print by fabricating narrative "sequences." By using ordinary devices such as double exposure and time exposure, he gave his comic-strip length tales a metaphysical dimension. Uelsmann instilled an unworldly aura in his work by dispensing with the idea of the single negative. His prints are seamless amalgams of contradictory information achieved by multiple printing — trees grow out of hamburgers surrounded by clouds, nudes unbend beneath swampy groves. Like Michals and Uelsmann, the Starns wanted to break out of the confining format of the single-image print, and they wanted their work to address issues beyond a precise description of the world.

At first they pursued separate careers at the museum school, with Mike making prints that bled off the edges of the paper and Doug printing multiple images on a single 16-by-20-inch sheet. In 1981, at the end of their first year, they took their work on the rounds of galleries in Philadelphia. "We were told we couldn't do it that way,"

Doug recalls, as gallery after gallery objected to the lack of white borders around their images. They also disregarded another convention of photography: the paper bearing their images was anything but pristine. "We were careful," Doug says, "but if a print got bent it was okay with us." The paper on which their photographic images appeared was fast becoming the focus of their work.

Their reception in Philadelphia only spurred them on. Now working together, they started printing bigger (on 20-by-24-inch sheets) and staining and toning the resulting borderless prints. Sometimes they let the edges of the paper get fogged by light and, in the most brazen step of their student years, they creased the paper itself. Not even the experimental Modernists of the 20s and 30s had gone this far. "It was a big decision," Mike says, "there were 150 years saying 'the paper is sacred.'" But to the Starns, the sacred had to be breached in the name of refurbishing the photograph's authenticity. In their eyes, only by violating the conventions of modern photography could its original luster and emotional power be restored.

Fortunately, the unstructured curriculum of the museum school left them free to pursue their intuitions, subject only to reviews by the faculty twice a year. "We basically didn't go to classes; we just worked in the darkroom," Doug remembers. The "correct" advice of some of their teachers ("You should clean up the edges") ran like water off a duck's back. But they also had teachers whom they remember as extremely sympathetic to their rebellious aims, and whose critiques advanced their progress.

Their sole model and "hero" figure at the school was Mark Morrisroe, a photographer whose penumbral, self-dramatizing pictures would later gain him an underground reputation in New York. According to the Starns, Morrisroe (who died of AIDS in 1989) "cared about the beauty" of his prints and "pushed the limits" of conventional presentation, purposely leaving dust spots on his images, for example. Morrisroe's outsider status even at the museum school was also something the Starns admired, although they otherwise had little in common with their upperclassman.

Their resolve to "show what the medium does" led the Starns to spend increasing amounts of time in the darkroom, experimenting with different ways of printing, toning, staining, and otherwise altering the traditional black-and-white print. "We thought, 'Why should this part of photography be just a craft?'" Doug recalls. They decided to show their collaborative efforts to the photography galleries in Boston. According to the Starns, both Brent Sikkema, then of Vision Gallery, and Carl Siembab, Boston's most venerable photo dealer, responded to the work but expressed doubts that they could sell it. Sikkema, however, suggested that the Starns visit Jean-Claude Lemagny, photography curator of the Bibliothèque Nationale since 1969, when in Paris.

In March 1985, when they were enrolled in the museum school's fifth-year program (in essence, a year-long studio sojourn in lieu of graduate studies) they went to Paris on a twelve-day school-sponsored trip. They made an appointment with Lemagny, and he bought two or three of their prints—the first purchase of their work by anyone. They also took photographs, in the Louvre and in the streets. These negatives would provide much of the raw material for their first gallery exhibitions: the Mona Lisa, the Louvre floor, a painting of Christ by Philippe

de Champaigne, a stone statue of a griffin on the Place St.-Michel.

Seeing the masterworks of Western art in the Louvre widened the Starns' field of reference dramatically, and added an important dimension to their subject matter. Where before their source pictures had been focused primarily on their cats, boots, art-school acquaintances (Mark Morrisroe, Ian Churchill), girl friends, and themselves, they could now refer to times and places other than their own. For the first time, their work seemed to extend beyond the hermetic milieus of Absecon and art school.

Later that spring, the Starns added a new and decisive element to their formal vocabulary: they began to tape together the edges of sheets of photo paper in the darkroom, so that their pictures could exceed the limitations of the manufactured "given" of 20-by-24 inches. After being taken apart for processing, the sheets were retaped to make a single image that could be hung on the wall. That summer, they received their first real public recognition, in a show called "Boston Now: Photography." Organized by the Institute of Contemporary Art there, "Boston Now" aspired to represent the range of Boston area photography, including among its thirty-seven artists such well-known figures as Bill Burke, Jim Dow, Olivia Parker, and Marie Cosindas. (Both Burke and Dow taught photography at the museum school.) But it was the Starns, along with Mark Morrisroe, who gave the show distinction and contemporaneity. To a visitor from New York, as this writer was, the Starns' work seemed to leap out from what was otherwise familiar territory.

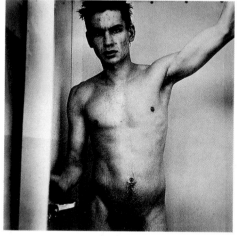

SELF-PORTRAIT. 1986.

MARK MORRISROE.
PHOTOGRAPH, 16 × 20".
COURTESY PAT HEARN GALLERY,
NEW YORK

Even before "Boston Now," however, observers had sensed something new and important in the Starns' work. Among them was Joseph Masheck, who the following year would write one of the first major articles on the Starns for the magazine *Arts*.[24] Masheck had first seen the Starns' pictures in a 1984 group show held in what he later described as "some abandoned railroad cars slowly sinking into the marsh at the edge of Boston Harbor."[25] (The exhibition is listed on the Starns' resume as "The Little Train That Could . . . Show.") Masheck also included the Starns in exhibitions he organized at 55 Mercer gallery in New York and the Carpenter Center at Harvard.

Another early enthusiast was Stefan Stux, who with his wife, Linda, ran a Newbury Street gallery devoted to painting and sculpture. Stux remembers seeing the Starns' photography for the first time in a show of fifth-year students at the museum school and being captivated by one piece in particular: a near-abstract, taped, three-part image of a horse's head. He vowed to find the artists who made it. They, however, found him first.

The Starns had gone once again to show their new work to Brent Sikkema at Vision Gallery. Sikkema remembers that he "tried to get them away from photography," telling them that their work would be much better served by an art gallery not identified with a particular medium, and suggesting they visit the Stux Gallery. The first time the Starns went to show their work at the gallery, however, they got cold feet and left without so much as speaking to anyone. Screwing up their courage enough to mount a second assault, they managed to introduce themselves, only to be confounded by Stefan Stux's unexpected response: "I've been looking for you!"

The Stuxes' influence on the Starns' career has been considerable. Stefan Stux gave them their first "one-man show" (alas, the commonly used art-world term does not quite fit the twins) in the fall following the "Boston Now" show. Then, in March 1986, he opened a second gallery in New York and presented the Starn Twins as one of his star attractions.

Stux's move was a strategic master stroke. With collaboration in the air, and the notion of discrete authorship under attack by Post-modernists, "the Twins," as they were billed, had a built-in allure. Even more alluring was

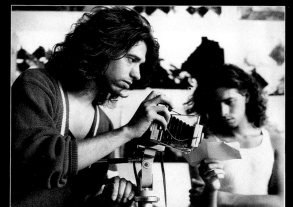

the impertinence with which they went about making a melange of modernist photography and painting. Moreover, they were fresh faces from outside the New York establishment. The critic Gary Indiana made sure the show created a Gotham City sensation when he wrote, in the centerfold of *The Village Voice*, "run, don't walk, don't miss it: it's brilliant."[26]

Later that year the Starns were selected for the 1987 Biennial of the Whitney Museum of American Art, and as soon as word leaked out collectors were beating a path to Stux's door. Eugene and Barbara Schwartz, well-known Park Avenue collectors of contemporary art, were the first true believers, followed by Don and Mera Rubell and Emily and Jerry Spiegel. After the Biennial, Charles Saatchi, the English advertising magnate and bellwether collector, began to acquire the Starns' work in quantity. When it became known that Saatchi was collecting

IN THE STUDIO, BOSTON, 1986

Starns' pieces, and that the venerable Soho art dealer Leo Castelli was fascinated by their work, the Stux Gallery had a waiting list of art lovers eager to have one of their own.

Not all the interest in the Starns was a result of a bandwagon mentality among collectors, however. Clearly their work had struck a chord that reverberated with special urgency in the art world of the late 1980s. It was fresh, ambitious, unashamed of its own beauty, and unapologetically unrelated to the conceptual posturings of Post-modernism or "critical" art. It seemed to fill a need for a more genuine, expressive art, and it happened to arrive at the precise moment when that need was acquiring a cogent, cohesive voice.

But the Starns' arrival on the scene was so well timed that to some minds it seemed calculated. Even before the Biennial, Masheck had worried about "something as yet still teetering on the brink of fashionableness" in their art.[27] Suspicions of "hype"—the orchestrated inflation of an artist's reputation and prices—grew as fast as the Starns' public recognition, fueled by the knowledge that they were only two years out of art school.

The art world had seen artists become wildly successful early in their careers before, of course; Frank Stella was all of twenty-two when his influential stripe paintings were first shown in New York, and Cindy Sherman was barely thirty when a museum retrospective of her staged photographs began to circulate. However, both of these artists' works seemed to fit neatly into an ongoing discourse about the nature of art. With the Starns, the situation was different: their work seemed calculated to dismiss the theoretical debates of the 80s, to turn its back on the intellectual process of art-making, to presage a return to an art-for-art's-sake self-sufficiency. In short, it seemed to pretend that art earlier in the decade had never happened.

However, the Starns' work proceeded not from any calculated effort to refute or rebut the art that came immediately before it, but from a guileless yet purposeful naiveté. "We stayed naive to keep our imaginations free," they say. They profess not to have heard of Cindy Sherman until 1984, nor to have learned anything about Julian Schnabel and David Salle until 1986. They first encountered the work of Anselm Kiefer in 1986 or 1987. While they had studied the history of photography in art school, and knew about movements like Pop Art, they felt that as students they should not become beholden to the past. "We knew about Moholy and Man Ray, but we wanted to say something else." In essence, then, their work represents not so much a rejection of the momentum of contemporary art than a deliberate obstacle in its path.

Ultimately, the reception afforded the Starns early in their career will prove less important than the values they choose to put into the foreground of their art. They have a willingness to trespass the conventional parameters of their chosen medium, a penchant for intuitive experimentation, an affection for specular drama, and an aspiration to make art that addresses such traditional and universal topics as mortality, beauty, and man's relationship to nature. As interest in art's ability to address these issues increases among the current generation of artists, and with it the urge to restore the spiritual role of the arts, the Starns are poised to help determine the future direction of contemporary art. They can no longer be considered outsiders; today they seem more like avatars.

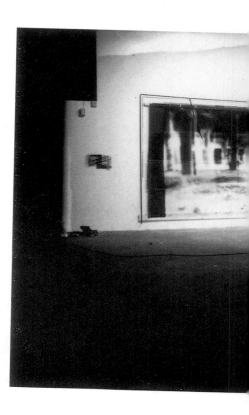

Having outgrown Boston's provincial art scene, the Starns now live and work in New York. Their studio is in Brooklyn, nestled between the Brooklyn-Queens Expressway and the mouth of the East River. From the front door there is a view of New York harbor and Governor's Island and, across the street, a sagging two-story building that houses a slaughterhouse specializing in ducks. When they walk to lunch at an Italian restaurant a few blocks east, the Starns are careful to keep their distance from this building, which gives off a slight but distinct odor.

The studio, a converted truck garage, is divided into four parts: a darkroom, a wood shop, an office, and— by far the largest area—a two-story-high room for the assembly of the pieces. In its vastness it recalls Frank Stella's gigantic studio, although Stella has several floors the size of the Starns' one. As is true for Stella, the assembly area of the studio serves an important role in the creative process. It is here that the Starns piece together their toned sheets of black-and-white photo paper, tape the sheets into their final forms, and mount the resulting assemblages in frames built expressly to fit them. The fabricating and framing decisions are made jointly, just as they share the work load in the darkroom. Theirs is a collaboration of a high order.

The studio floor is still marked by stripes of paint that were put there to demarcate parking spaces, but many of the walls are new and freshly painted. Above the entrance is a loft-style room furnished with desks and a

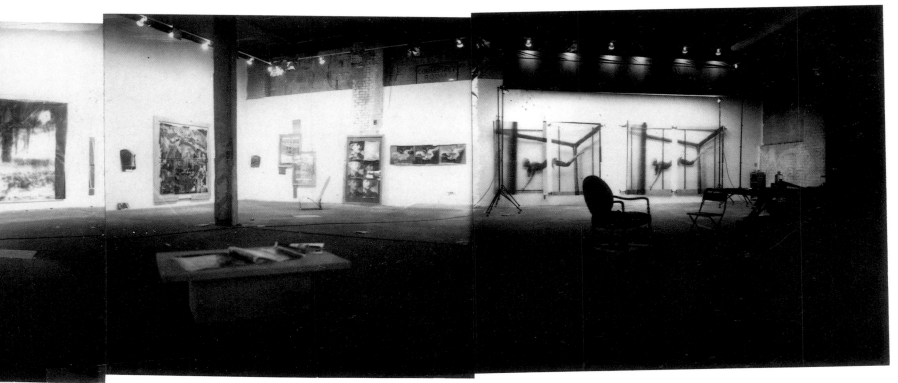

STUDIO VIEW, NEW YORK, 1989

coffee table; at the foot of this business area is where Doug parks his new Mazda Miata—like the studio itself, a sign of the brothers' success. An elaborate, high-powered stereo system allows the Starns to listen to rock music while they work in the darkroom. Their tastes run to house music, the Rolling Stones, Guns n' Roses, and other similar guitar-heavy bands, and like the guys in the movie *Spinal Tap* they keep their volume control set on "11."

The well-equipped darkroom is as large as many Soho lofts. Its prominent features include an enlarger, mounted so that it projects negatives across the room, a moveable wall onto which the Starns tape their sheets of photo paper, and a long, wide sink, built to accommodate their developing and toning procedures. It is a darkroom many photographers would envy, although working in its expanse requires a fair degree of stamina.

The Starns say they love photography, and yet they seem irresistibly drawn to violate its norms. As a result, some of the same photographers who would envy their darkroom would contend that their work isn't *real* photography, but a gussied-up, artificial version. Some in the art world—especially those invested in their work—would be quick to agree; they want the Starns' pictures to be received as art, plain and simple. After all, "art"—meaning, to too many minds, painting and sculpture only—has always been worth a great deal more than "mere" photography.

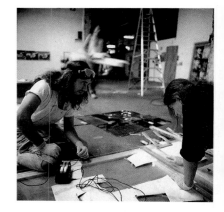

(ABOVE AND OPPOSITE)
IN THE STUDIO, NEW YORK, 1989

Nevertheless, photography led the Starns to become artists, and it is photography that continues to provide the fuel for their creative spirit. They see photography as a medium that has never been fully investigated, the way painting has, and they intend to remedy that shortcoming. In five years of mature collaboration, they have come astoundingly far.

One would like to think of artists being born whole, inventing their work and their personas in single strokes and then unveiling them to the world. In reality, the Starns struggled for years to discover the ramifications of their teacher's admonition, "Think about your paper." Only in their fifth, "studio," year of art school, when they invented new means to explore the physical nature of the medium, did their work begin to acquire its current intensity and resonance.

Throughout their first years in art school their work was on 20-by-24-inch sheets of paper, the way it comes out of the box. Following the lead of Mark Morrisroe, the Starns focused on ways to create an awareness of the surface of the print. They stained and toned the paper with off-the-shelf chemicals, scratched and wrinkled the negatives, and, eventually, scratched and wrinkled their prints as well. Theirs was a reaction to the documentary content of camera images, a way of defeating photography's penchant for literal description in a classical, perspectival mode. It was also a rejection of the standards and styles of art photography—even those which were obviously constructed and overtly artificial. "I knew it wasn't what the gallery world wanted," Mike remembers of their work of the time.

It certainly wasn't what photography audiences could accept, despite the example of photographers like Robert Frank. Frank, in a series of black-and-white Polaroid pictures begun in 1974, scratched words and phrases into his negatives, leaving a literal but visually immediate record of his emotional life on film. Frank's

pictures, however, have been a hard sell in the marketplace. Slightly later, and in slightly different fashion, Joel-Peter Witkin began making grotesque tableaux in which he selectively scratched and blotted out parts of his negatives and printed through translucent paper to mask out or degrade areas originally rendered by his lens. The Starns simply took this tendency to violate the lenticular given of an image a step further, attacking not only the surface of the negative but also that of the print.

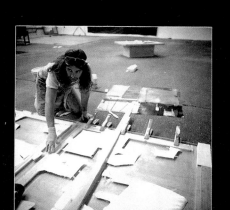

By their account, the impetus to assault the print came not from any analysis of what others were doing simultaneously—their field of reference in art school having been remarkably small—but from a dissatisfaction with the limitations placed on photography by the likes of Ansel Adams and Alfred Stieglitz. They were unhappy with pure photography, and unhappy with their own work to date. That changed in 1984, when they hung their pictures in the Boston "Little Train That Could . . . Show." At the opening, they sensed something amiss, or missing, in their work, which at the time consisted of one sheet of paper per image. The next day, they returned to the show, took down the prints, folded and creased them, and put them back on the wall.

To say that they were pleased by what they saw is an understatement. To the Starns, the distressed, faceted pictures had the force of a revelation. Instantly, they knew they had taken an important step in their search for a new and freer form of photographic image. They perceived that photographs, in the conventional understanding of them, were self-limiting; one had to pretend to ignore their support. By crumpling that support, they were able to transform the image and, at the same time, force us to see the photograph itself as an independent, physical object.

But if this work wasn't the photography world's idea of good photography, it wasn't quite what the audience for painting and sculpture could fathom, either. Despite the prominent presence in the prints of the artists' "hand"—the surface treatment that lets us know a human consciousness has been at work, which is normally lacking in photographs—the pictures did not attain the scale we associate with paintings. In size, they were still like conventional photographs.

After returning from their trip to Paris in March 1985, they decided to try breaking into a larger scale by enlarging an image onto more than one sheet of photographic paper, creating an overall, contiguous montage made up of several discrete rectangular pieces. Their first successful effort was *Dark Portrait*, an image of Mike printed several shades darker than convention would dictate. They started by arranging the sheets of light-sensitive paper on the darkroom wall, using ordinary transparent tape to hold them in position. Then, with the enlarger chassis turned horizontally, they projected the image across the darkroom and focused on the grid of paper. After the sheets were exposed, disassembled, and then individually developed, toned, and dried, the Starns next had to rejoin them. Characteristically, they chose the same tape that served them in the darkroom, and they taped the prints not only on the back, where no one would see it, but also on the front.

By putting the tape on the front of the image, they drew further attention to the surface and physical presence of the paper, added yet more evidence of their darkroom manipulations, and once again distanced and

34

displaced the image itself—what, in conventional photography, would be the putative subject of the picture. What began to emerge is that the terms by which their images could be received and understood were shifting from those of photography to those of painting. No longer was the camera image the only focus of the picture, or even its primary one; instead, the treatment—what had been done to the picture, in the darkroom and afterward—achieved primacy. The result was not so much a photograph as it was a unique work of art. After finishing *Dark Portrait*, the Starns looked it over and put it away. "We hated it," they remember feeling.

But they also knew they had done something, something that was not the same as David Hockney's panoramic assemblages of snapshots, or Bernd and Hilla Becher's repetitive grids of industrial structures, or Chuck Close and Lucas Samaras's larger-than-life Polaroid portraits. Months later they brought out *Dark Portrait* and looked it over again. Then they embarked on the ambitious piece called *Place St.-Michel* (with an image of a stone griffin taken in Paris) and the first *Seascape*. Both works are of a floor-to-ceiling size that emulates modern paintings more than photographs; they are scaled for the spaces of Soho galleries, not for the book page or portfolio case.

At first the brothers arranged the paper in grids, using it as it came from the box, but soon they realized the possibilities of cutting it into shapes. There followed a series of experiments with cut and arranged paper, including *Double Stark Portrait in Swirl* (1985–86) and *Mark Morrisroe* (1985–86). In *Double Stark Portrait* (page 77), the paper shapes form an arc around the figure's head; in the Morrisroe portrait, a rim of slightly lighter paper separates Morrisroe's shadowy figure from the background.

After leaving Boston's museum school in the spring of 1985, the Starns had set up a new studio in Boston and furnished it with a darkroom big enough to allow them to make very large pieces conveniently. They built a moveable partition so that the distance from the paper to the enlarger could be easily adjusted. To help them arrange the pieces of paper on the partition's surface prior to the exposure, they marked the position of the projected image with black tape. Not surprisingly, this second kind of tape eventually found its way onto the surface of the work, as in *Rose Petals with Black Tape* (page 75).

The urge to bring the evidence of their technical manipulations into the foreground of their pictures is one of the engines that propels the Starns' work. Besides the transparent and black tapes, they have used black ribbon in several pieces, including *Crucifixion* (pages 120–21) and *Watson with Ribbon* (page 104); in the studio, the ribbon is used as a means of estimating the sizes of their hand-built frames. (*Crucifixion*, made from fragments of the large "Christ" images, is an unframed work, which makes the use of the ribbon somewhat of an aside.) In similar fashion, the Starns use Plexiglas not merely as a conventional covering to

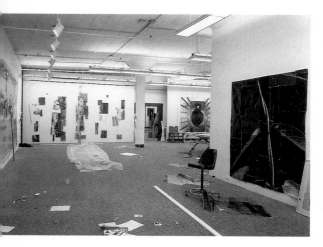

STUDIO VIEW, BOSTON, 1988

protect the photographic surface, but as a part of the work itself; sometimes it leans into the frame, or it splits the photographic image in two. To further emphasize the plexi's physical presence, they glue wood blocks to its inner surface. The excess glue becomes a visual feature of the work, like the tape and ribbon, functioning in part as a sign of the art's hand-crafted nature.

In the fall of 1985, when their first exhibition at Stux Gallery took place, the elements of the Starns' technical and formal vocabulary were already visible, although at the time the multiplicity of means employed suggested more potential than accomplishment. Works like *Dark Portrait, Seascape, Place St.-Michel with Lead and Plexi,* and *Macabre Still Life* were displayed. Some were framed and some not; some were taped together and some consisted of single sheets; some were wall-size and some were small, even for photographs. The diversity of the presentation was matched by the apparent diversity of subject matter, including an early, life-size version of Philippe de Champaigne's recumbent Christ.

The almost inchoate diversity of formal means and subject matter in the show was further emphasized by the Starns' decision to hang their works salon style, an arrangement that verges on the haphazard. Such a method of presentation flew in the face of the eye-level, side-by-side hanging style that has been a convention of modern art for most of this century; instead, it harked back to the days in the nineteenth century when the competitive salons of the French Academy and commercial "picture galleries" hung paintings from floor to ceiling.

The Starns intended the display as an anti-Modernist gesture, not as a nostalgic one. Nevertheless, the evocation of nineteenth-century display practices undoubtedly spurred some critics to associate the Starns with the Victorian era. So did the prints themselves. Elisabeth Sussman, for example, wrote of the Starns in the catalogue of the "Boston Now" show:

> The Starn Twins transform "direct" views of landscape, and portraiture, into artifacts that emulate vintage prints. Events are presented through the eyes of past photography, echoing older visions in process (daguerreotype, calotype, sepia prints) and content. Rumpled, toned, framed, produced in small or large scale, their prints challenge Walter Benjamin's assumption that aura only attaches to the traditional art of painting. Rather, aura (presence, value) is found in the artifact (and vision) of the vintage photograph. It is this commodification of the photograph through suffusing it with aura, which lends the Starns' photographs their most significant characteristic.[28]

Sussman's account pinpoints the apparently nostalgic romanticism of the Starns' work, even as it places it within the fashionable discourse of Post-modernist criticism—a paradox that continues to inform the reception of their art. Interestingly, she equates the emphasis on "aura" in their photographs with art's "commodification," even though one could argue that by evoking nineteenth-century art, the Starns attempt to return to an "innocent," pre-commodified era of art-making. Those early daguerreotypes and calotypes, after all, were never in the same league as paintings; the practice of photography in nineteenth-century culture was either pragmatic

and commercial, as in the case of portraiture, or a pastime for amateurs—well-to-do gentlemen, mostly, who in today's terms would be considered Sunday painters.

Just how far the Starns were willing to experiment, and how adaptable and variable their processes were, became apparent when they produced an edition of one hundred prints for the Institute of Contemporary Art in Boston. Each of the prints, which were commissioned in 1986 as a fund-raising device, is unique. Yet all are derived from the same negative: a picture of two horses' heads, seen close in and cropped, that the Starns had taken at their sister's horse farm. Working with one camera image, they produced a tour de force of theme and variation. The colors range from yellow to blue; some are "straight" prints and some are collages; some bear a single image and some a repeat pattern of as many as sixteen horse pairs. The "Horses" are essentially monoprints that show the young Starns at their most inventive—most likely because the constraints of the project gave their energy a specific focus.

In their first show in New York, at Stux Gallery in the spring of 1986, the Starns continued to define their work in terms of difference and diversity, elaborating on their printing and framing techniques while maintaining their idiosyncratic style of presentation. *M.*, a nine-by-almost six-foot portrait of a young woman wearing a floor-length white dress, showed an increasing facility with multiple printing and toning; the variably sized prints that make up the piece are alternately toned brown and black, creating a checkerboard effect in the portrait's background. Two works mentioned earlier, *Double Stark Portrait in Swirl* and *Mark Morrisroe*, marked a new ability to shape the photographic paper to the subject. But the show's centerpiece, in a vitrine in the center of the gallery, was their *Stretched Christ* (1985–86).

Stretched Christ (pages 67–68), based on the same Champaigne painting in the Louvre as their earlier *Christ*, is in many respects the Starns' most memorable image of the 80s, and one of their most complex. It consists of three different series of prints of Champaigne's painting, interleaved to create a coherent though elongated figure. Two surfaces of paper are used, and there are two tones to the basically black-and-white image. Framed in wood and glass in the manner of a *cassone* painting, and more than eleven feet long, it can hardly fail to impress.

And impress it did. Having caught the eye of the curators of the Whitney Museum of American Art, *Stretched Christ* next appeared in the Whitney's 1987 Biennial. There, together with *Mark Morrisroe, Double Stark Portrait in Swirl*, and two dozen other pieces—all hung, as usual, salon fashion—it created a critical sensation. Suddenly the Starns were no longer commuters living on the fringe of the New York art world; they were thrust onto its center stage.

The Starns were not the first photographers to present their work as an "installation," nor were they the only artists of the 1987 Biennial to opt for a salon-style hanging. (Bruce Weber's superheated fashion images were displayed in similar fashion not far away.) But they were among the first at the Whitney to pin photographs directly to the walls, without any covering and without any nod to the "fine-art" conventions of the medium.

True, most of the Starns' pictures in the show were framed, but even there convention did not hold: the frames ranged in style from blond and unfinished to gilded and antiqued. Some looked as if they had been pieced together from scrap lumber, and one insouciant framed piece—an abstract one, at that—was left leaning against a wall. Salon hanging or not, one would have been hard-pressed to ignore the Starns' contribution to the show.

When the Starns' repertory began to expand, it did so in part in reaction to public and critical responses to their exhibitions. "One group is inspired by the misunderstanding of the last group," Doug says. After some critics called their spring 1986 Stux show "Victorian," they produced a body of work having no images—a flirtation with abstraction and, it almost goes without saying, clearly non-Victorian. (To the Starns, these pieces, which were shown at the Massimo Audiello gallery in fall 1986, demonstrated their focus on the nature of photography and its presentation.) After some collectors asked the Stux Gallery if certain pieces could be framed to protect them against damage, the Starns began to parody and extend the purposes of framing, leaning Plexiglas against the photographs (as in *St.-Michel Claw*) and gluing wooden blocks between the image proper and its mostly transparent covering.

The Starns also have followed clues that were embedded within their work from the start. In 1988, for example, they started using sheets of photographic film as well as photo paper. In works like *Double Rembrandt with Steps* and *Yellow Seascape with Film and Wood Blocks*, they use film to create an added effect of translucency and layering. The layers of historical codes in the Starns' Rembrandt piece—the Old Master era in Europe, the more modern steps, even reference to Rembrandt's role in the history of print-making—are made explicit by the layering of pictorial images that the combination of film and paper makes possible. To the Starns, the film is more like what they are used to in the darkroom—more, that is, like a negative. But its effect is to create a window on the past, one that magnifies and focuses the Starns' preoccupation with art history, archaeology, and architecture. It is, like Rauschenberg's use of actual objects on canvas in his combines, the ideal means for achieving the texture of pastiche.

Increasingly, their manipulations are performed as much on the materials of presentation as on the photographic images themselves. In *Rookery with Wood Block* (page 109), the heart of the main, overall image of a well-known Chicago building has been excised and then replaced by a carved rectangle of wood. *Film Tunnel with Man* features an image-bearing wooden post in front of a mammoth image of an underground chamber, and the *Lack of Compassion* series (pages 116–17) consists of a suite of leaning, raw-wood slabs adorned with photographs of political and religious martyrs. The use of wood and the three-dimensional qualities of these works suggest that the Starns' interests now have as much to do with sculpture as with photography.

This is clearly true of the first work they produced in the Brooklyn studio, in the fall of 1989. Starting with a negative of an ancient Minoan figurine called the bull jumper, which Mike had photographed during a honeymoon trip to Greece, the brothers printed large film positives and devised a support for them using thin

plywood strips held in tension by pipe clamps. The tension bows the wood, forming convex or concave armatures that cause the film to bow out from the wall. One such piece, *Concave, Convex Bull Jumper*, is divided into both convex and concave arcs, like a bifocal lens turned sideways (pages 126–27). The bull jumper series was followed by a new series of horse pictures, using an image of a Greek statue, that are built in a similar fashion. Works such as these are still heavily dependent on the presence of the photographic image, but much of their visual complexity and wit—not to say their beauty—comes from their dimensional, physical presence.

No matter what the materials or method of construction, all of the Starns' work to date is characterized by a sense of fragility and temporality. Their use of tape to hold the sheets of paper together, the casual form of their frames, and the fragmented, chemical quality of the photographs themselves conspire to remind us of the art work's mortality. Some collectors have been hesitant because of this, fearing that damage and decay are inevitable and that their investment will be lost as a result.

But the Starns are ardent about the aging process and its role in their work. To them, the work of art is a living being, with its own life and inevitable death. "Things deteriorate over their lifetime," they say. "Art cannot be excused from time." True, they have checked the chemical characteristics of the tape they use on the front of their prints (in terms of pH it is practically neutral, they say, and thus will not affect the photograph), and they are aware of the demand for "archival" longevity. They want to create a new ground for appreciating the beauty of a photograph, one that does not depend on adherence to traditional craft values. "The cracks aren't there for an antiqued look," they say. "Unlike a Mark Rothko that has changed with age and is not the painting it originally was, our work is conceived to change and age. Its aging is not its death but its life and creation."

The Starns are identical twins—*monozygotic* is the scientific term—born of the same egg and sharing the same genes. In person, they are barely distinguishable, and then mostly by incidentals. On the day we first meet, Mike, recently married to Anne Pasternak, wears a wedding ring; Doug has a small scar over the bridge of his nose, just above his right eyebrow. Mike wears a blue shirt and jacket, Doug a black shirt hanging over blue jeans. Mike's hair frames his face, while Doug's is pulled back into a pony tail.

They are young, casual, and boyishly handsome. By all appearances they are totally relaxed and comfortable—with each other, with their visitor, and with their newly minted status as important twentieth-century artists. But both also have a way of dropping off into silence, or of waiting for someone else to speak up, that belies a wary attentiveness. They have often been described as shy, but their manner seems more thoughtful than that. Still, there is an intensity about them that makes them seem eager to get on with things. And what they most want to get on with clearly is making art.

Needless to say, identical twins are a constant object of study in psychology. They are in some respects mirror images; twins separated at birth have been found to have nearly identical personality traits. But twins also fascinate because they mirror division, echoing by their very existence the instability and fragmented nature of human identity.

At their lectures, they start by introducing themselves. "I'm Doug," says Doug. "And I'm Mike," says Mike. The audience always laughs. Part of the joke, of course, is that to a large part of the art world it doesn't matter which is which; their art seems to have issued from a single sensibility. They are "the twins," a single author divided perfectly in two.

The Starns see themselves differently. Doug says that Mike occasionally looks like him, or that he (Mike) can look like himself, but that he (Doug) never looks like Mike. Mike disagrees. They recall that for much of their fifth year in art school, Mike painted while Doug continued to print photographs. Now they feel that billing themselves as "The Starn Twins" at the start of their career was an attention-getting device with some unhappy consequences; today, they prefer to be identified as themselves. In recent exhibitions, the announcements have read either as Mike and Doug or Doug and Mike Starn.

Still, they remain so close to each other that being with them has its uncanny moments. At lunch not far from their studio, Mike orders spaghetti bolognese. Doug shakes his head and smiles, then asks for the same. Mike orders a Coke. Doug says he'll have wine. Mike changes his order from Coke to wine. They share the same shy, reticent manner when discussing themselves, and the same convictions about which of their pieces are the best and which no longer seem to work. Sometimes they finish each others' sentences.

Both use a camera, whether on their travels or in the studio, where they document the stages of assembling

their composite images. But judging from photographs of them at work, and from the evidence of works like *Double Mona Lisa with Self-Portrait* (1985–88), they tend to stand at each other's side while taking pictures. In the darkroom their interaction is more complex and intuitive, though no more specialized, as they attend to the multiple tasks of printing and developing as if following a mutually agreed-upon script.

Much has been made of the Starns being twins, in part because their work invites it. The titles are enough to suggest how fascinated they are with their own duality: *Double Stark Portrait in Swirl* of 1986, *Double Chairs* and *Double Mater Dolorosa* of 1987, *Double Mona Lisa with Self-Portrait* and *Double Rembrandt with Steps* of 1988. Even when the doubling of the subject is not explicitly announced, the Starns seem to prefer things in twos. The 1986 Horses series, for example, is based on an image of two horses in profile; the *Portrait of Doug* of the same year shows him both upright and upside down, like a playing card figure. Pairings can also be found within single subjects appropriated from paintings, like the two breasts visible in *Nipples* (page 86) and the two seated nudes in *Large Blue Film Picasso* (page 106). (One exception is the figure of Christ, which so far has been reproduced either singly or in threes.)

Perhaps the most psychologically laden of these doubled or paired pictures is *Two-Headed Swan* of 1989 (page 18). Based on a seventeenth-century Dutch painting by Jan Asselijn titled *The Threatened Swan*, *Two-Headed Swan* brings to mind the Roman version of the legend in which Leda is impregnated by a swan (the god Jupiter, in disguise). Leda then brings forth an egg containing the legendary twins Castor and Pollux.[29] In the Starns' work, a second swan head has been added, the flip side of the first, a literal *doppelgänger*. Its mouth(s) fixed open in a state of alarm, the swan seems ready to break the boundaries of its cage, which in the Starns' reinterpretation could be taken for the frame of traditional art.

In one sense, the image is a metaphor of the Starns' eagerness to break the boundaries of the art world, using the photographic image as a means of reconstituting and refashioning their received knowledge of culture. It is also laden with psychological insight; as twins, the Starns look at identity as something friable and problematic. They share with Freud and others the assumption that who we are is more complex than it might seem on the surface—even, in this context, on the surface of a painting. This may explain why the Starns have affixed a piece of shiny metal above the swan. It functions as a mirror, specifically calculated to capture us, the viewers of the piece, to both draw us in and hold us at a distance. It makes twins of all of us. Surely Freud would have been amused.

Finally, one cannot contemplate the Starns' transformation of Asselijn's work without noting the sense of anxiety it contains. The background, with its barely discernible reeds, is murky and stormy, and the swan seems to be screeching in distress. By adding a second head, and the reflective piece of metal, the artists have magnified this anxiety and focused it on the issue of identity.

Pictures such as *Two-Headed Swan* and *Double Stark Portrait in Swirl* have prompted critics to use such terms as Oedipal and Other when discussing the themes embedded in the Starns' work. Both words come

originally from psychoanalytic theory (although they have been used by Jean-Paul Sartre, Claude Levi-Strauss, and many others since), and they suggest how much the idea of personality figures in the reception of their work. Gary Indiana wrote in *The Village Voice:*

> The enlargement and multiplication of details and shadows, the fracture and recomposition of complete images, act as metaphors for a complex psychic equilibrium in which the Other is also oneself, claiming half of a shared ego.[30]

Robert Pincus-Witten, writing in *Arts*, took this fashionably post-Freudian interpretation a step further, arguing that the Starns' work is inescapably "fetishized and eroticized." "Within the Oedipal system, narcissism is the external manifestation of a truncated ego-development—one both fixated at the pre-genital yet deemed desirable as a means of determining the boundaries of creativity," he noted, implying that the Starns' creativity is merely an outcome of arrested development.[31]

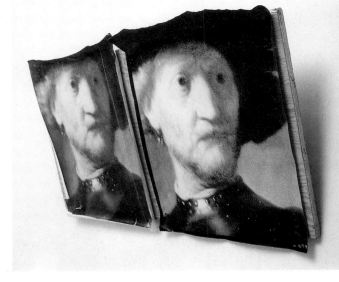

REMBRANDT HEAD DETAILS. 1989

Looked at culturally instead of psychologically, however, the Starns' work is more a reflection of a widespread trend in 80s art toward collaboration. By working in pairs, artists like the Bechers, Komar and Melamid, McGough and McDermott, and Clegg and Gutmann make both an aesthetic and a social statement. Their collaborative efforts challenge the essentially Modernist idea of the autonomous author, submerging two points of view into one. With the twins, of course, the point of view seems shared from the start. It is impossible to distinguish their individual contributions to each piece, and when pressed to explain who did what their answers range from vague to evasive.

Increasingly, their attention seems focused on the nature of art itself, and on the ways in which the history of image-making acts as a buffer between their perceptions of the world and the world itself. Their photographic images of paintings by Rembrandt (a portrait of a man assumed to be the artist's father), Leonardo da Vinci (the enigmatic Mona Lisa), Picasso (*Two Seated Women*), John Singleton Copley (*Watson and the Shark*), and others are in one sense Post-modernist appropriations of masterpieces in Western art and, in another, a means of inscribing themselves within that tradition.

The Starns do not recapitulate these icons of the art-historical canon so much as they renovate them. The paintings are usually photographed *in situ*, hanging on the walls of the museums that own them—Boston's Museum of Fine Arts, the Louvre, the Art Institute of Chicago. As a result, the Starns' images are far from perfect

copies. *Double Mona Lisa with Self-Portrait* (page 88), for example, includes not only the painting but also its protective, presumably bullet-proof shield, in whose surface one sees the reflected images of the artists. In addition, the Starns often excerpt those parts of the painting that seem particularly expressive. In *Copley's Watson with Blue* (1988), the only trace of the original scene is the figure of Watson in the water, a floating body with its arm outstretched and eyes bulging. The indeterminacy of the body—it is not entirely clear whether he is alive or dead, and the rendition leaves his gender ambiguous—is the sole focus of the piece. (In the original 1778 work, which purports to document a shark attack on a well-off slave trader named Watson, the scene is also psychologically indeterminate. Watson, the putative hero of the piece and the man who commissioned the painting as a monument to himself, is relegated to the bottom of the canvas, where he shares space with an enormous shark. The central figure in the composition is a black man standing in the rescue boat, who holds the rope flung toward the stricken Watson. In their transformation of the painting, the Starns have refocused attention back to Watson, eliminating both the black rescuer and the shark.)

There also are references to the canon of fine-art photography throughout the Starns' work. The series of plants done in 1988 began after they became acquainted with the work of Karl Blossfeldt, a German photographer whose 1928 book *Urformen der Kunst* (Archetypes of Art) attempted to show that nature is the font of artistic form. Blossfeldt's straightforward "Neue Sachlichkeit" (New Objectivity) approach embodies the aesthetic of Modernism between the wars and could hardly be more antithetical to the Starns' patently subjective aims. But the tension between the two gives works like *Curly Leaf* (page 73) and the plant details a life of their own. (By contrast, Robert Mapplethorpe's flower photographs, to which the Starns' plant pictures have been compared, are largely about eroticism, not aesthetics.)

The series of images of hands—*Blue Hands, Blue Hands with Black*—is a self-conscious homage to Alfred Stieglitz's pictures of the hands of Georgia O'Keeffe, which were part of Stieglitz's extended portrait of his wife. Starting with their own camera image of clasped hands, taken in 1982, the Starns have produced a wide variety of prints, ranging from single images to multi-paneled installations. Stieglitz, one of the most eloquent advocates of American Modernism, is perhaps the twentieth-century photographer with whom the Starns have the most in common. Unlike Blossfeldt, Stieglitz believed in photography's expressive, transcendental powers, formulating the ideas of "equivalence" to relate its descriptive and metaphoric capabilities. The hand served him as a metaphor for creativity and authorship, as it did for many Modernist photographers. But unlike the Starns, Stieglitz also believed in the inviolate integrity of the camera image.

Interpreting the Starns' penchant for doubling solely in Freudian terms obscures a more important thematic aspect, which is the degree to which the twins' choice of mirrored subjects represents an attempt to identify themselves as artists with quintessentially heroic figures. To establish their lineage, they reach back into pre-Modernist times in terms of artists (Leonardo, Rembrandt) and subject matter (Christ, Nathan Hale). In the Modernist era, they replicate Picasso and mimic Kandinsky and Stieglitz, artists whose aspirations for art

entailed a broad spiritual dimension. As opposed to Marxist art theory, which sees the artist as a cultural producer, a laborer in the aesthetic field, the Starns view the artist as a father figure and shaman who embodies universal moral and spiritual values. Their use of doubles and mirror images reflects their desire to inscribe themselves within this system of belief.

The Starns' longing for an art of spirituality and transcendence, which in some eyes is tantamount to nostalgia, is expressed not just by their references to canonical images from the archives of painting and photography. Their use of blank, imageless photographic paper also suggests, through the rhetorical conventions of abstraction, the possibilities that lie beyond the literal description of the world. Works like *Red and Black Square* (1986), *Black Group #2* (1987), and *Sol* (1988) are formed of pieces of photo paper stained in various metallic shades but without any identifiable image (pages 113, 112, and 110). They are radical attempts to free the photographic medium from the burden of representation, just as Man Ray's Rayographs in the 1920s were meant to free the medium from the dominion of the lens. *Sol*, along with *Corona* and *Corona Extra* (the names come from Mexican beer), is also an attempt to depict in a finished piece the appearance of the paper in the darkroom before it is exposed and processed.

At the same time, however, these abstract pieces appeal to the traditions of abstraction in twentieth-century painting and sculpture, traditions that are bound up with the urge to create an art outside (and above) the realm of everyday life. This is true not only of entirely imageless works like *Sol*, but also of pieces like *Yellow and Blue Louvre Floor* and *Kandinsky*, both made in 1988. *Yellow and Blue Louvre Floor* depicts the museum's checked floor, to be sure, but the image is treated as a kind of geometric abstraction *trouvé*, without any reference to a horizon line or any other contextual clues. *Kandinsky* (page 112) is made of scraps of paper left over from another image and cut into forms that suggest the formal devices and spiritual aspirations of European abstraction between the wars.

As the English critic John Berger first argued in *Ways of Seeing*, oil painting as we know it is innately materialistic.[32] The paint is a kind of material, of course, and when it is applied to canvas the result is an image that is essentially a kind of property that can be bought, traded, and moved from place to place. Abstraction, and especially the spiritualized abstraction of Kandinsky and the American Abstract Expressionists, can be seen as an attempt to dematerialize art, to transcend its physical self by jettisoning reference to any image. At the same time, photography has been associated with materialism since its invention. Despite its relative lack of physical presence compared to painting (its surface is usually neutral, smooth, unremarkable), photography serves to record the material reality in front of the lens. Historically, it is a product of a materialistic, industrial age.

By treating photographs in the same manner as painters treat canvas, the Starns tend to dematerialize both mediums. True, the photograph's materiality

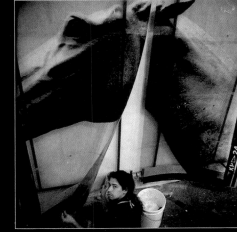

WORK IN PROGRESS, NEW YORK, 1989

is in one sense heightened by their manipulations. But there is no built-up surface in their work, as is commonly found in paintings, and in their recent film pieces none of the opacity that we expect from works on canvas. Nor is there any sense of obligation to hew to the dictates of lenticular recording, to show us something of "the world" as it is defined by the camera. As a result, the Starns' art is able to aspire to represent that which lies outside of representation. If the terms of this escape seem retrospective or old-fashioned, it is because of what they represent: romanticism at its most profound.

Like William Blake, Caspar David Friedrich, and other Romantics of the late eighteenth and early nineteenth centuries, the Starns focus our attention on their own sensibility. Still, there is a social dimension to their work, which manifests itself in pieces like the ambitious *Lack of Compassion* series and another series based on pictures of Anne Frank. The former series, which is an ongoing project, consists of raw wooden planks on which are affixed images of martyrs who were persecuted and killed because of who they were or what they believed. Some of them are individuals, like Gandhi, Malcolm X, and the Kennedys; others represent peoples or races, including a gypsy boy, a lynching victim, and an Amazonian Indian. Since it was begun in 1988, *Lack of Compassion* has grown from forty to more than one hundred and twenty individual pieces, which when stacked and piled together give the installation the somber weight of a cemetery. The Starns are donating the series to the Israel Museum in Jerusalem, where it is slated to be permanently displayed.

The Starns are concerned about the world in other ways as well: In a work like *Rain Forest with Ciba and Wood* (1989) they try to tackle environmental issues. *Rain Forest* (pages 122–23), produced for a benefit for the Amazon basin called "Don't Bungle the Jungle," is almost as complex as the jungle itself and seems less sentimental than the pieces devoted to individuals. But like all the Starns' socially concerned, outwardly directed works, it focuses more on what is represented, and our associations with that representation, than on the manner of its representation. One could argue, then, that *Rain Forest* runs the risk of returning the Starns' dematerialized art to earth.

Perhaps their most convincing works about suffering and victimization to date are derived from Champaigne's recumbent image of the dead Christ. The figure of Christ is itself dematerialized, attaining a spiritual dimension despite its carnal (and, in Champaigne's rendition, eroticized) form. Like the roses that are also a frequent subject of the Starns, the Christ figure represents a fragility and balance that is essential to the Romantic imagination. And like the horses, it represents an Otherness that is not so much Freudian as it is metaphysical.

Crucifixion, a wall-work made up of a multitude of irregularly shaped pieces of paper, ribbon, wood, tape, and a halo of wire, recreates the conventional Biblical scene of Calvary by standing Champaigne's "Christ" upright. (*Vertical Christ with Black* [page 85], made a year earlier, features a similar revision in orientation.) The Christ image is reproduced five times, with the central figure higher and more complete than those flanking it. As a result, the work suggests that those at Jesus' side, thieves and common criminals, were also martyred, and

that all shared in the body of Christ. *Crucifixion* may be unusual in terms of theology, but its message echoes the Starns' implied belief that all victims are in some way heroes, and vice versa.

When the Starns produced *Crucifixion, Film Tunnel with Man,* and the first *Lack of Compassion* pieces in 1988, they seemed to be increasingly concerned with emphasizing their work's dimensional and sculptural qualities. This suspicion has been borne out by their 1989 works that use film mounted on armatures formed of plywood, iron bars, and pipe clamps. Unlike most sculpture, however, and unlike their own earlier work, the *Bull Jumper* and *Athenian Horse* pieces are light, airy, and in part transparent. Since the film images are of stone sculptures, the ethereal quality of the work contradicts the substance of the image—stone seems to float in the air. Once again, the Starns have found an original and complex way to refer to art's origins.

The appropriation and re-use of pre-Modern art, and specifically religious art, is a characteristic of American art of our day. Joel-Peter Witkin has made a life-size Christ figure out of thousands of contact prints; Cindy Sherman has fashioned herself as a Madonna figure from Renaissance painting. Other artists, especially sculptors, have gone back into art history even further, reviving classical motifs such as columns and draped torsos. Part of this historicizing impulse, which the Starns exemplify, has links to the Post-modernist fascination with the commodification and reproduction of style. However, the particular choices artists have been making recently suggest something else: that there is a widespread yearning for the restoration of art's former authority.

This authority is both cultural, in the sense of art constituting a beacon for society at large to follow, and spiritual, inasmuch as art has traditionally functioned as a source of religious imagery and, in some cultures, as a way of generating religious experience itself. Never mind that our understanding of art's earlier roles may be distorted by our own longings: it seems inevitable that art in the 1990s will address itself to issues far outside the art marketplace.

In the same way, there are signs that artists are becoming increasingly eager to address unresolved historical and social conditions. Besides the Starns, one thinks of Christian Boltanski and his references to the Holocaust and the human spirit, of Anselm Kiefer and his simultaneous evocations of German legend and that country's recent history, and of Julian Schnabel, whose recent paintings on red velvet focused on animal-rights issues.

For art to reclaim its authority in all these matters, however, it must restore what Walter Benjamin, in his landmark 1936 essay "The Work of Art in the Age of Mechanical Reproduction," called the aura.[33] According to Benjamin, the reproductive technologies of photography and film destroyed this aura, which for most of history has been the ground on which works of art were received. More than fifty years later, paradoxically, art's aura—its uniqueness, its prestige, its capacity to express individual points of view and to embody the highest human aspirations—is the issue precisely at the center of contemporary art. And it is, finally, the issue that gives the Starns' work its enormous vitality. That Mike and Doug Starn have chosen to use photography in their efforts to renovate art's aura is yet another paradox, and an endlessly fascinating one.

It would be presumptuous to compare the Starns at this stage of their career with figures as large and luminous within twentieth-century art as Picasso and Rauschenberg. Nevertheless, one could venture to observe that the intensity and velocity of the Starns' creative collaboration to date is reminiscent of Picasso's ground-breaking interaction with Braque in the years 1908 to 1914 and that, like Rauschenberg, they seem to be tireless manipulators of received images. But what ultimately connects them to the prolific, self-propelling traditions of Picasso and Rauschenberg is their approach to making art: the meanings of their pictures derive not from any coherent narrative description or any purely formal qualities, but from the collage-like process of assembling the raw materials of an image into a vivid, expressive, reconstituted whole. As is also true of Rauschenberg, the image-bearing constituents of their works are rich with autobiographical and cultural associations, but what ultimately prevails is the urge to revivify those associations. To a large extent, the Starns' art is about the conditions and possibilities of picture making, and as such it constitutes a telling critique of the most pessimistic tenets of Post-modernism.

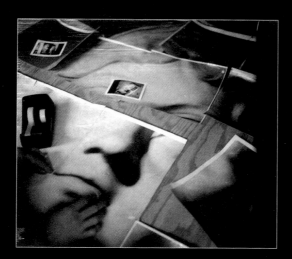

NOTES

1. Robert Pincus-Witten, "Being Twins: The Art of Doug and Mike Starn," *Arts* (October 1988), p. 77.

2. Joe Jacobs, "The Starn Twins," *Splash* (November/December 1987), n.p.

3. David Bonetti, "Rising Starns," *The Boston Phoenix* (October 30, 1987), p. 4.

4. Richard P. Woodward, "Mike and Doug Starn," *Art News* (December 1988), p. 146.

5. Michael Brenson, "Art: Whitney Biennial's New Look," *The New York Times* (April 10, 1987), p. C24.

6. Klaus Ottmann, "Doug and Mike Starn," *Flash Art* (January-February 1988), p. 126.

7. Jack Bankowsky, "Mike and Doug Starn," *Artforum* (January 1989), p. 109.

8. Daniela Salvioni, "Doug and Mike Starn," *Flash Art*, no. 143 (November/December 1988), p. 120.

9. Gianfranco Mantegna, "Doug and Mike Starn," *Tema Celeste*, no. 19 (January-March 1989), p. 69.

10. Joseph Masheck, "Of One Mind: Photos by the Starn Twins of Boston," *Arts* (March 1986), p. 69.

11. See Roberta Smith's "Singular Artists Who Work in the First Person Plural," *The New York Times* (May 10, 1987), p. 29, and Kay Larson, "The Starn Twins," *Vogue* (September 1987), p. 459.

12. Jacobs, "The Starn Twins."

13. Masheck, "Of One Mind," p. 69.

14. Larson, *Vogue*, p. 450.

15. Jacobs, "The Starn Twins."

16. Pincus-Witten, "Being Twins," p. 74.

17. Francine A. Koslow, "Doubling Photography: The Starn Twins," *Print Collector's Newsletter*, vol. xviii, no. 5, (November/December 1986), p. 166.

18. Gary Indiana, "Imitation of Life," *The Village Voice*, (April 29, 1986), p. 87.

19. Koslow, "Doubling Photography," p. 164.

20. Indiana, "Imitation of Life," p. 87.

21. Jacobs, "The Starn Twins."

22. This, and all other quoted remarks by the Starns, is based on a series of interviews and phone conversations with the author in the fall of 1989.

23. Although the family recently sold its supermarkets to a national chain, visitors to South Jersey still can see the Starn name on its former grocery stores. Those who visited the Jersey shore twenty-five years ago may also remember the Starn name from another sight: the Captain Starn's restaurant, which was once owned by the Starns' great uncle.

24. Masheck, "Of One Mind," pp. 69–71.

25. Ibid., p. 70.

26. Indiana, "The Starn Twins," *The Village Voice*, April 22, 1986, p. 71.

27. Ibid., p. 71.

28. Elisabeth Sussman, "Fiction" in *Boston Now: Photography* (Boston: The Institute of Contemporary Art, 1985), p. 48.

29. In the Greek version of the Leda and the swan legend, Castor and Pollux are not twins but stepbrothers. That the Romans changed the story is curious, but one essential point remains the same: the brothers were said to reside both in heaven and on earth.

30. Indiana, "Imitation of Life," p. 87.

31. Pincus-Witten, "Being Twins," pp. 72–73.

32. John Berger, *Ways of Seeing* (New York: Penguin Books, 1972), pp. 83–84.

33. Walter Benjamin, "The Work of Art in the Age of Mechanical Reproduction" in *Illuminations*, translated by Hannah Arendt (New York: Schocken Books, 1969), pp. 217–252.

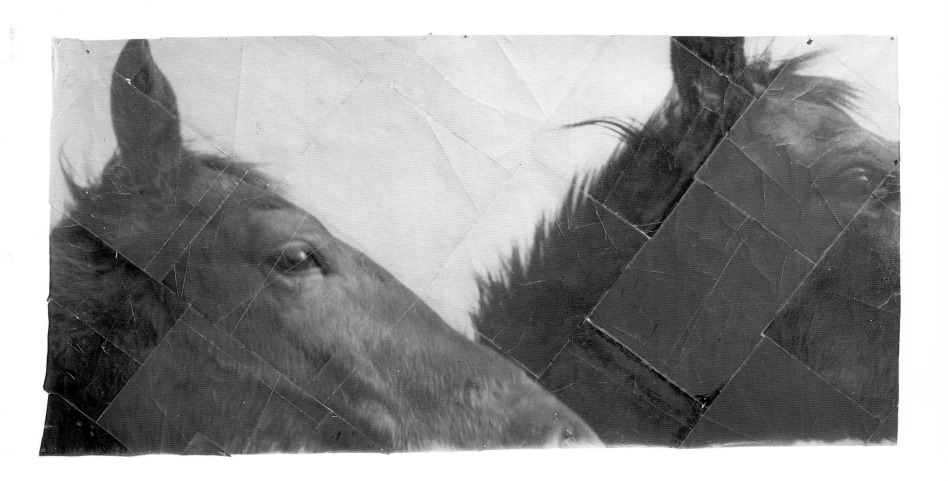

HORSES. 1986

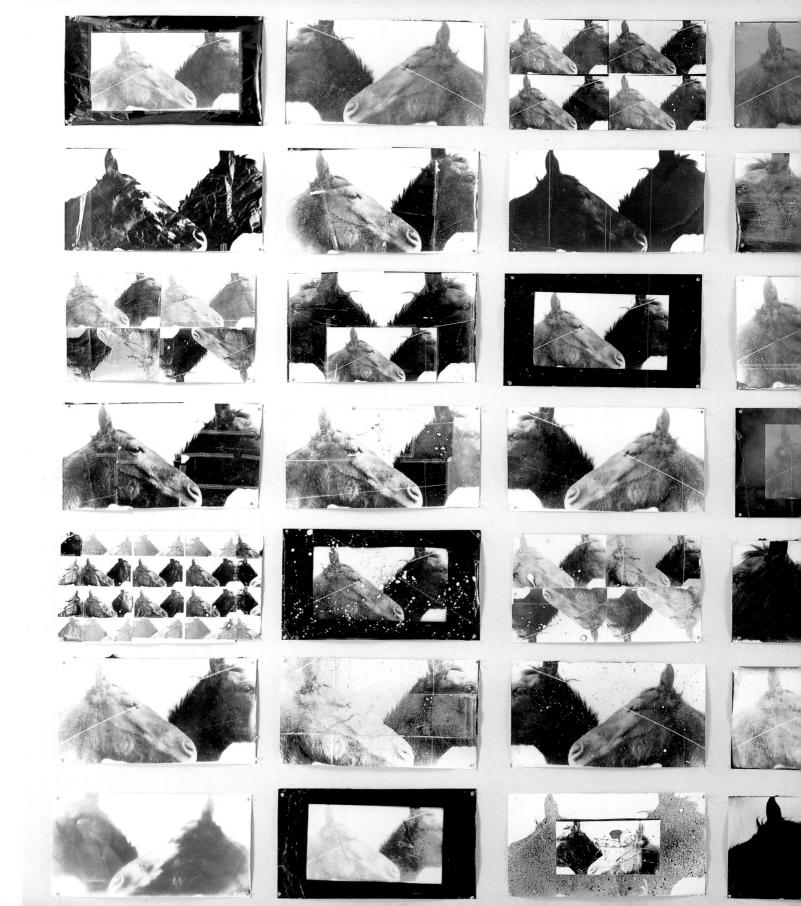

52

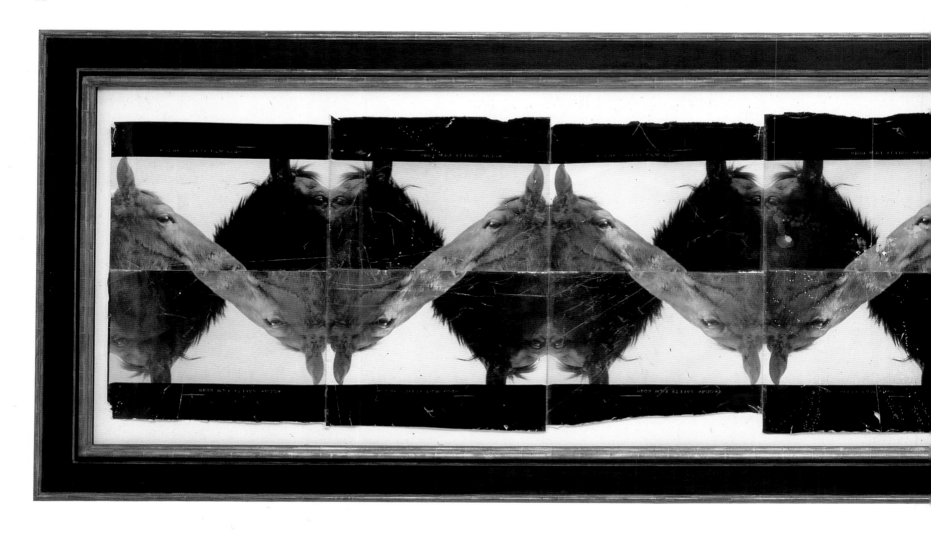

HORSES. 1985–86

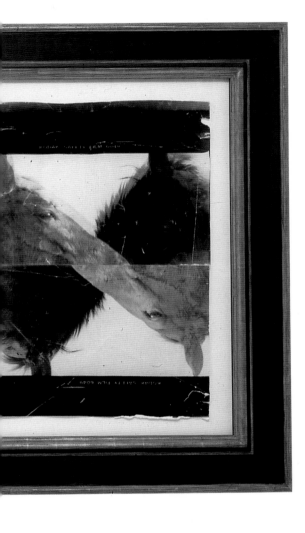

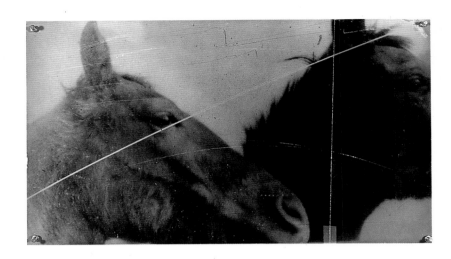

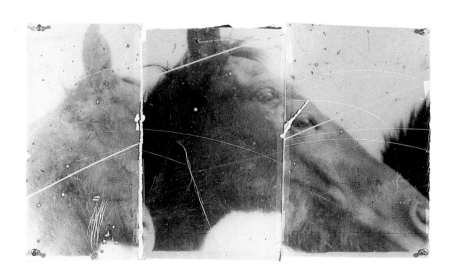

HORSES. 1985–86

HORSES. 1985–86

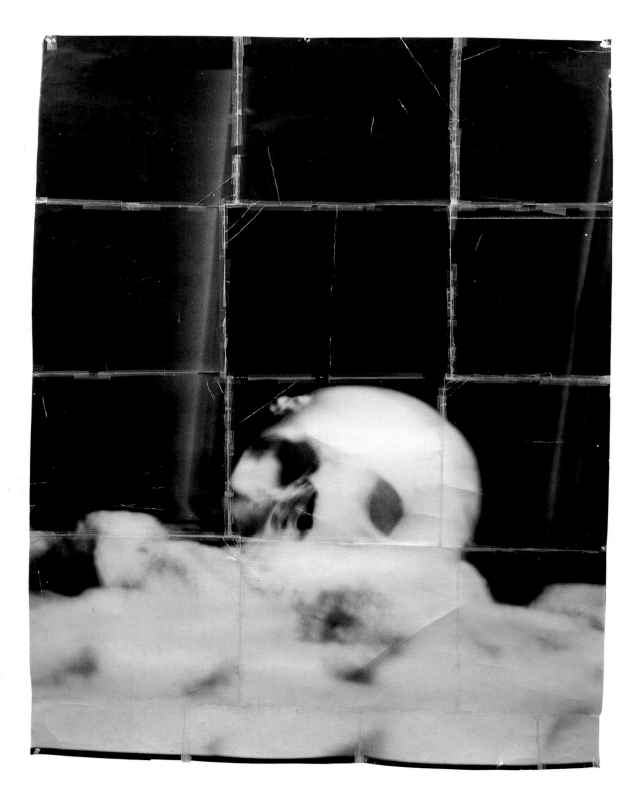

MACABRE STILL LIFE. 1983–85

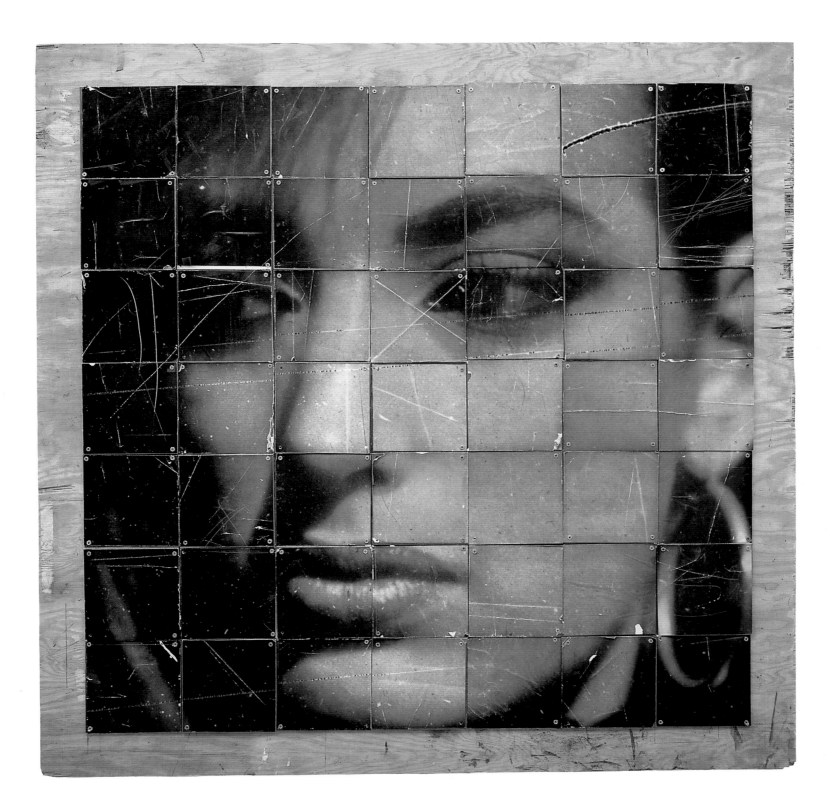

L. 1986

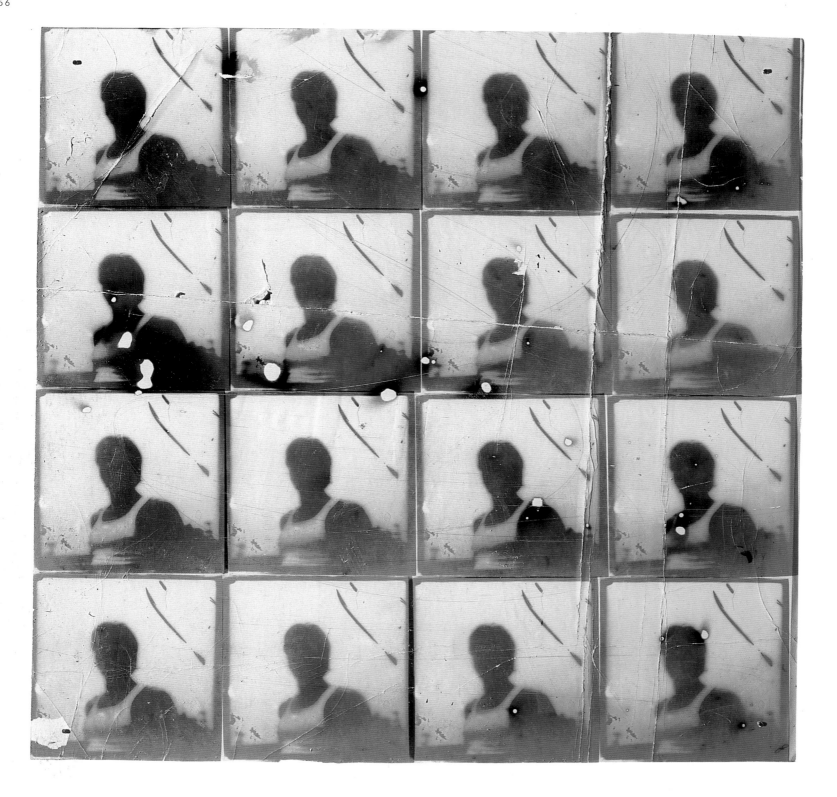

MARK MORRISROE WITH CHAIR (DETAIL). 1985–87

(OPPOSITE) MARK MORRISROE WITH CHAIR. 1985–87

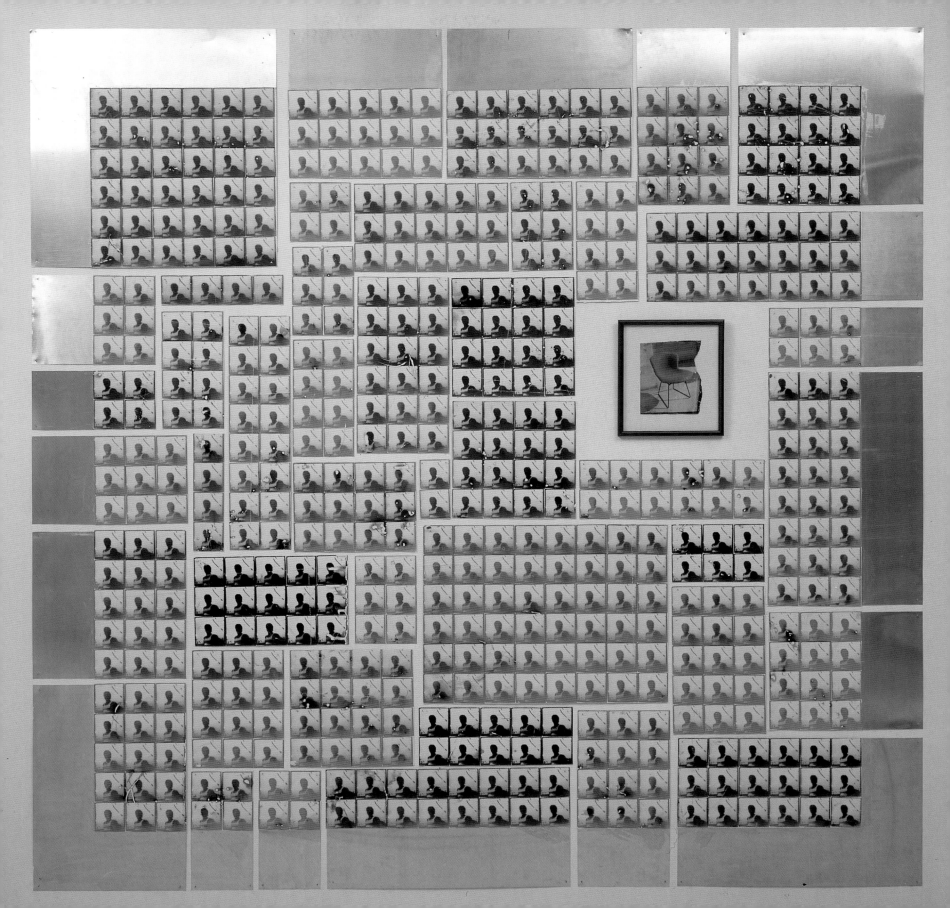

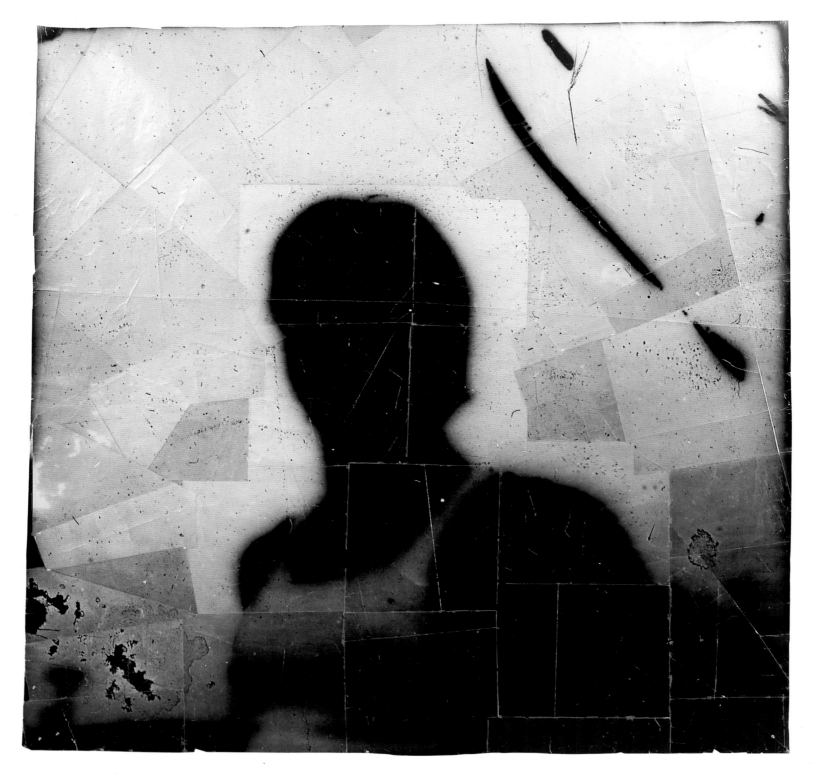

MARK MORRISROE. 1985—86

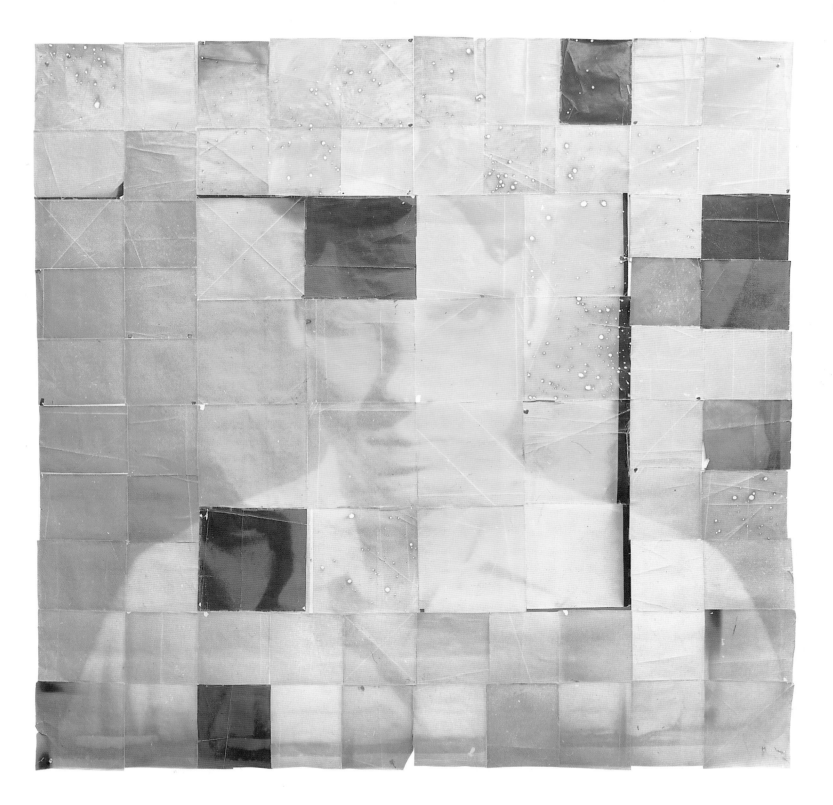

IAN CHURCHILL. 1985–87

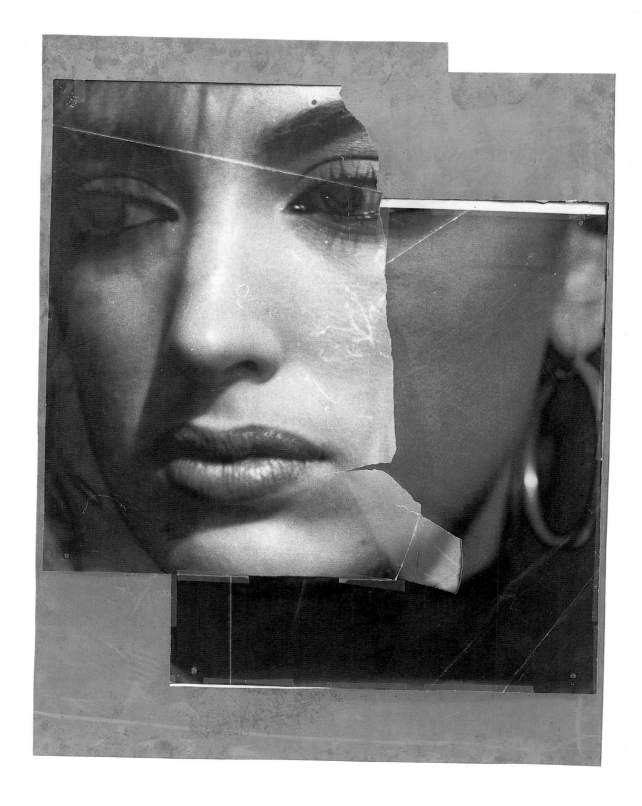

LISA ON METAL. 1988

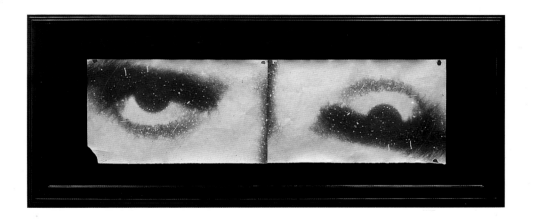

IAN'S EYES. 1987

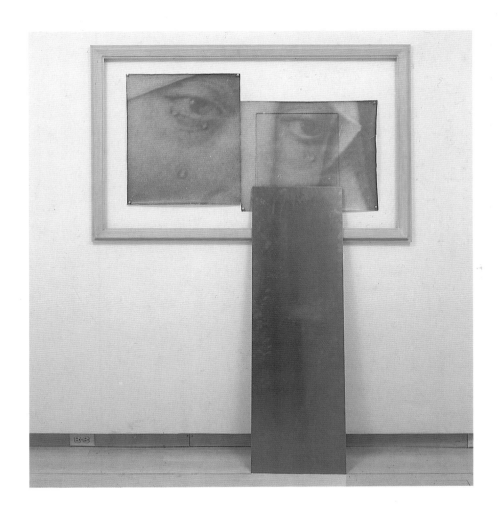

TEARS WITH METAL AND PLEXI. 1987

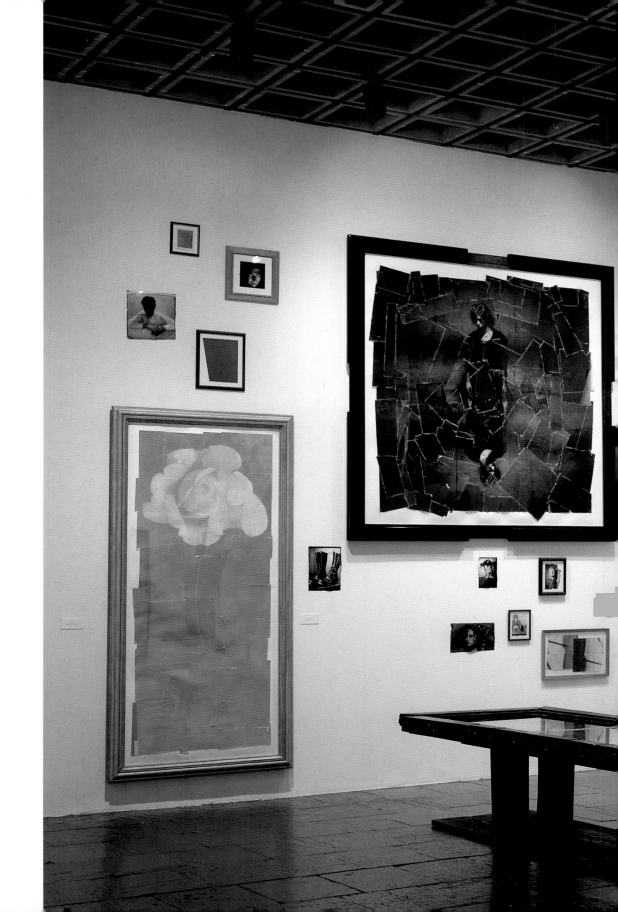

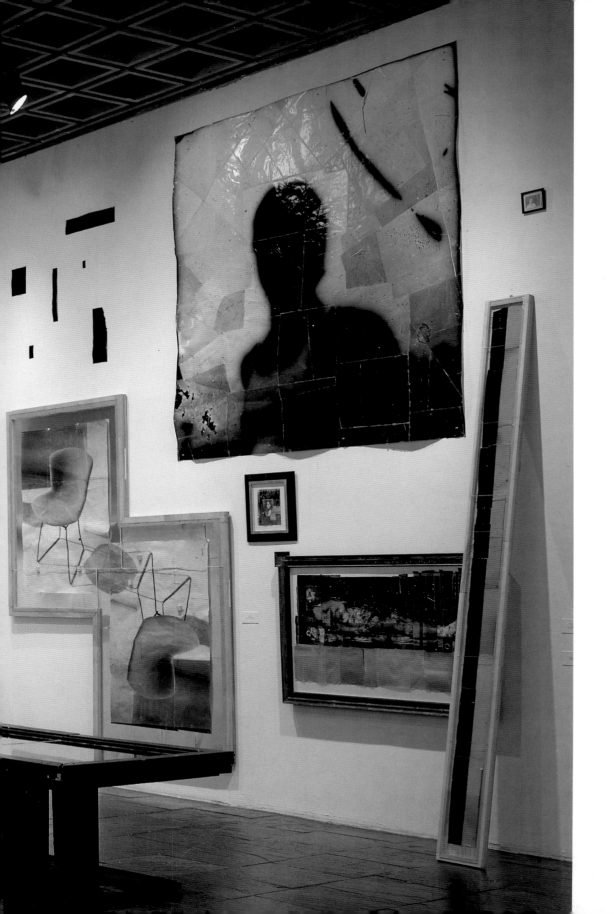

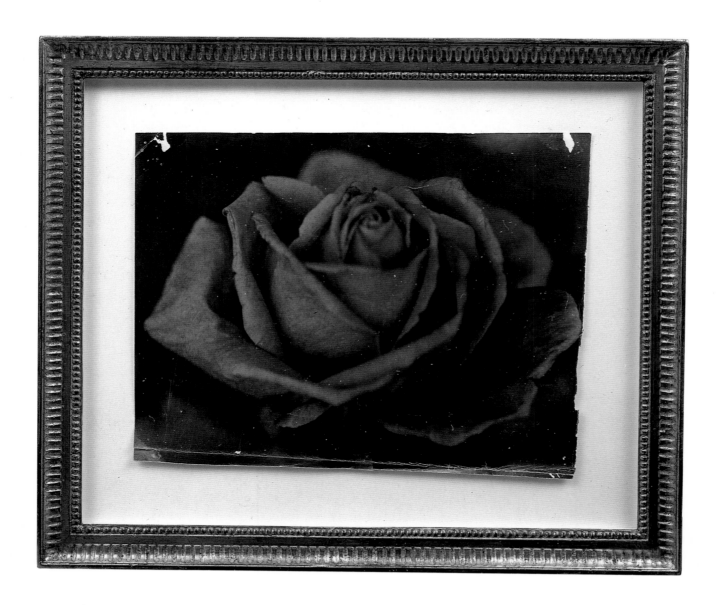

BLEACHED ROSE. 1982–86

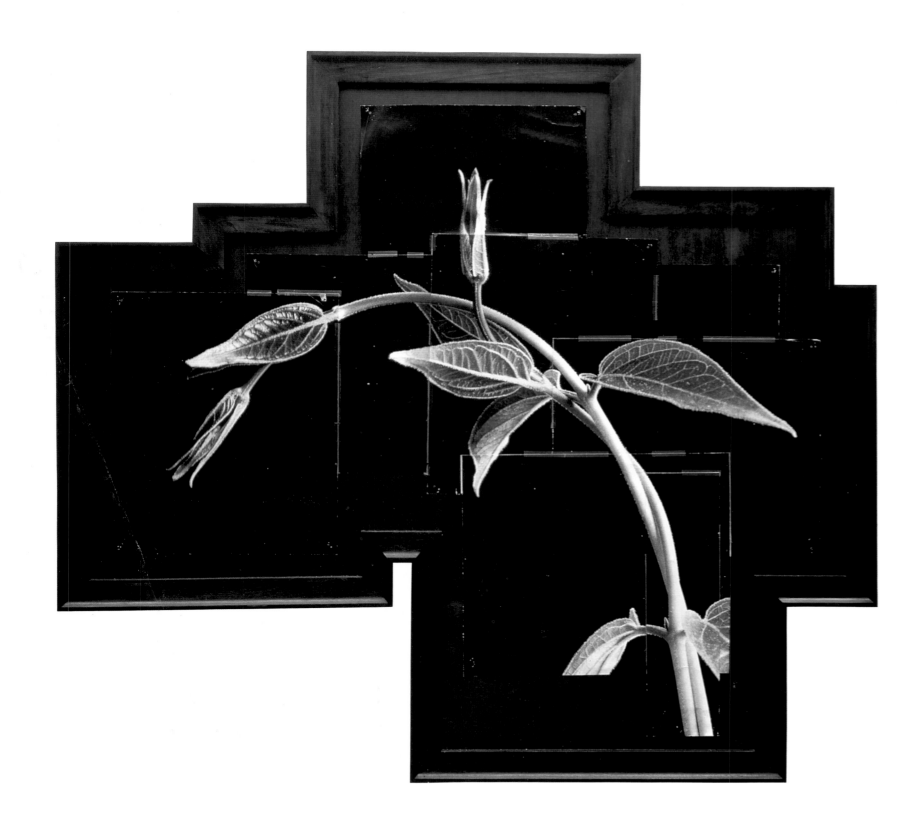

PLANT DETAILS #3, 1988

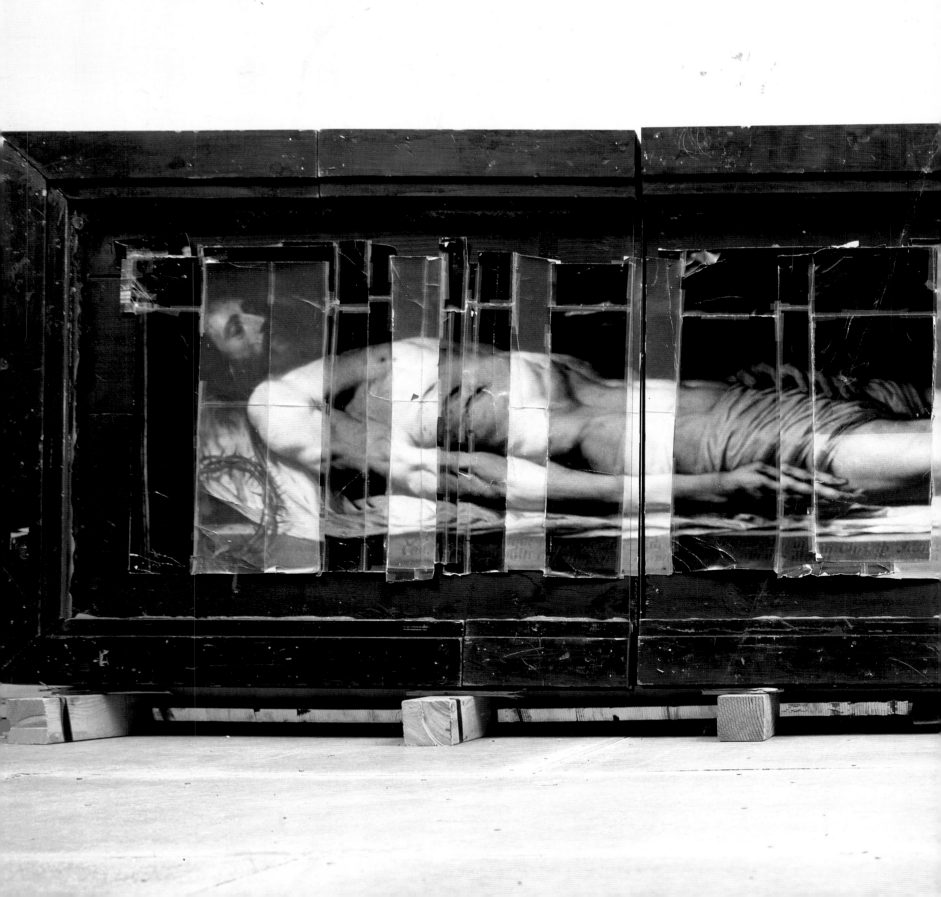

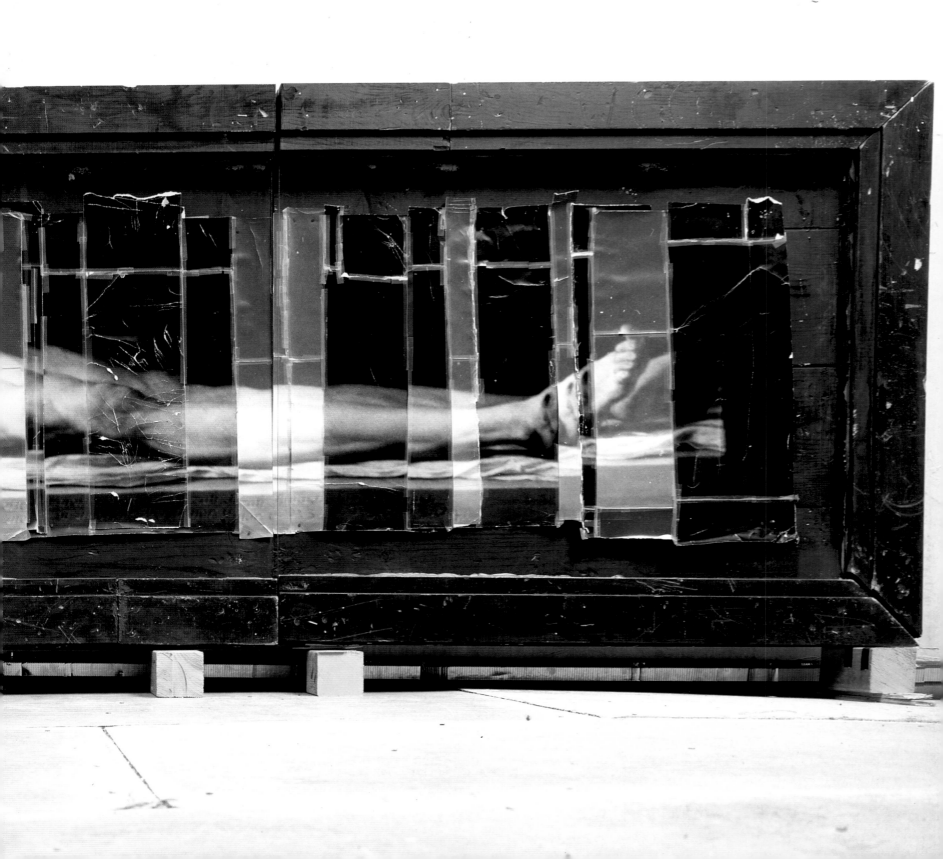

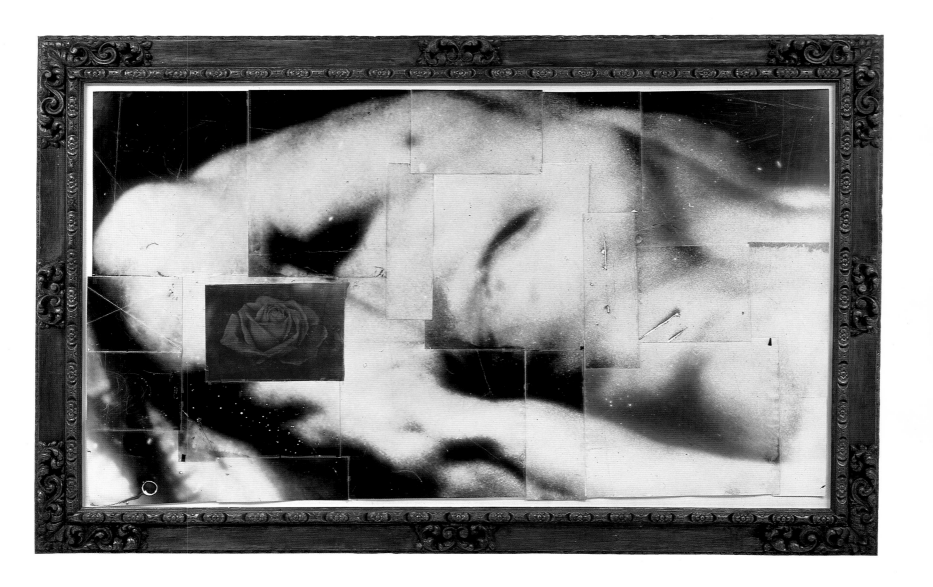

ROSE WITH CHRIST. 1982–86

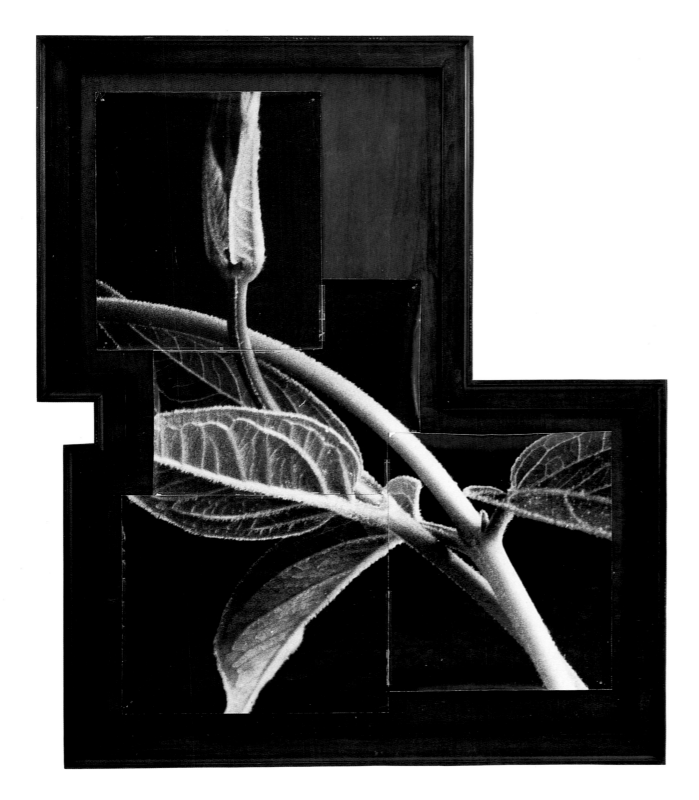

PLANT # 3 DETAIL, 1988

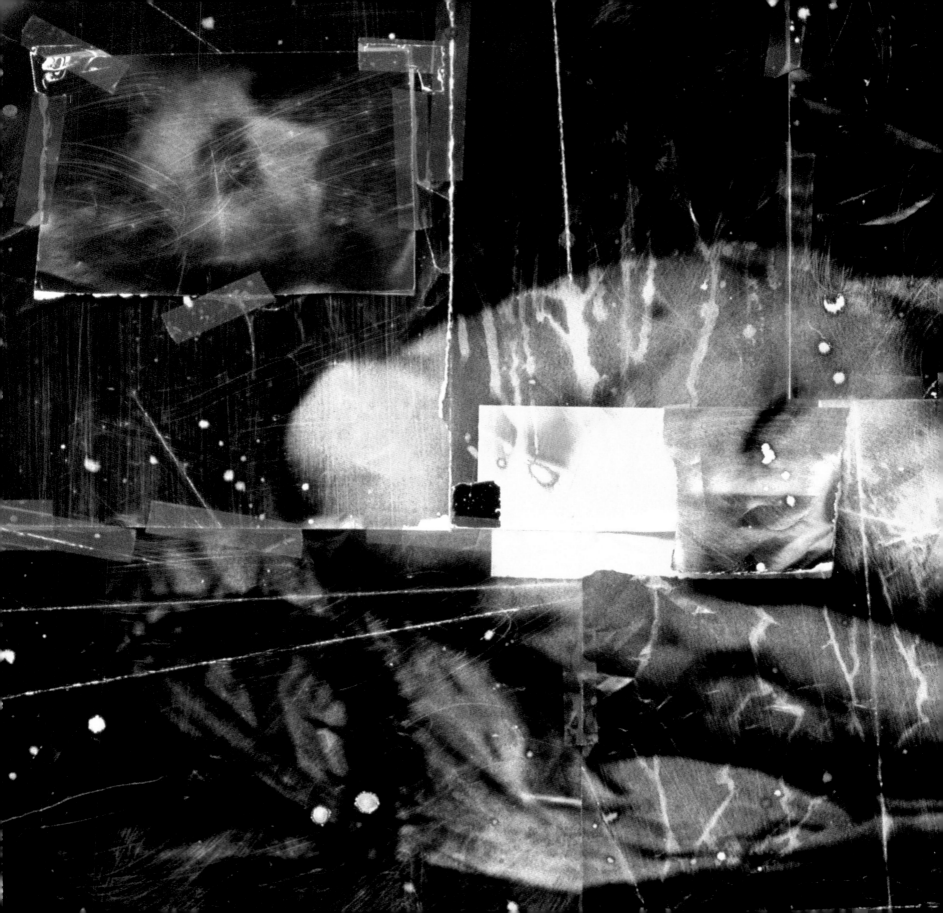

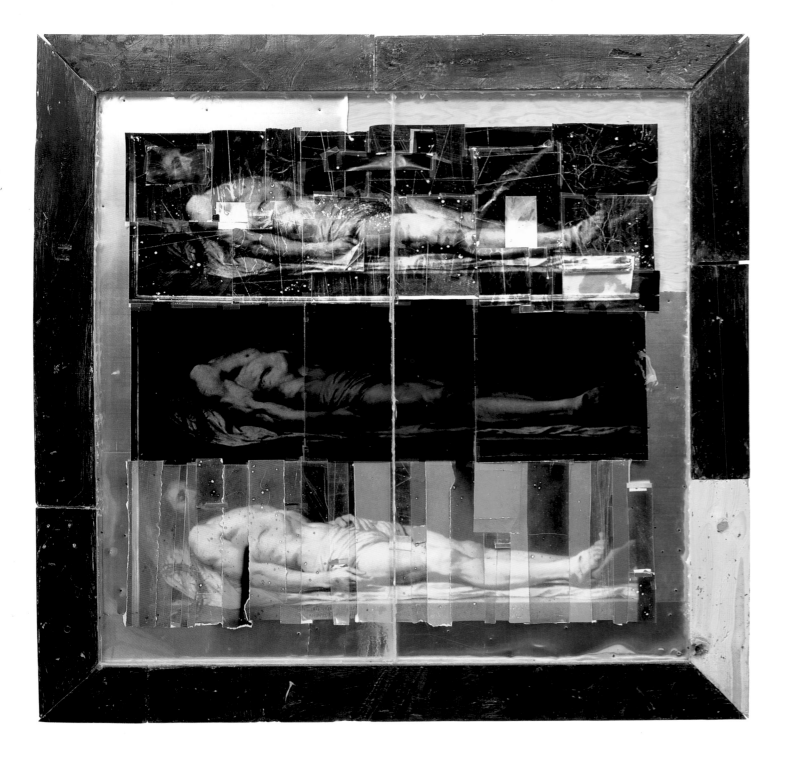

(PREVIOUS PAGES) *STRETCHED CHRIST. 1985–86*

TRIPLE CHRIST. 1986

(OPPOSITE) *DETAIL, TRIPLE CHRIST*

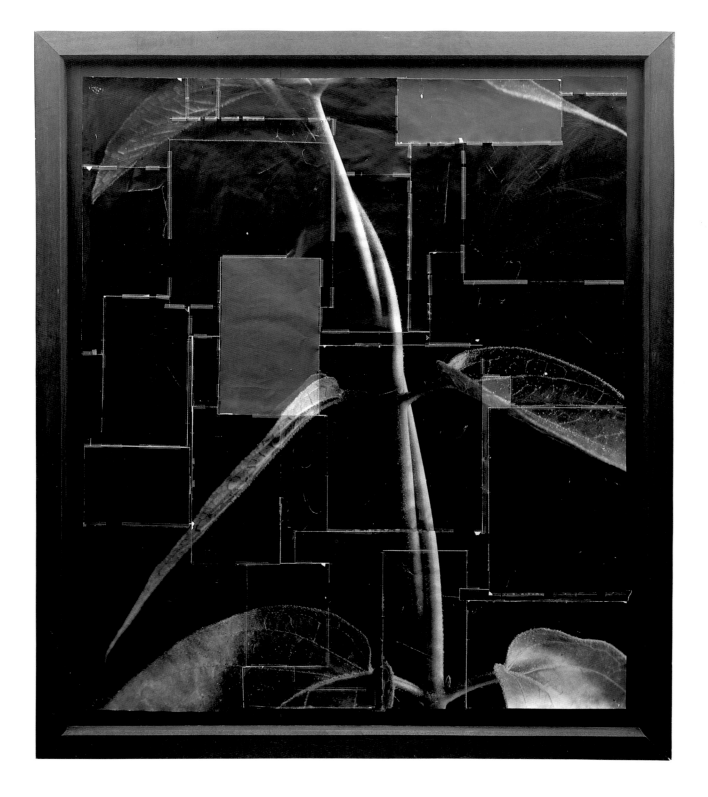

PLANT #1, 1988

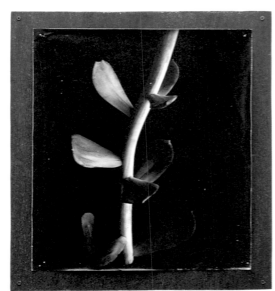

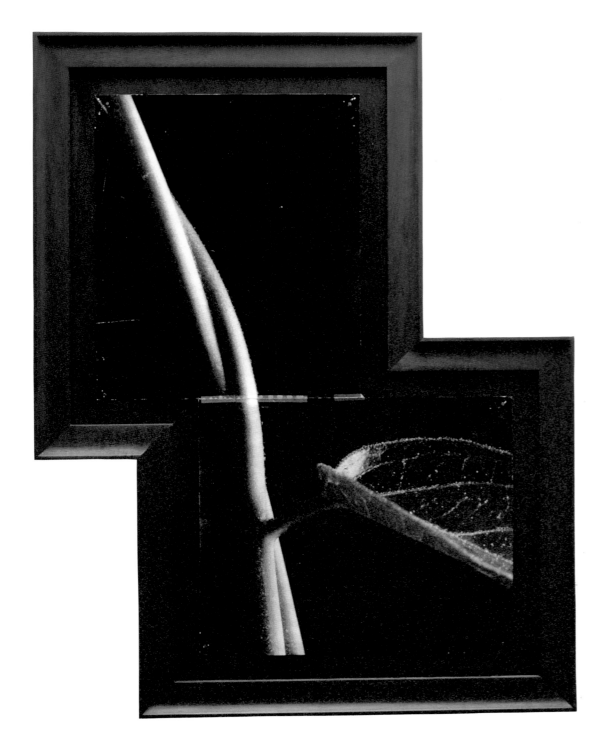

INTERTWINED DETAIL, 1988

CURLY LEAF, 1988

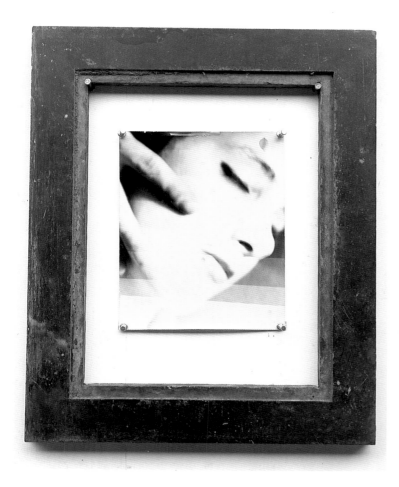

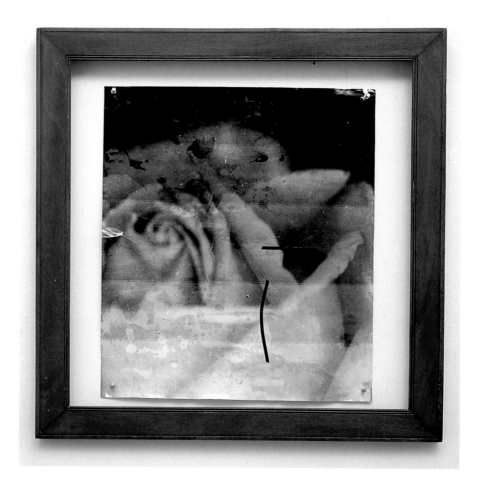

M. WITH SLATE. 1984–87

ROSE PETALS WITH BLACK TAPE. 1985–87

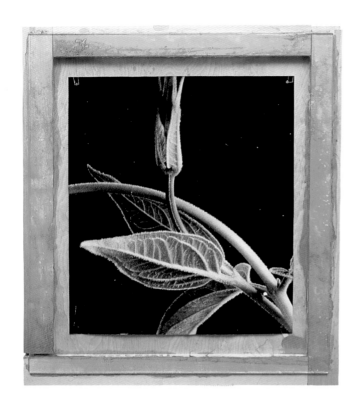

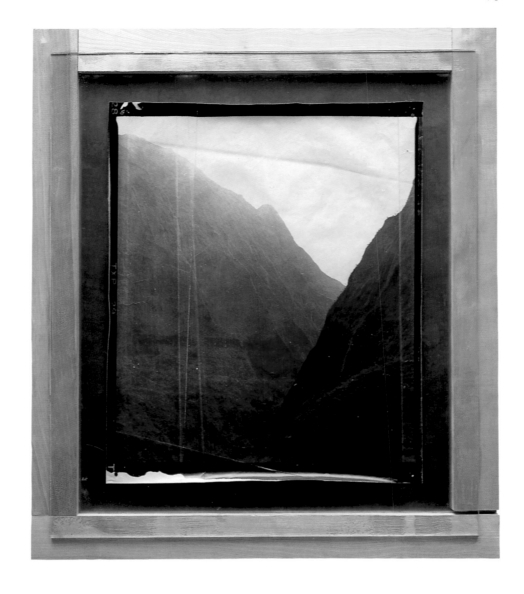

PLANT #3 DETAIL. 1988

KAUAI. 1988

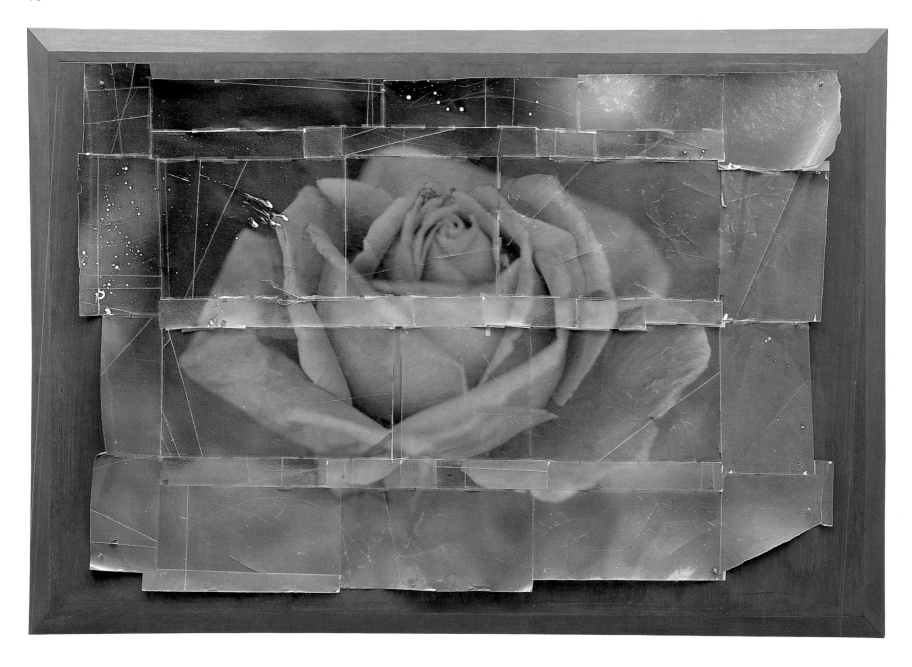

ROSE. 1982–88

(OPPOSITE) DOUBLE STARK PORTRAIT IN SWIRL. 1985–86

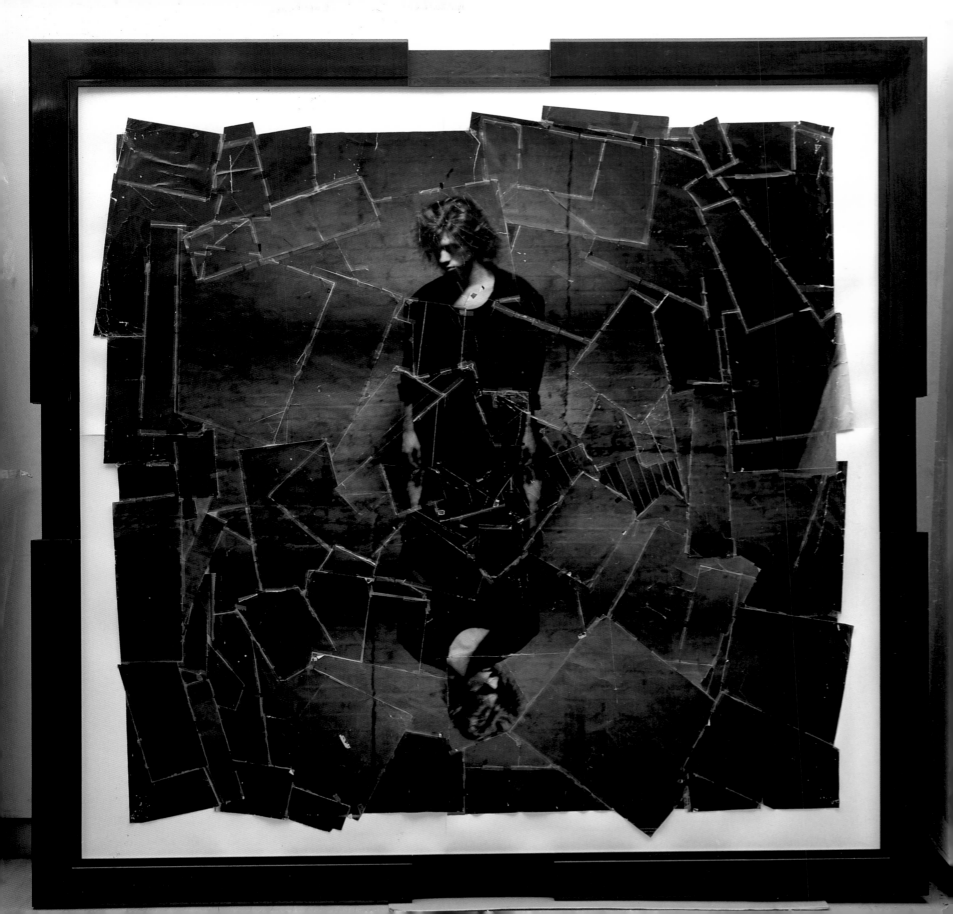

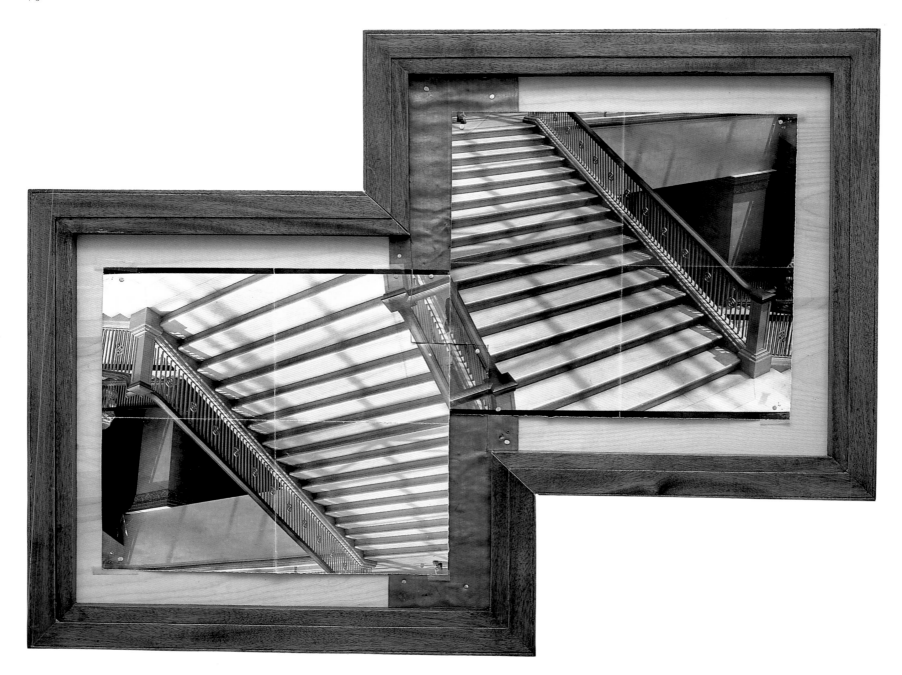

DOUBLE STAIRS. 1987

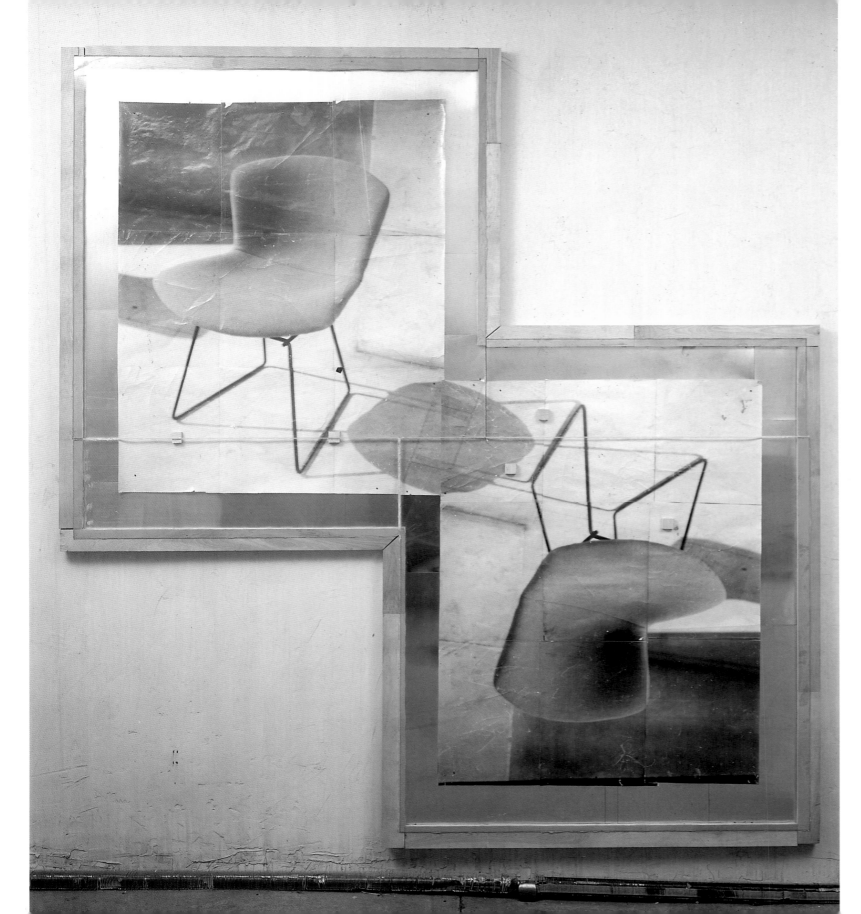

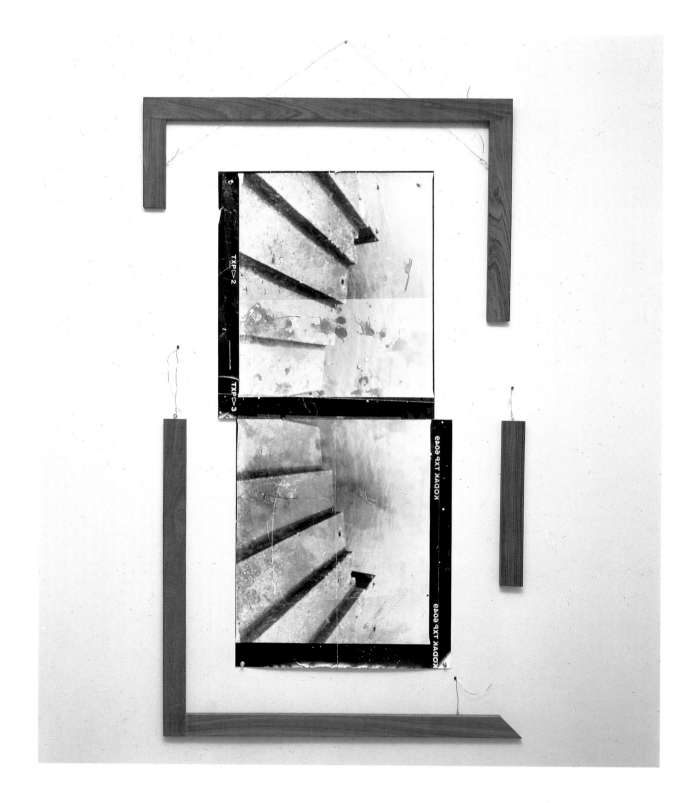

LAKE MICHIGAN STEPS. 1987

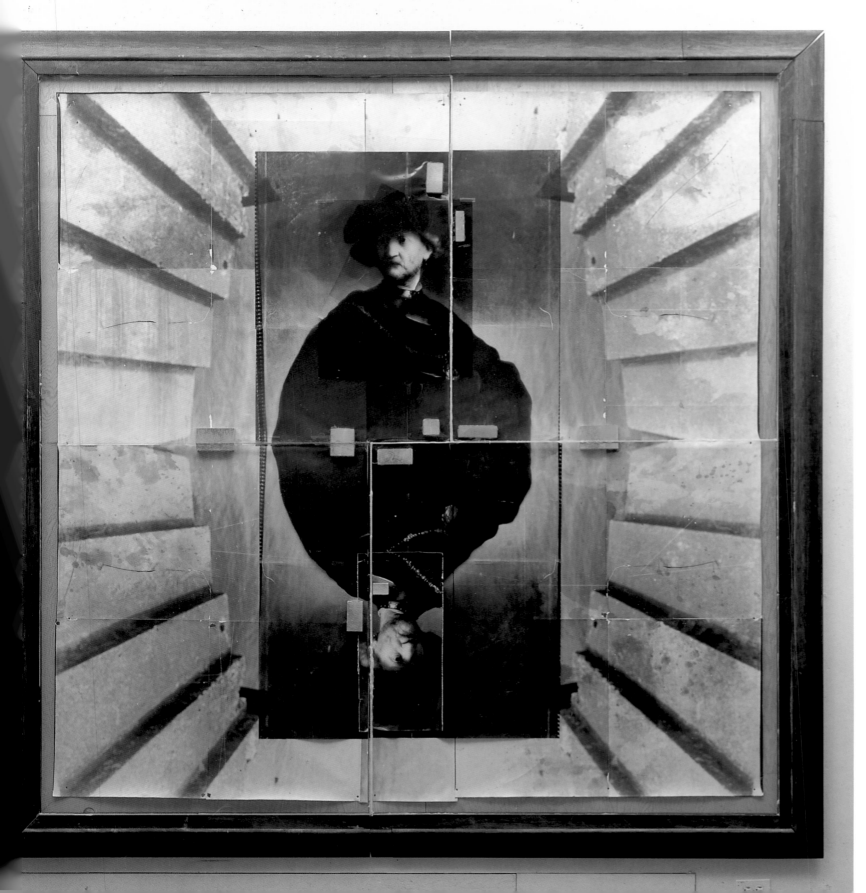

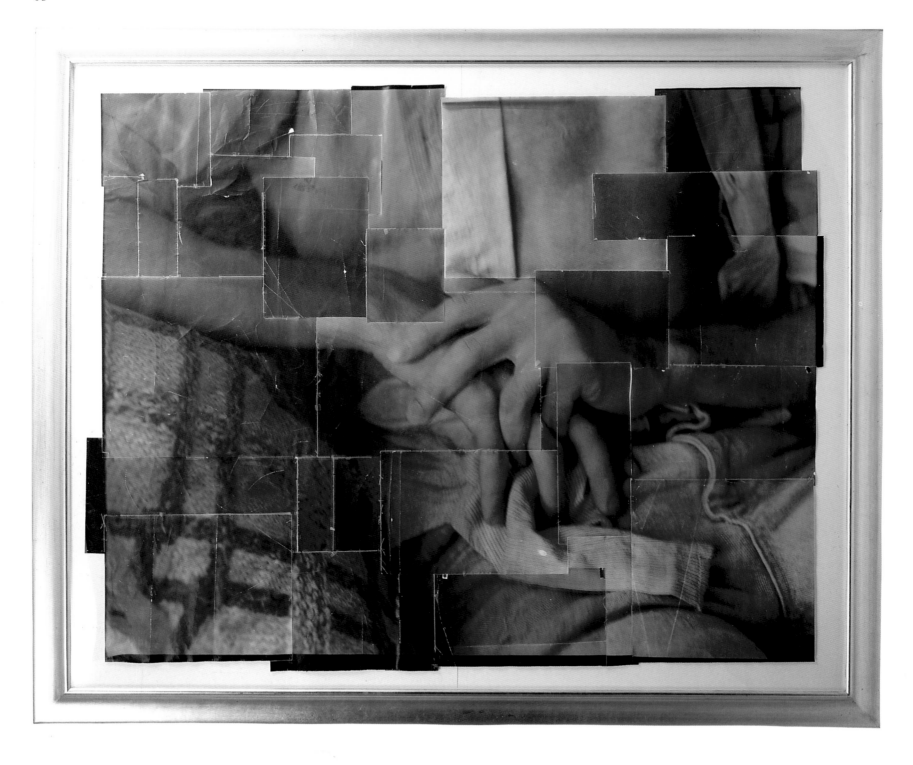

BLUE HANDS. 1982–87

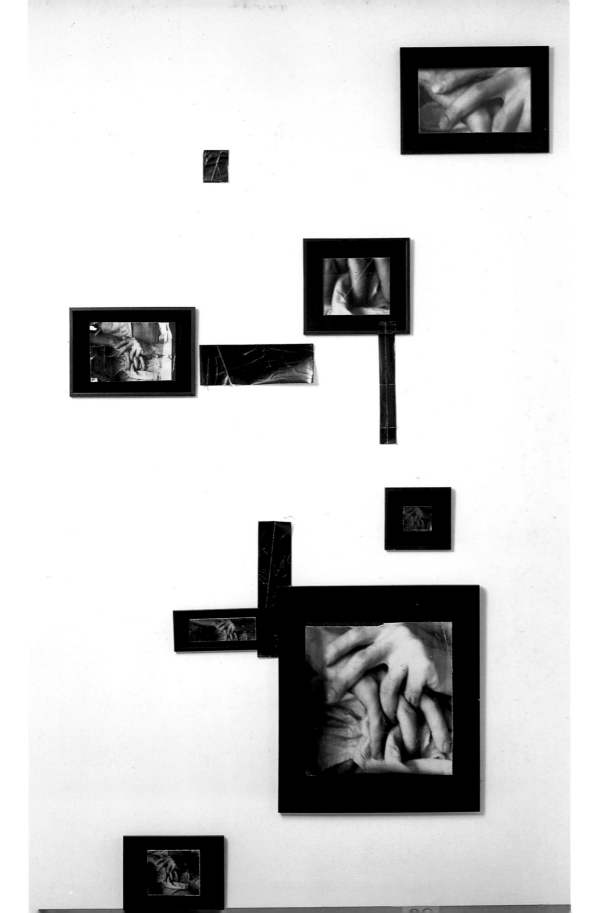

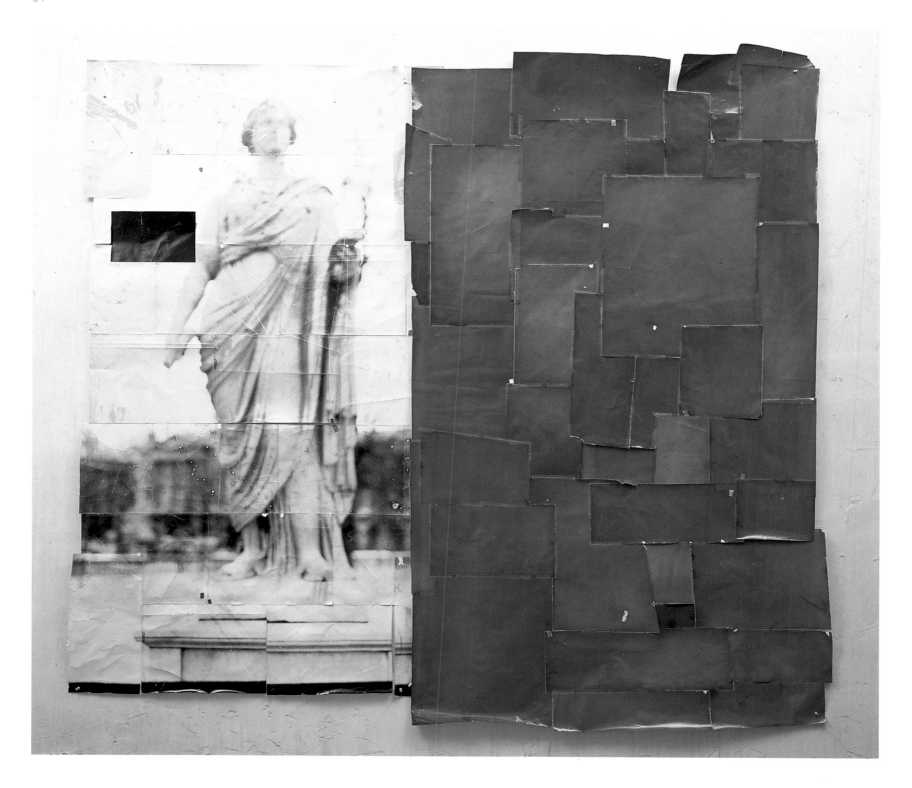

TERRACE JEU DE PAUME, 1987

(OPPOSITE) VERTICAL CHRIST WITH BLACK, 1985–87

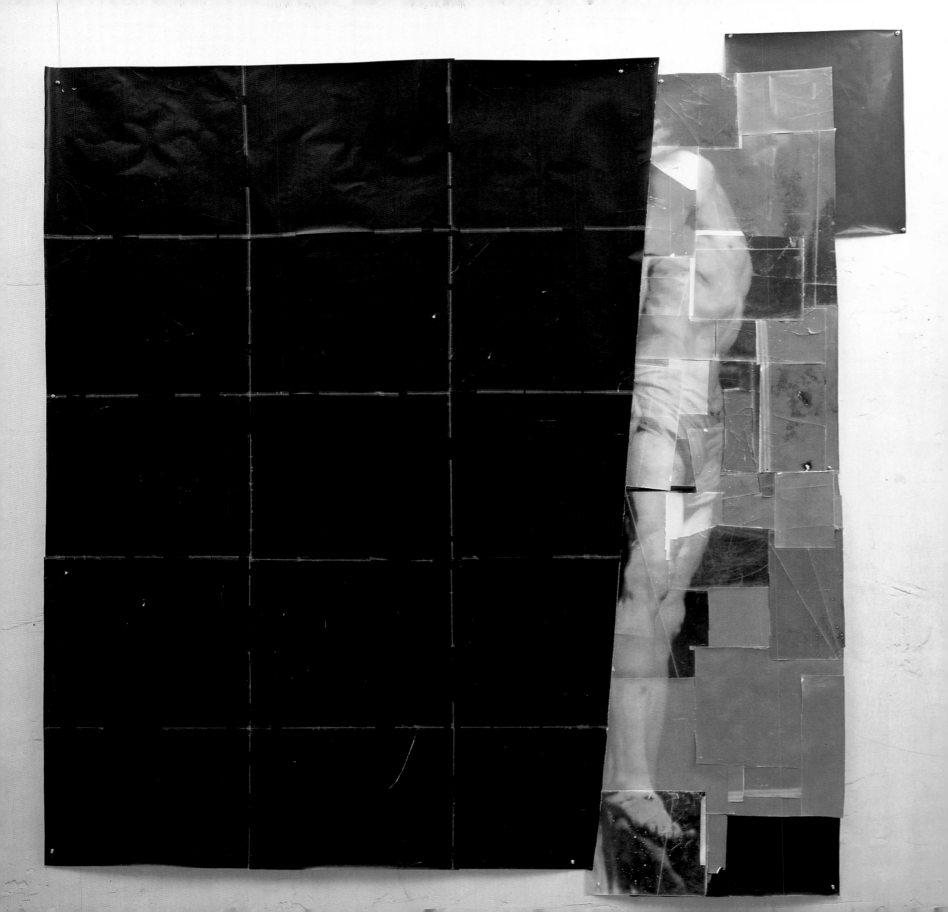

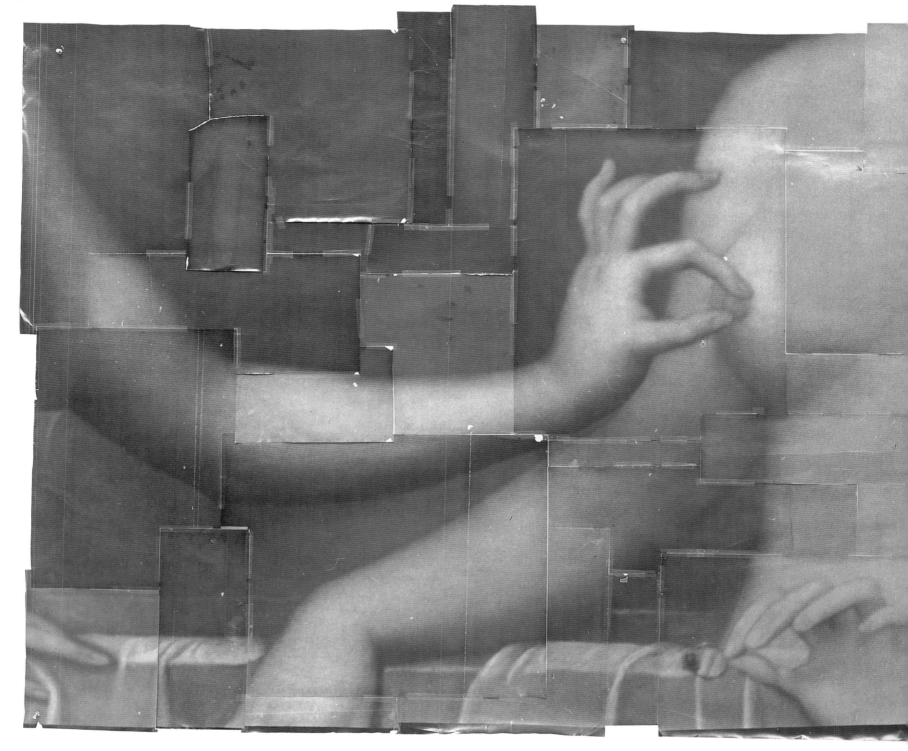

NIPPLES. 1985–87

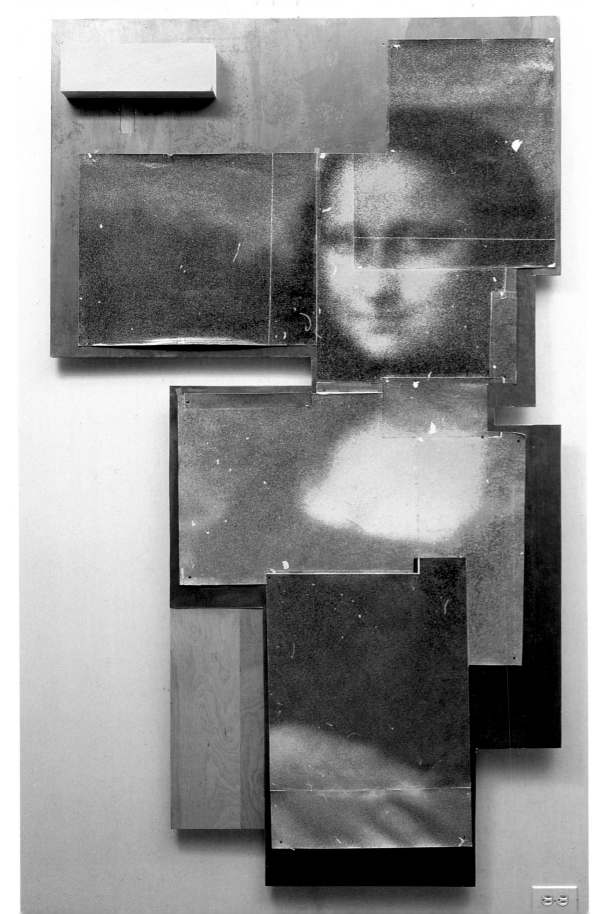

87

JAGGED MONA 1985-88

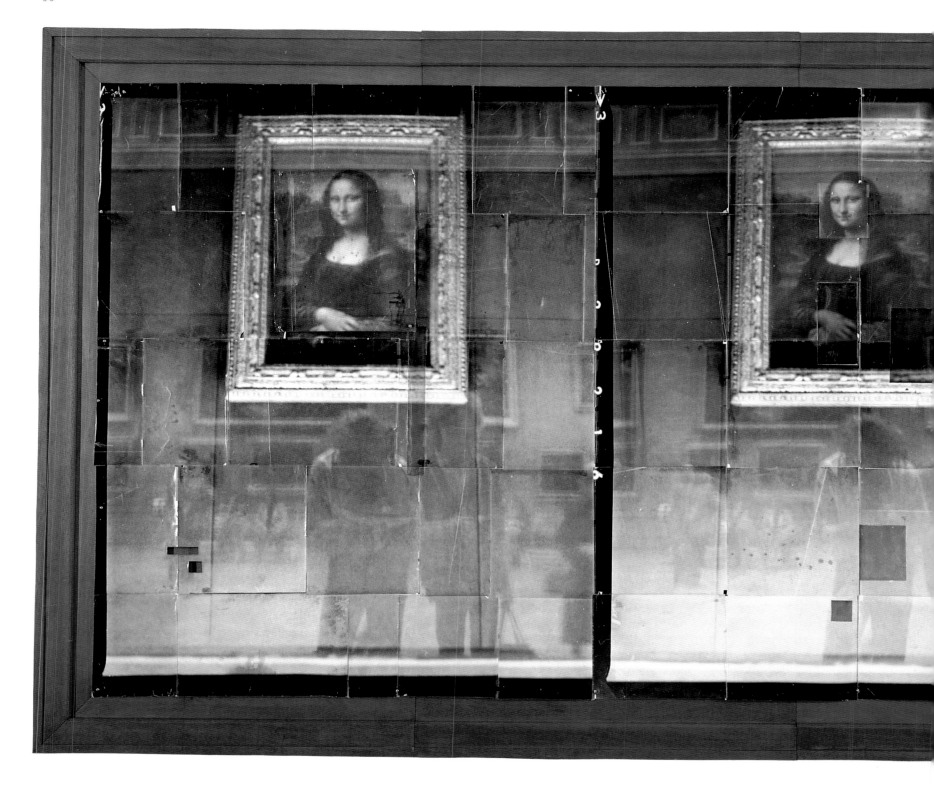

DOUBLE MONA LISA WITH SELF-PORTRAIT, 1985–88

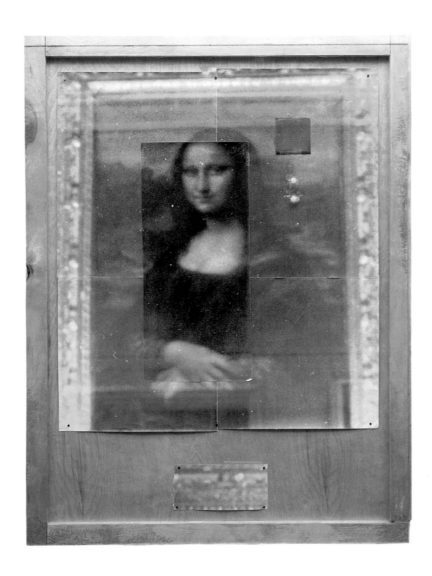

YELLOW MONA LISA WITH PLEXI AND WOOD. 1985–88

YELLOW AND BLUE LOUVRE FLOOR. 1985–88

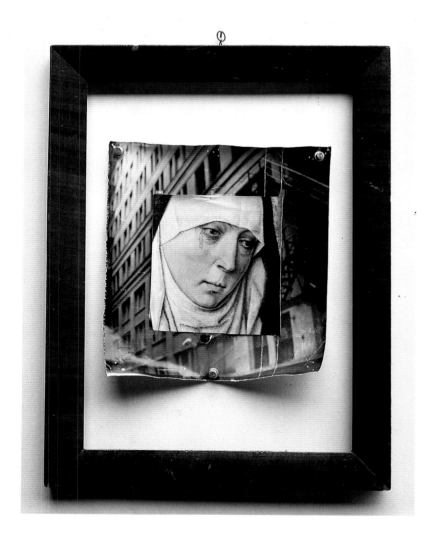

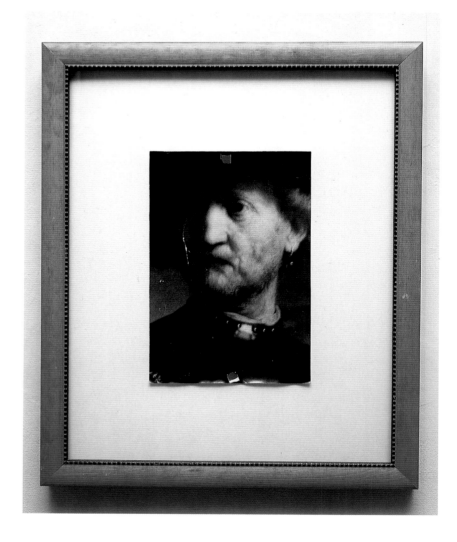

MATER DOLOROSA WITH ROOKERY AND FRAME. 1987

REMBRANDT. 1987

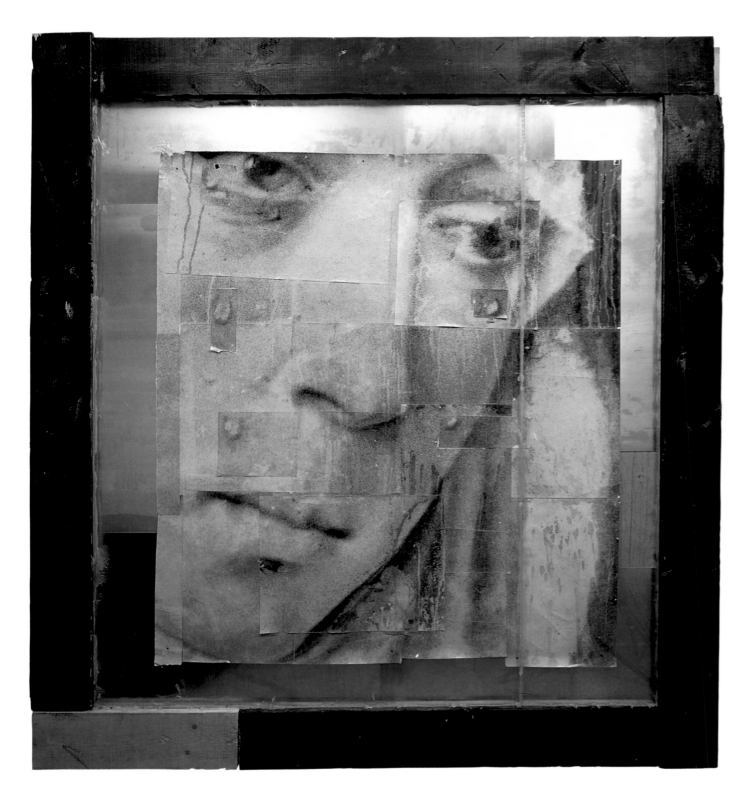

MATER DOLOROSA. 1987

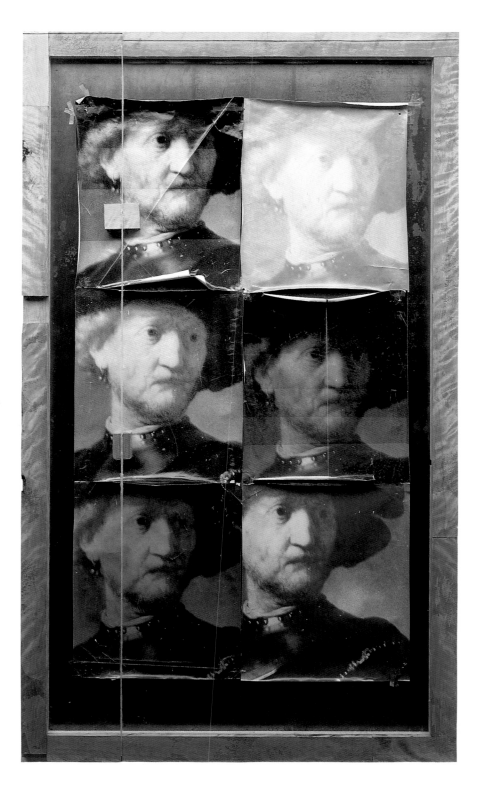

REMBRANDT (HEAD DETAILS), 1989

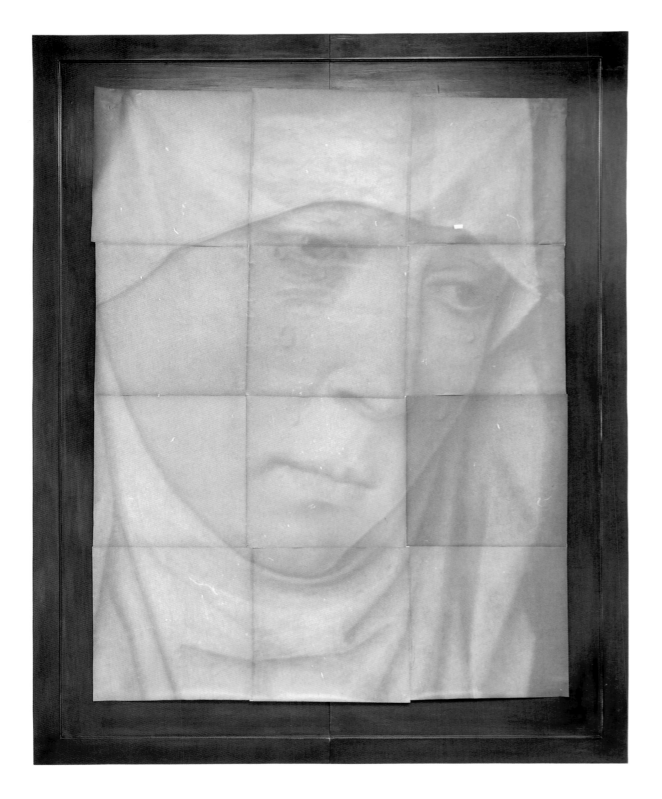

GREEN MATER DOLOROSA. 1987

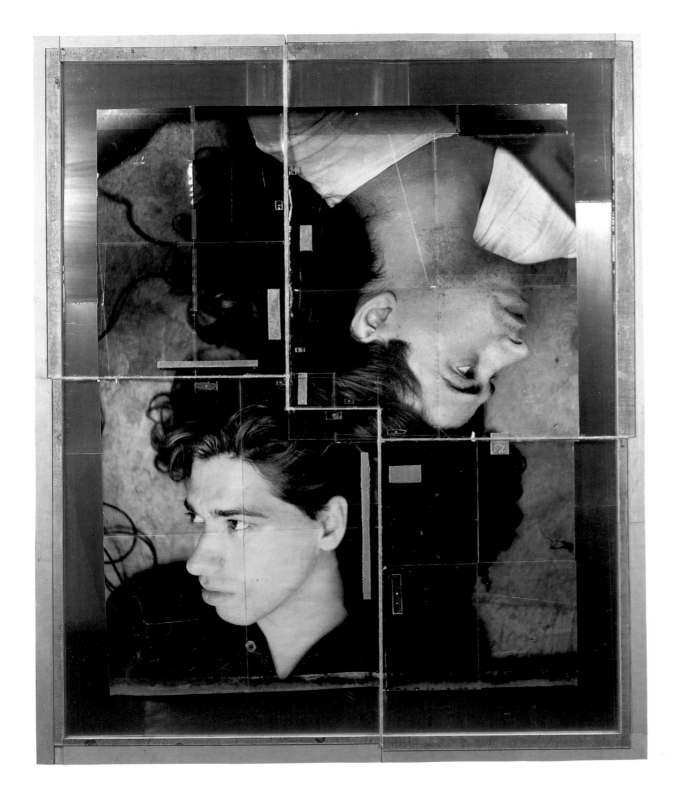

SELF-PORTRAIT WITH PLEXI AND WOOD. 1987

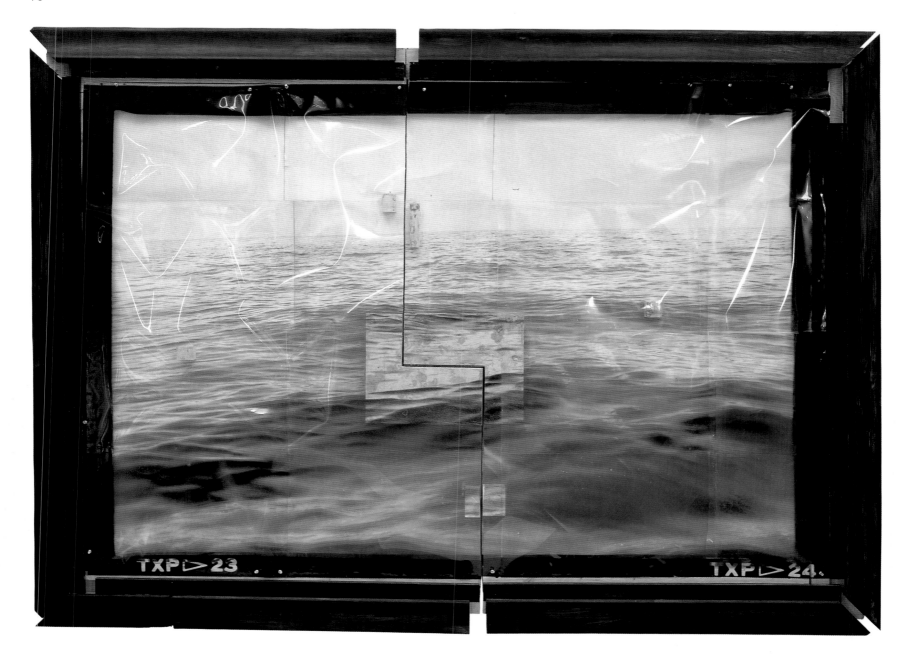

YELLOW SEASCAPE WITH FILM AND WOOD BLOCKS. 1989

(OPPOSITE) YELLOW SEASCAPE WITH FILM AND WOOD BLOCKS (DETAIL). 1989

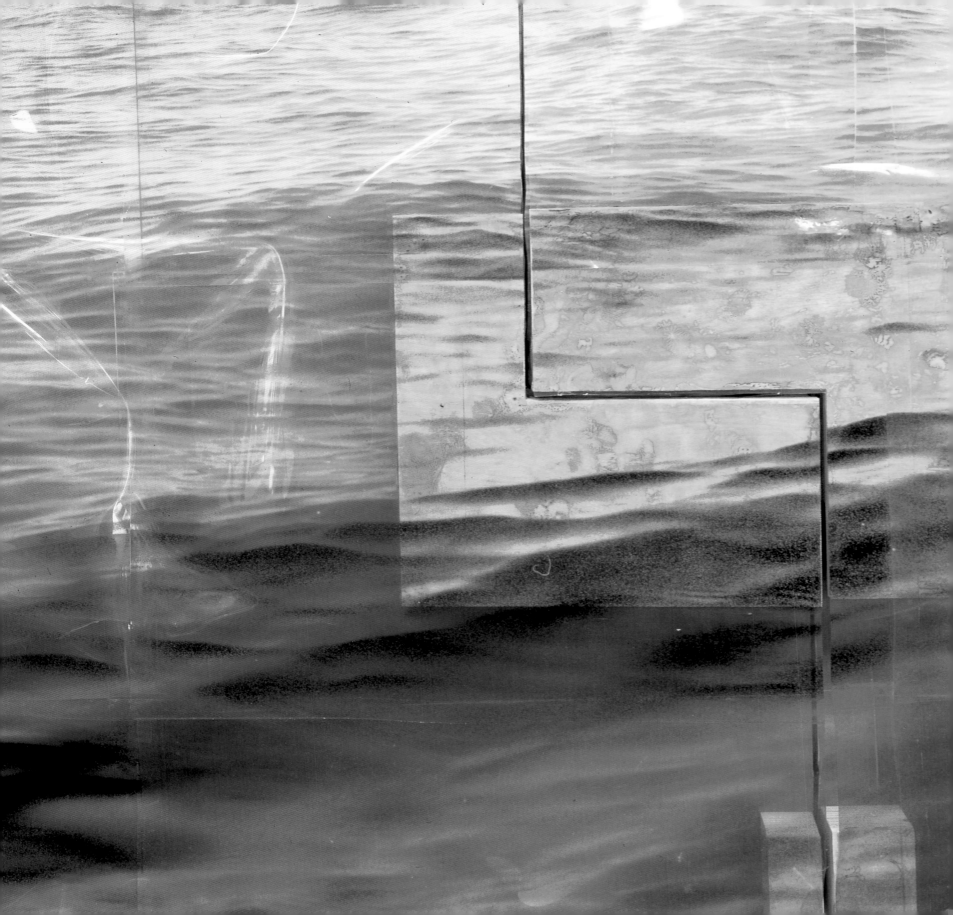

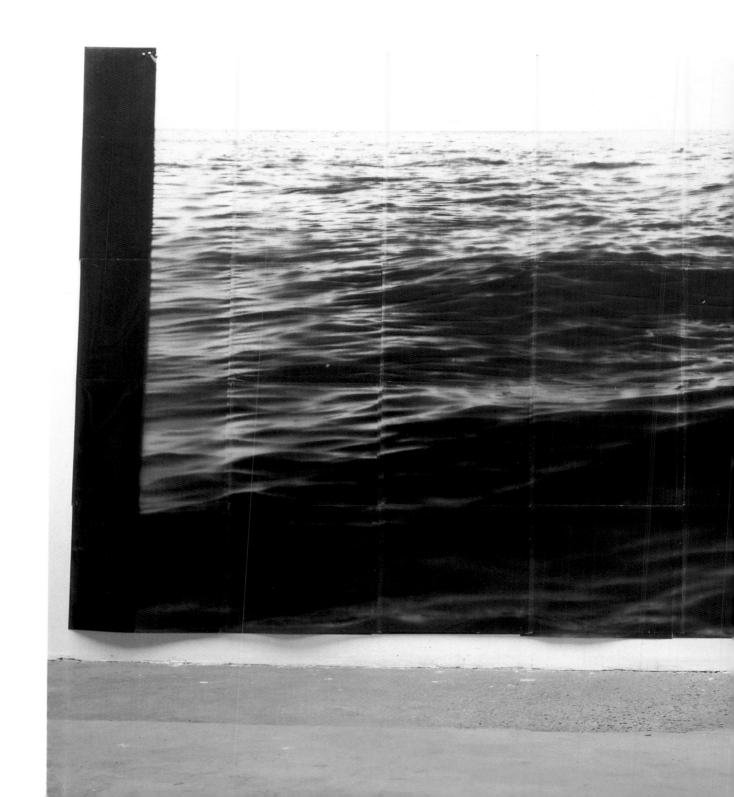

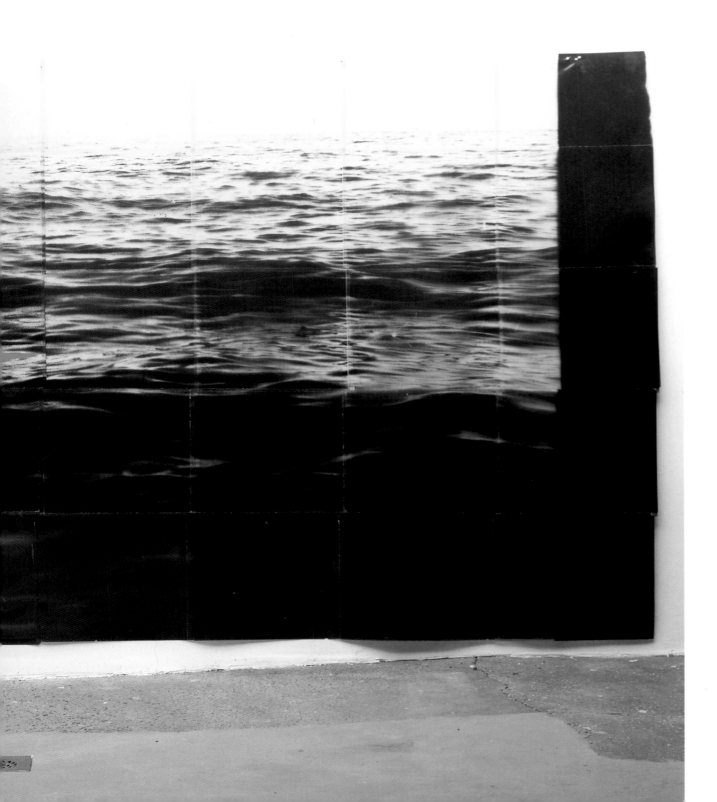

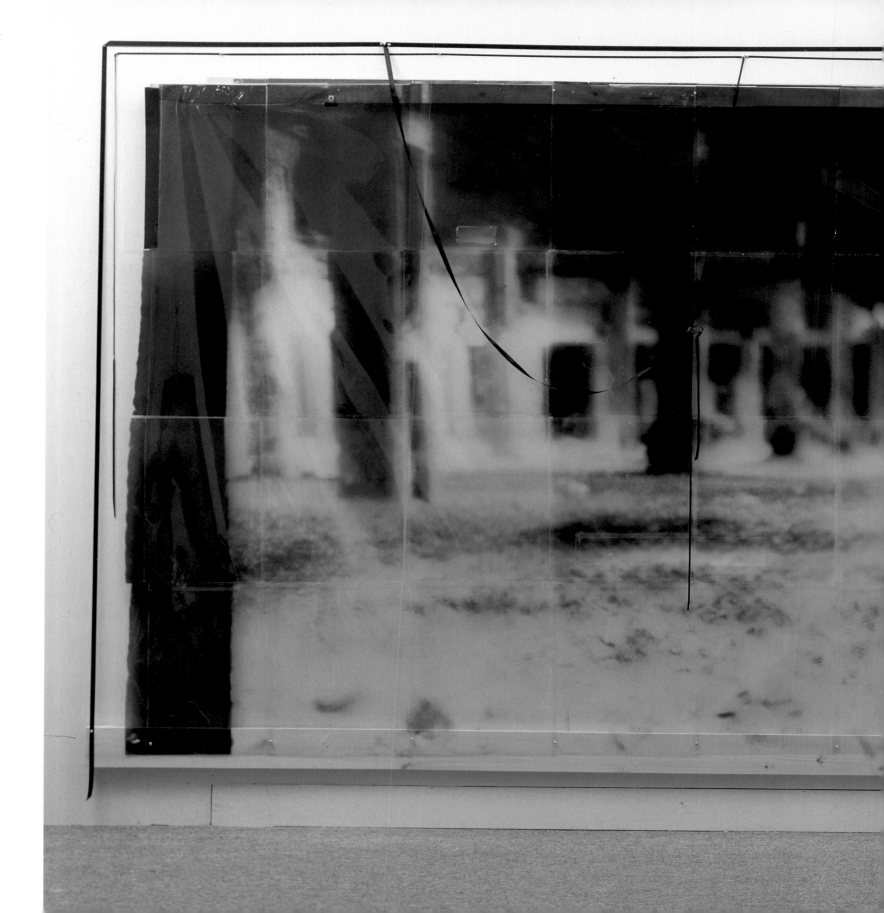

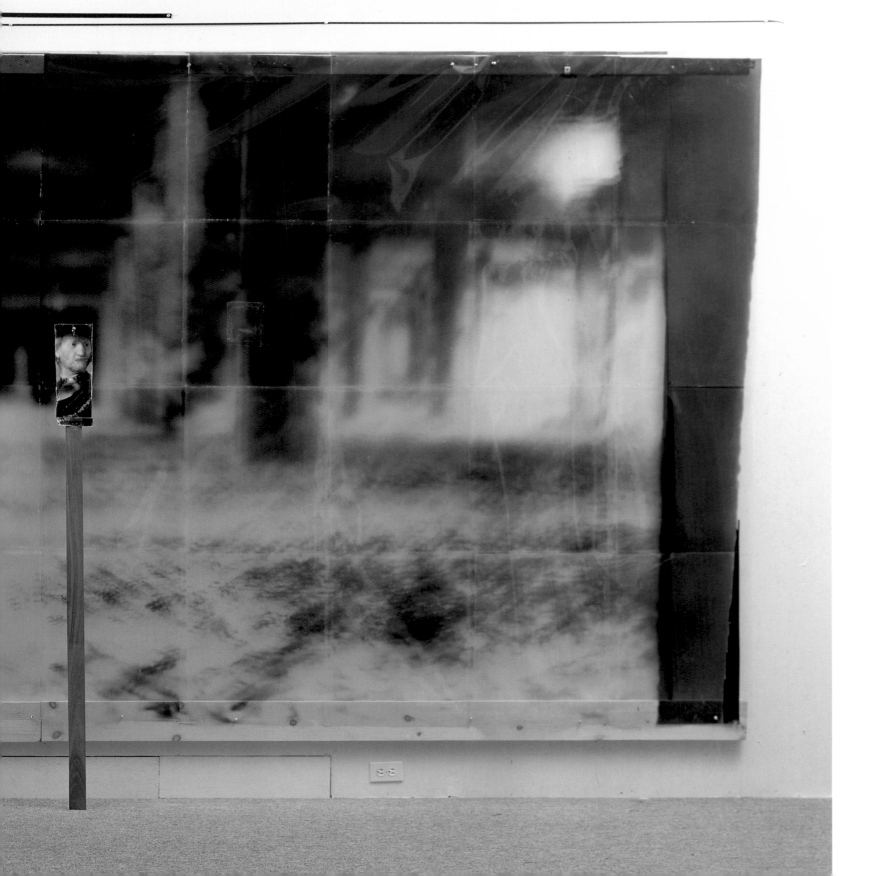

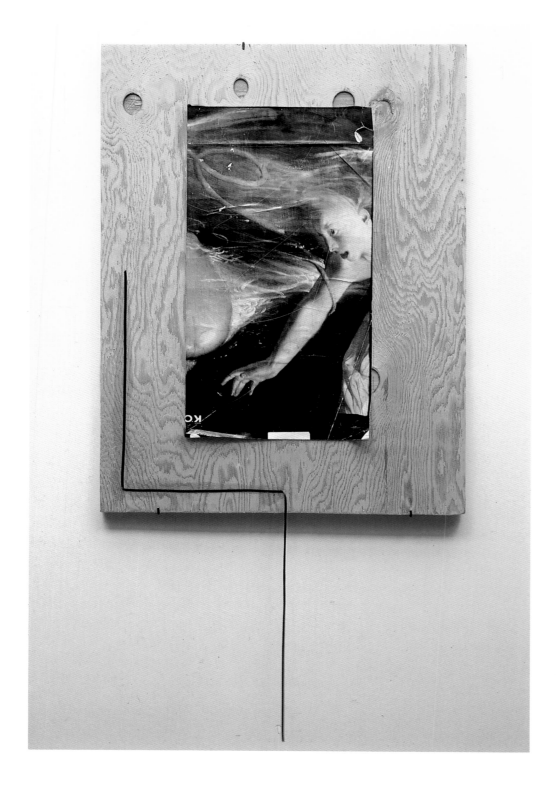

WATSON WITH RIBBON, 1988

(OPPOSITE) REMBRANDTS ON SEASCAPE, 1987

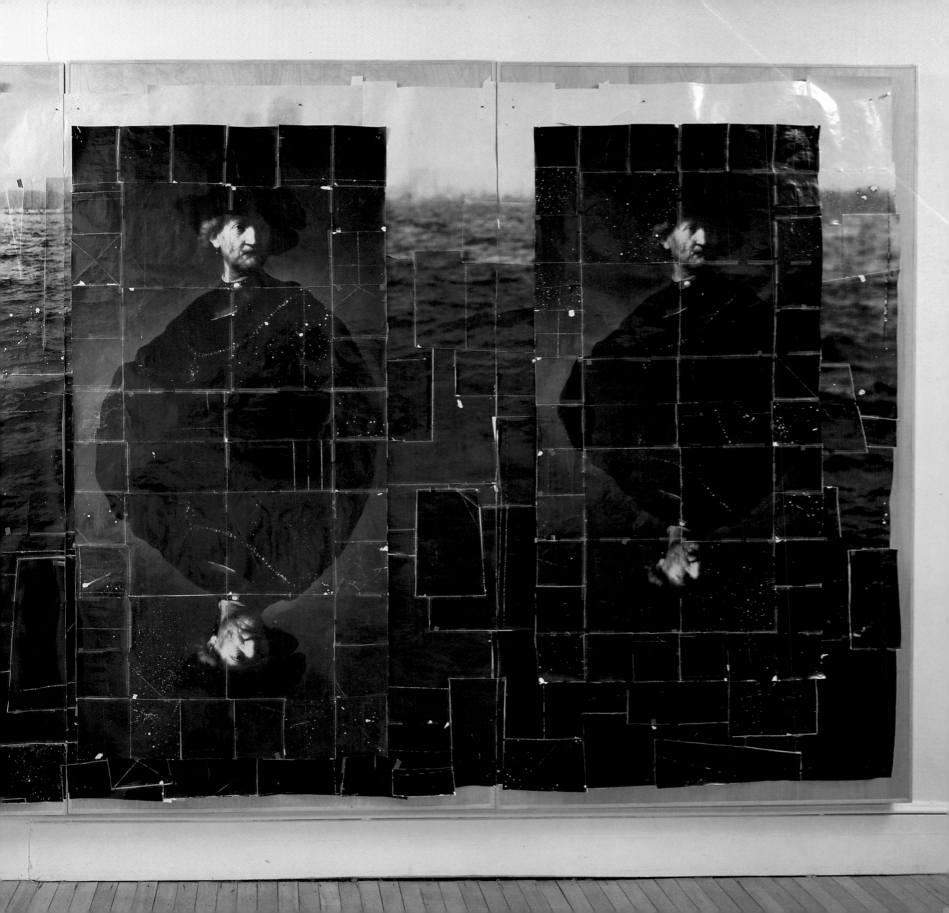

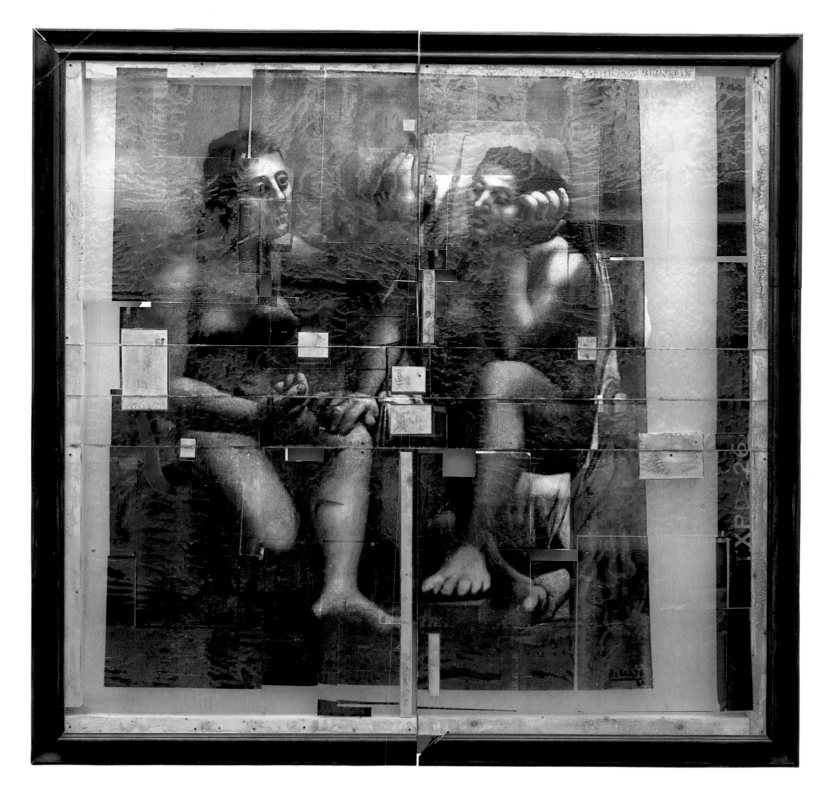

LARGE BLUE FILM PICASSO. 1988–89

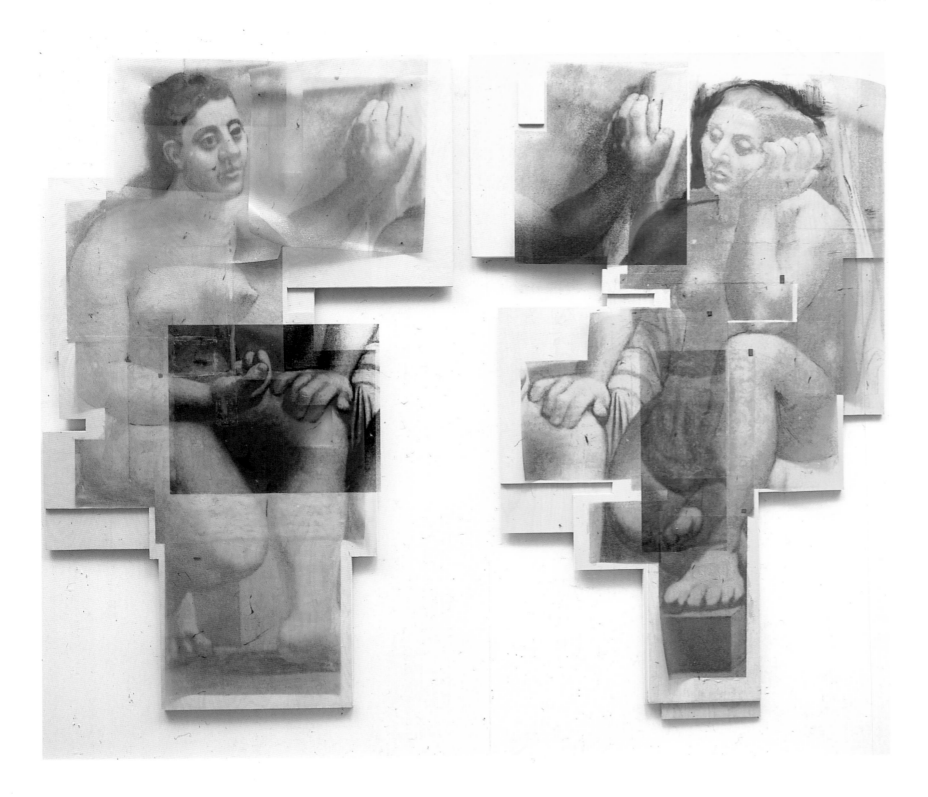

LARGE COPPER PICASSO. 1989

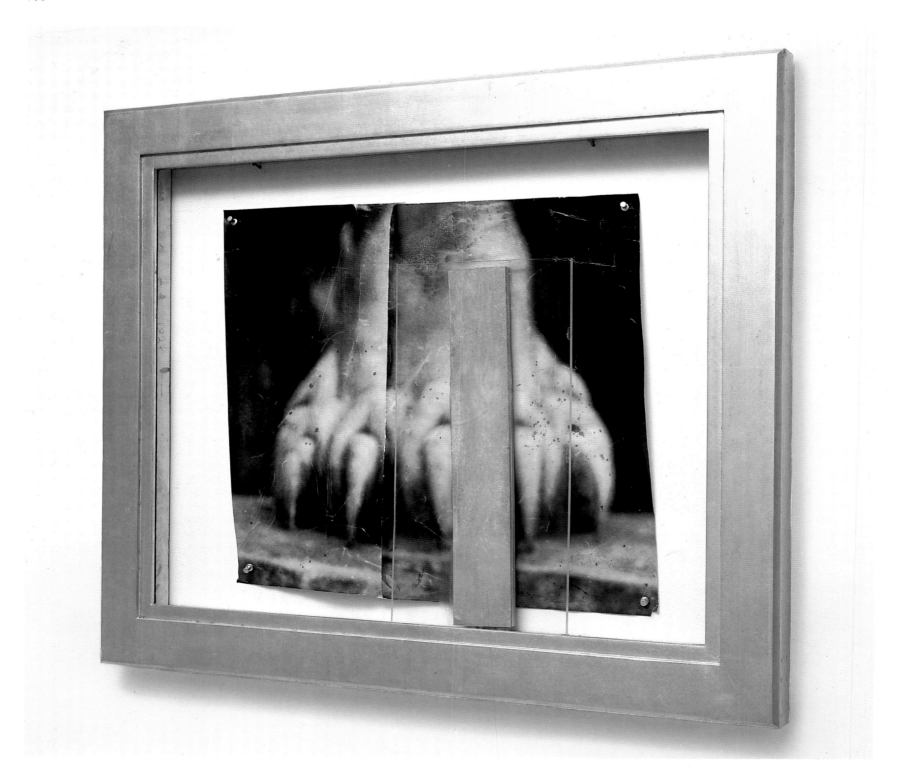

ST.-MICHEL CLAW, 1985–87

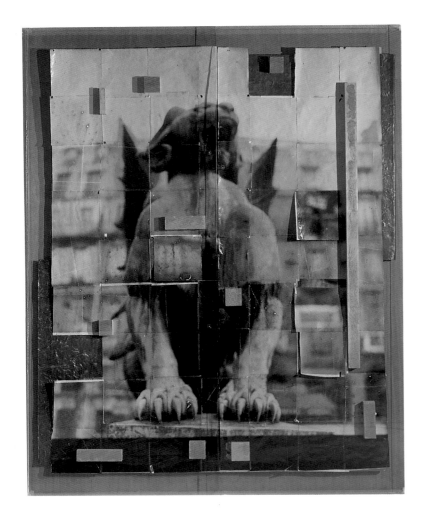

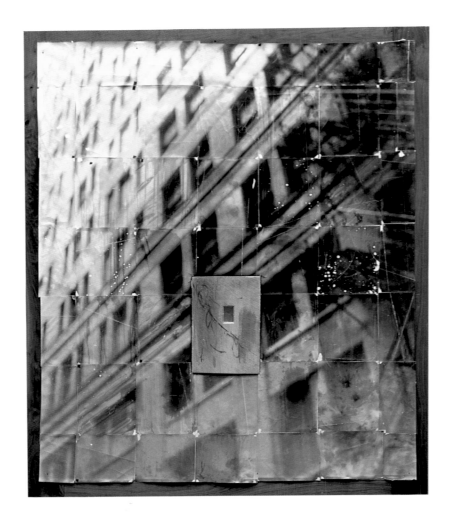

PLACE ST.-MICHEL WITH LEAD AND PLEXI. 1985–87

ROOKERY WITH WOOD BLOCK. 1988

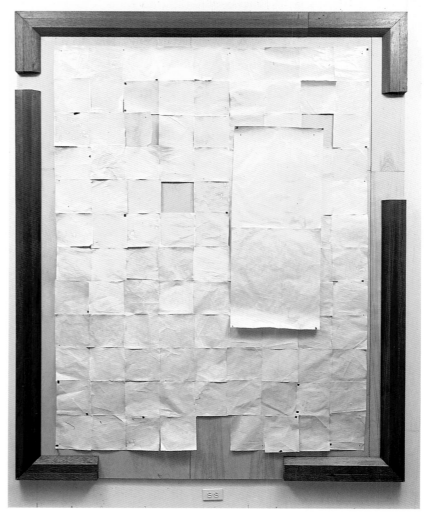

CORONA. 1987

SOL. 1988

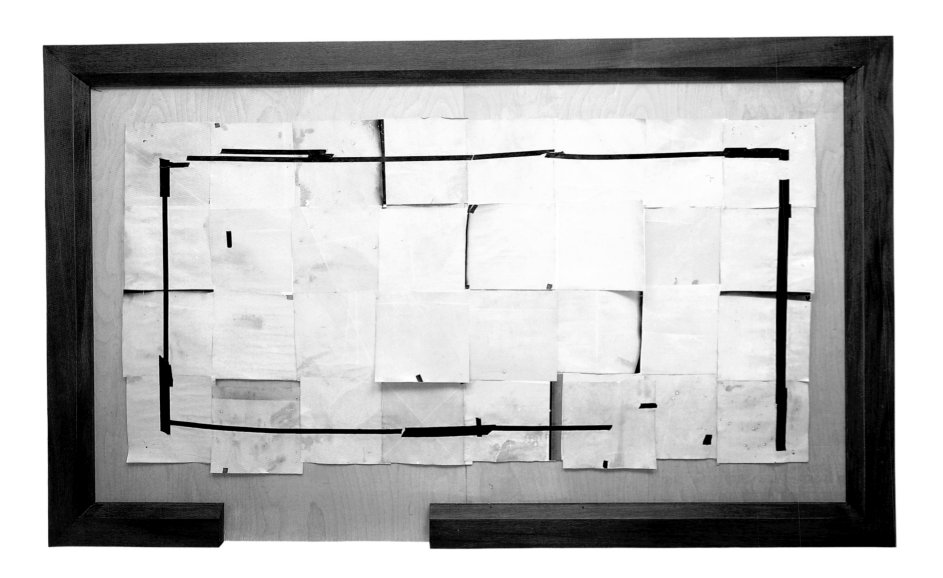

CORONA EXTRA, 1987

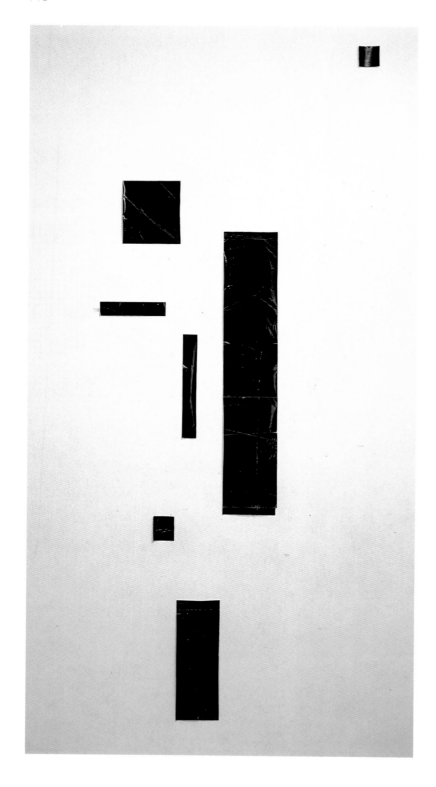

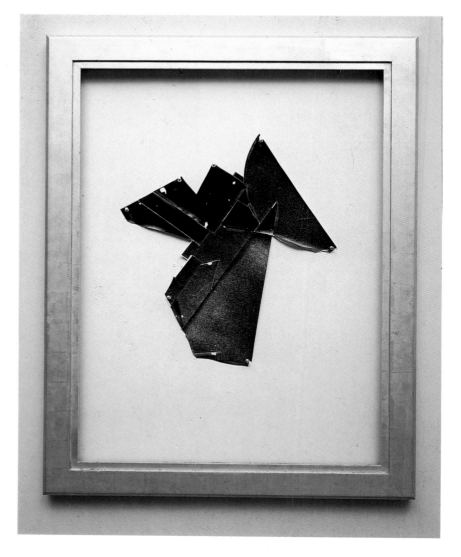

KANDINSKY, 1988

BLACK GROUP #2, 1987

(OPPOSITE) RED AND BLACK SQUARE, 1986

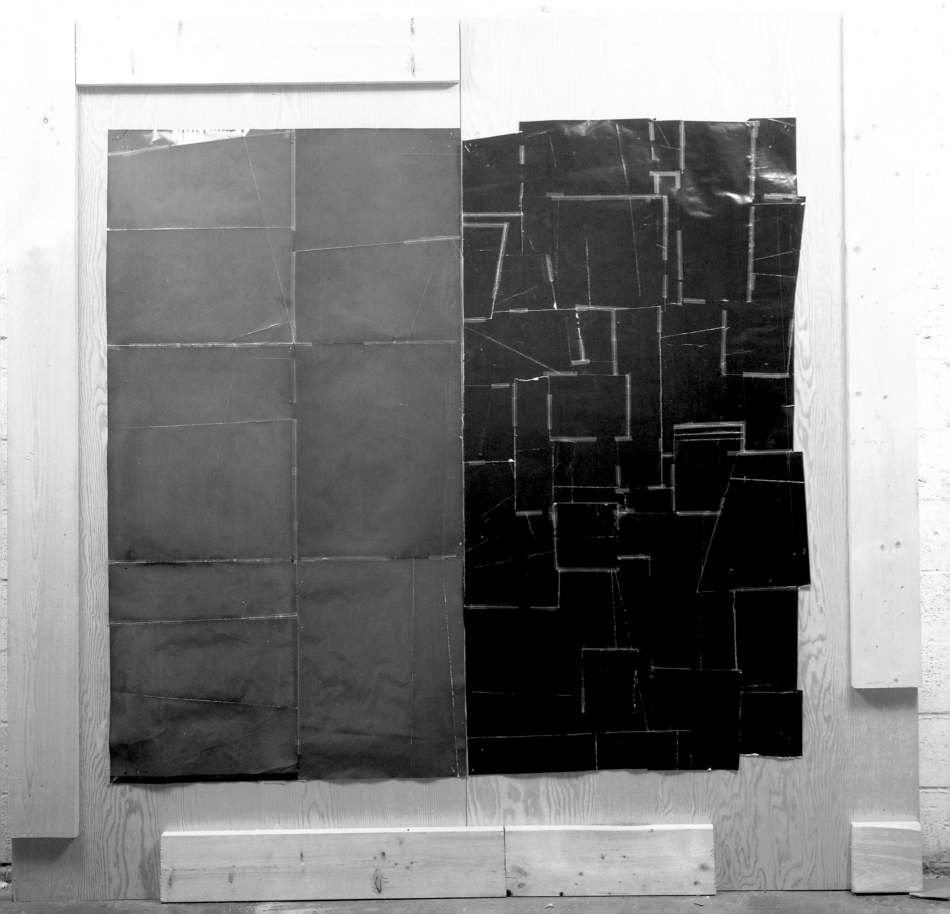

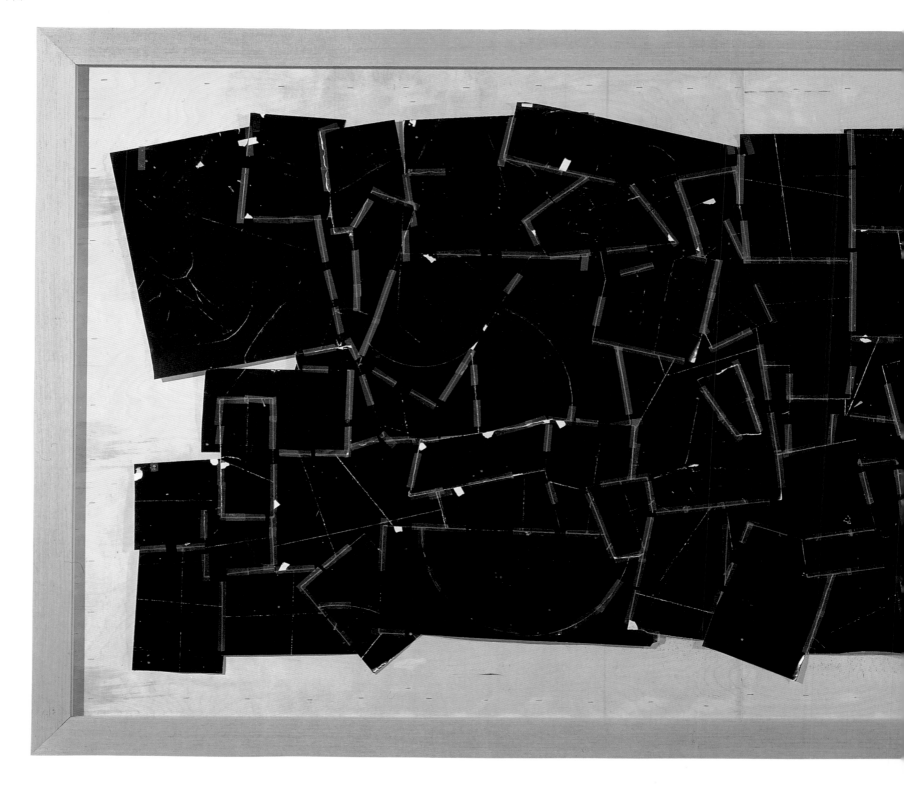

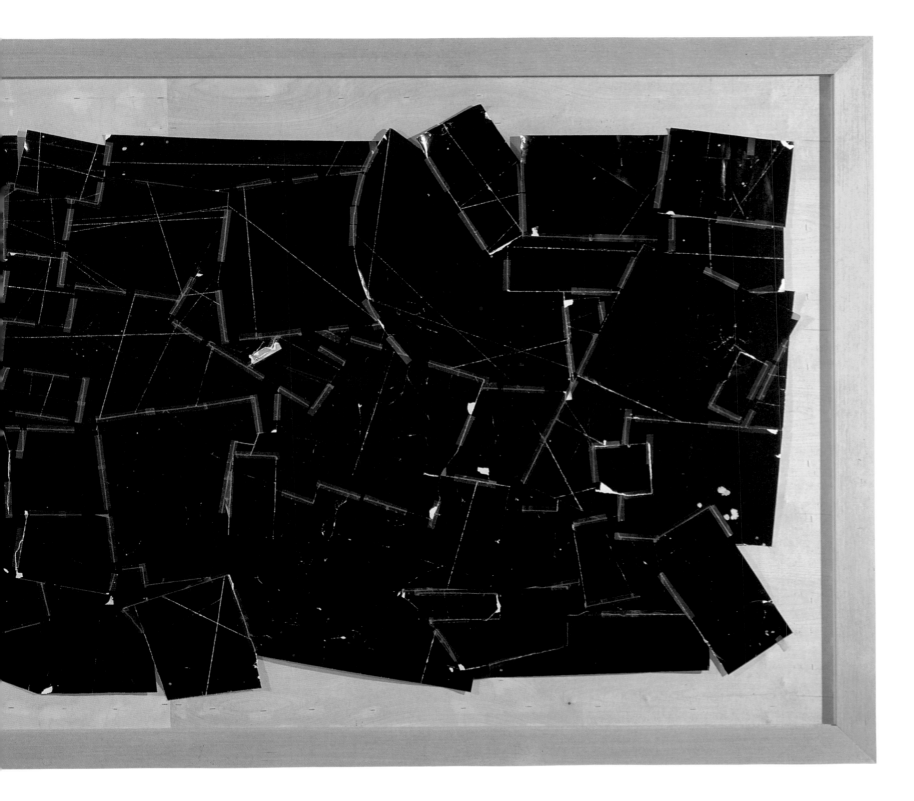

BLACK PIECE, 1986

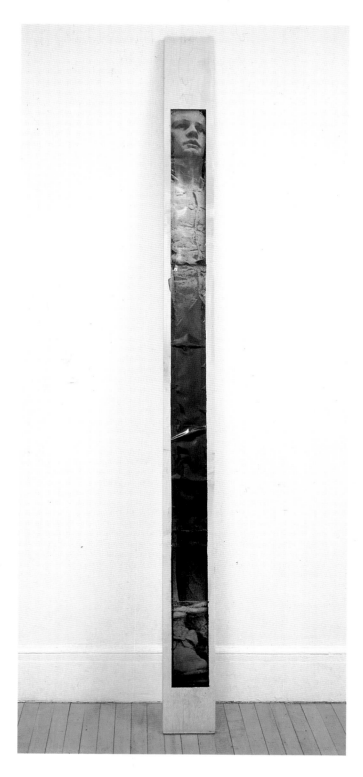

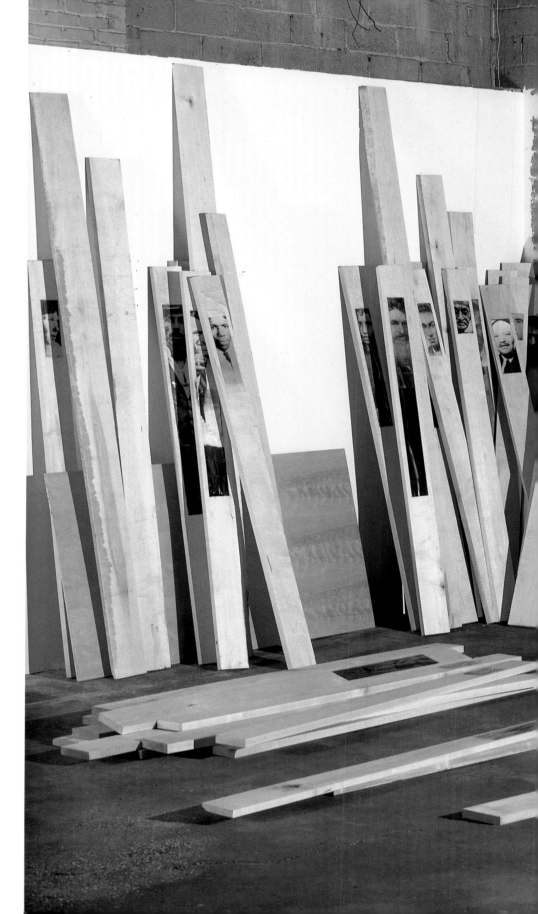

LACK OF COMPASSION. 1987–88

(OPPOSITE) INSTALLATION VIEW, *LACK OF COMPASSION*, 1988

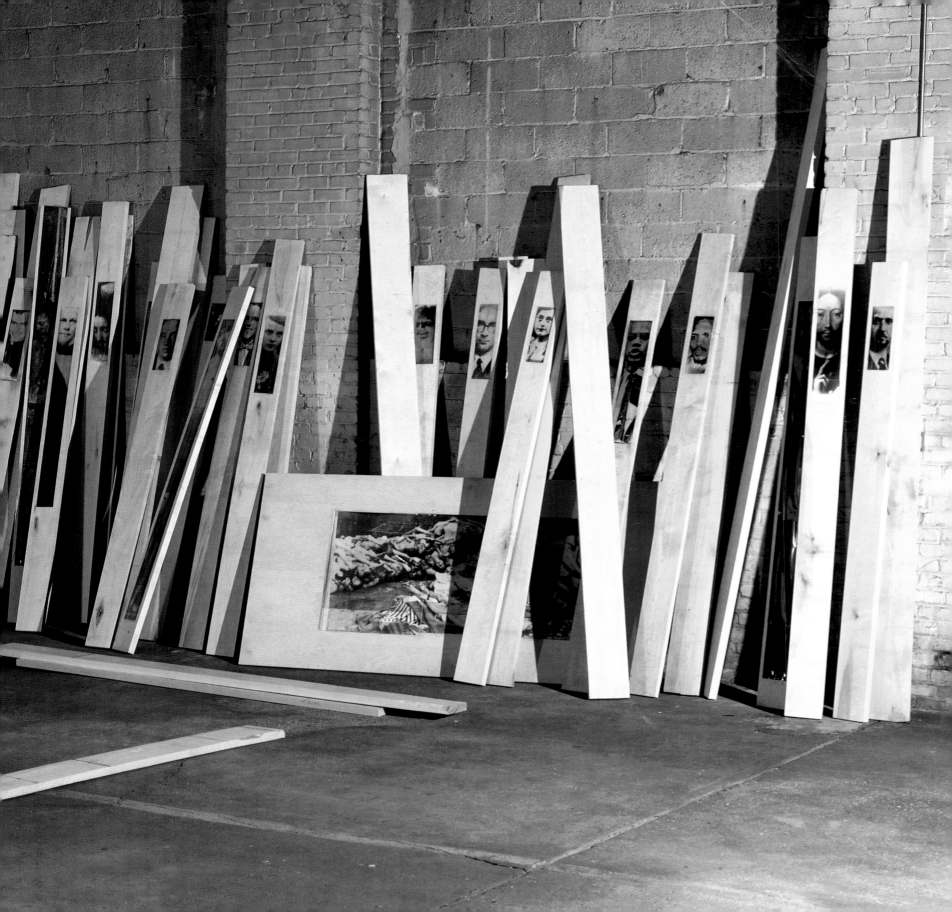

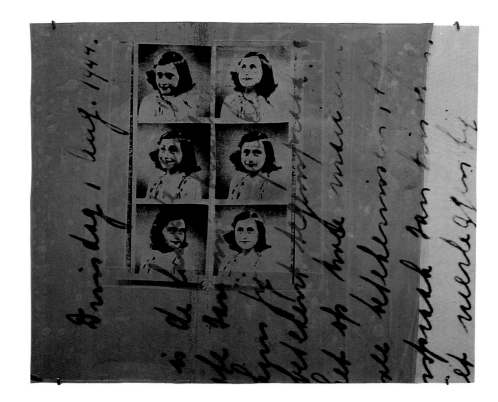

SMALL PORTRAIT OF ANNE FRANK. 1989

ANNE FRANK GRAVE MARKER. 1989

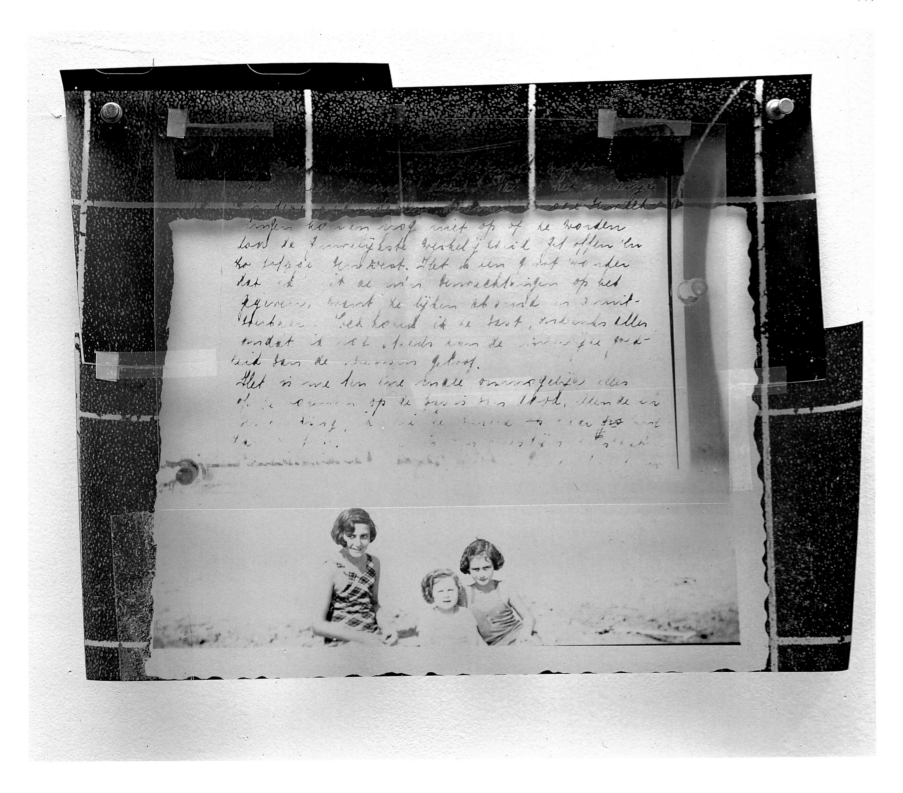

ANNE AND MARGOT FRANK ON THE BEACH, 1989

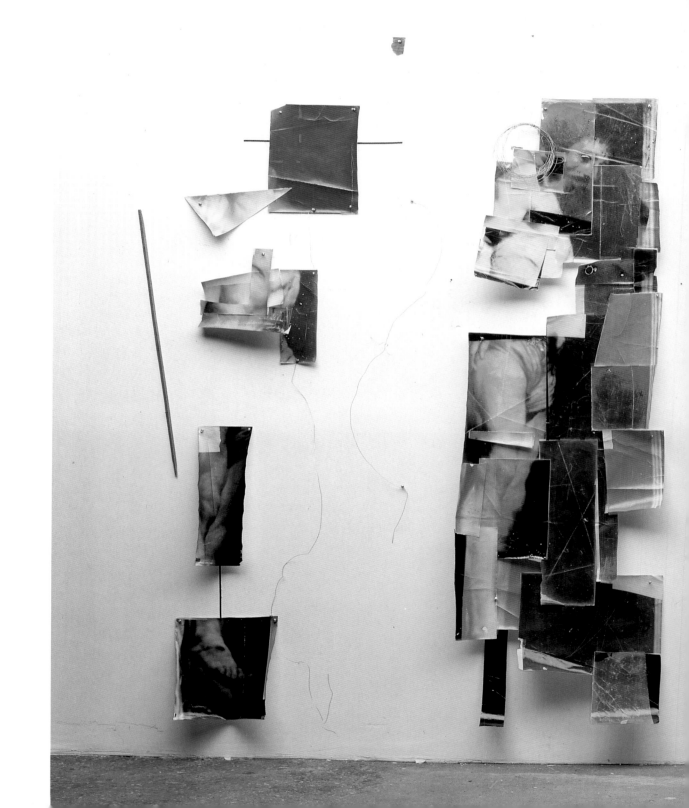

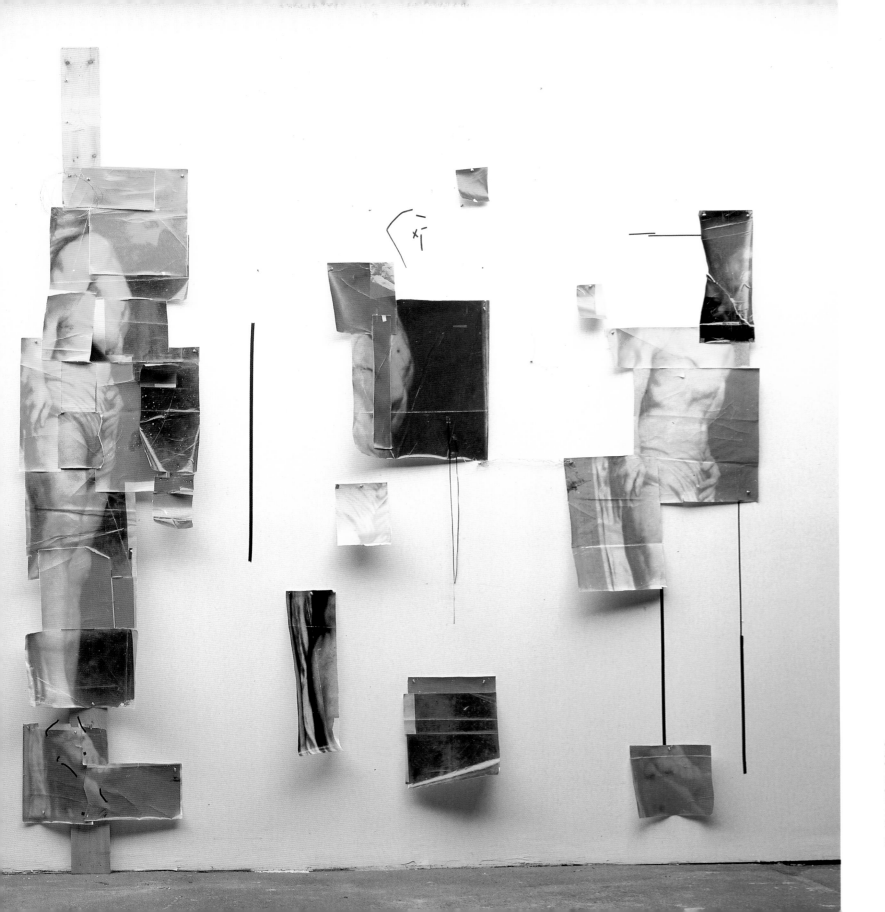

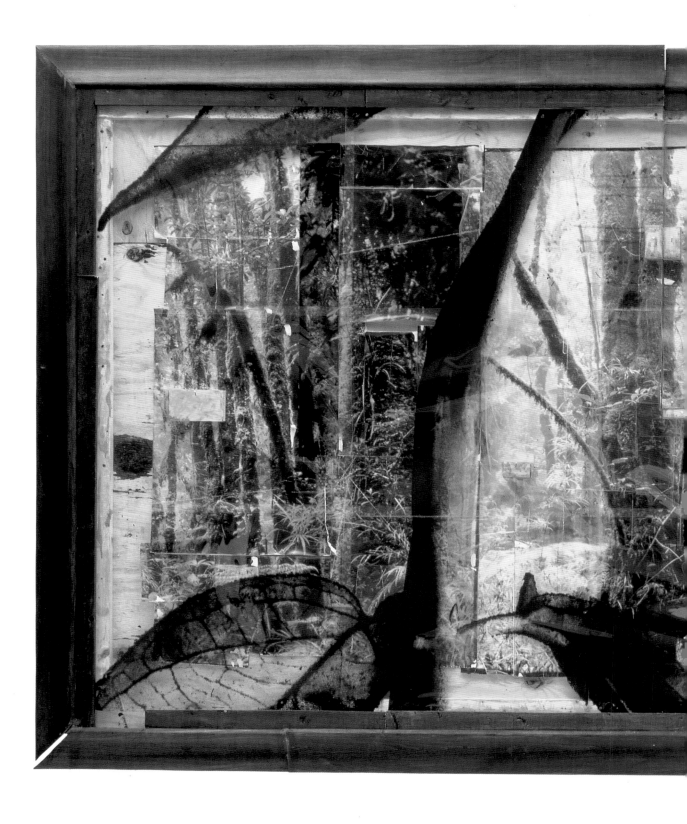

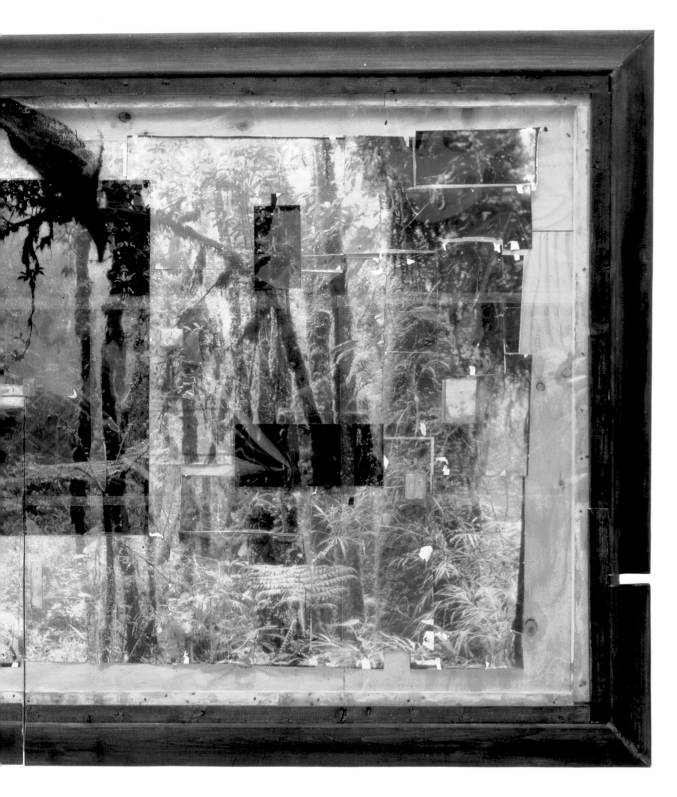

RAIN FOREST WITH CIBA AND WOOD. 1989

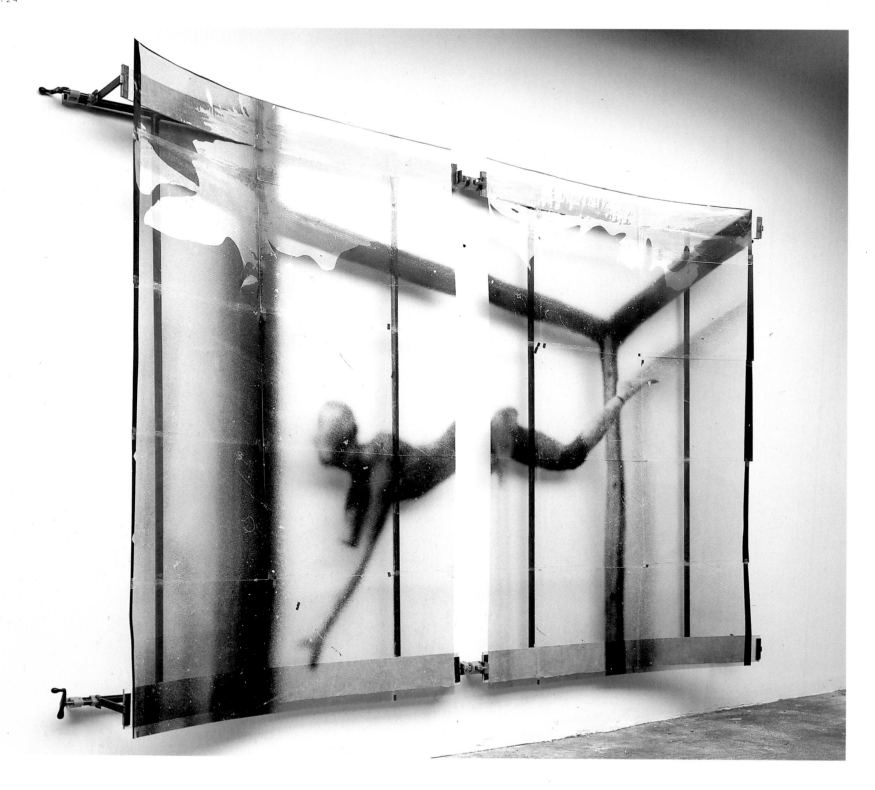

CONCAVE BULL JUMPER, 1989

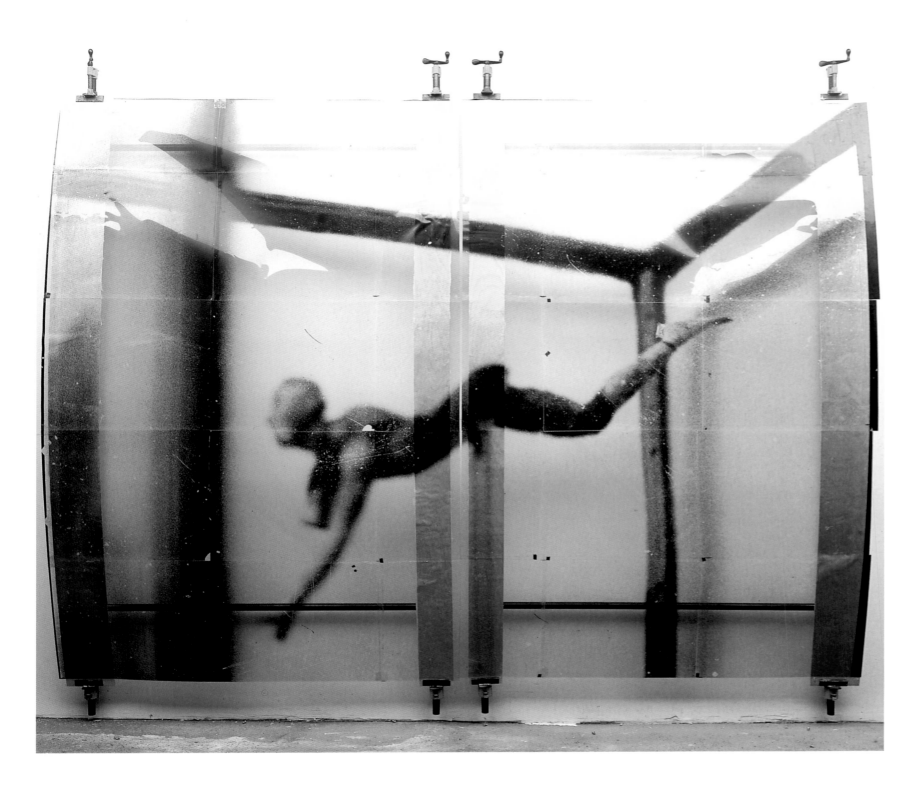

CONVEX BULL JUMPER. 1989

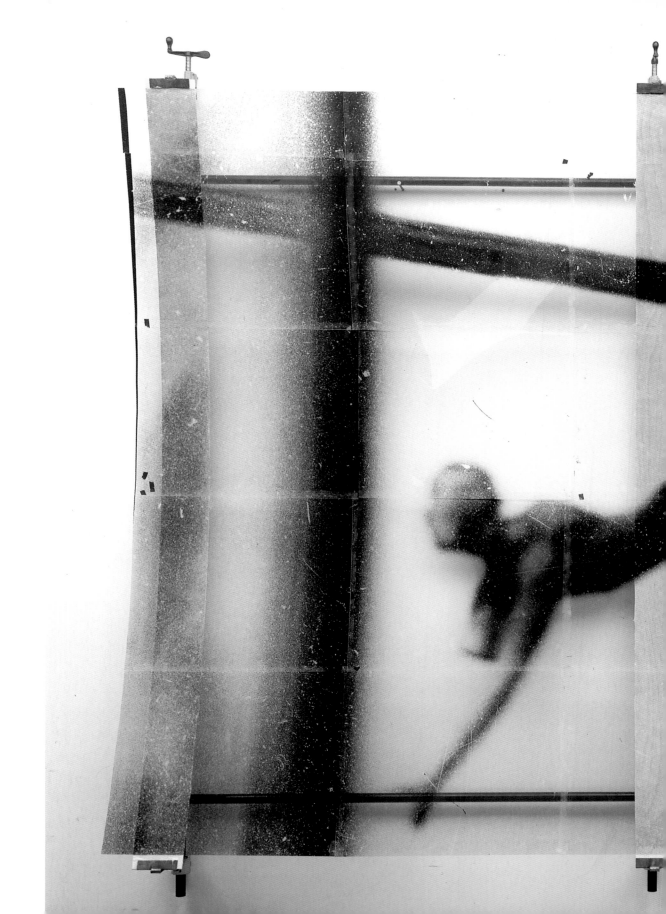

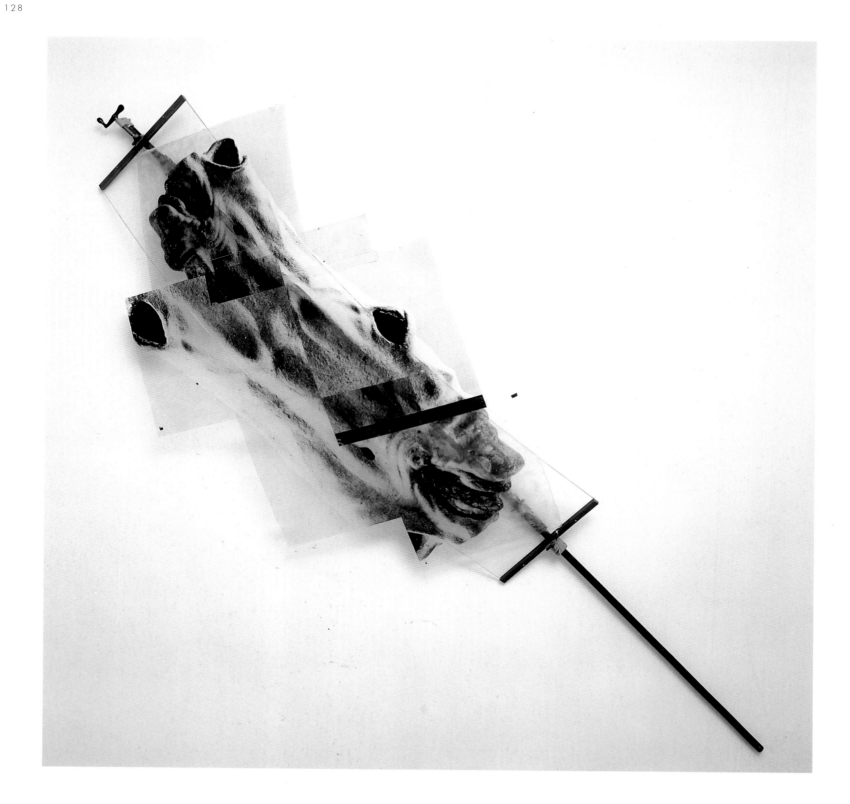

HORSE SPIT. 1989–90

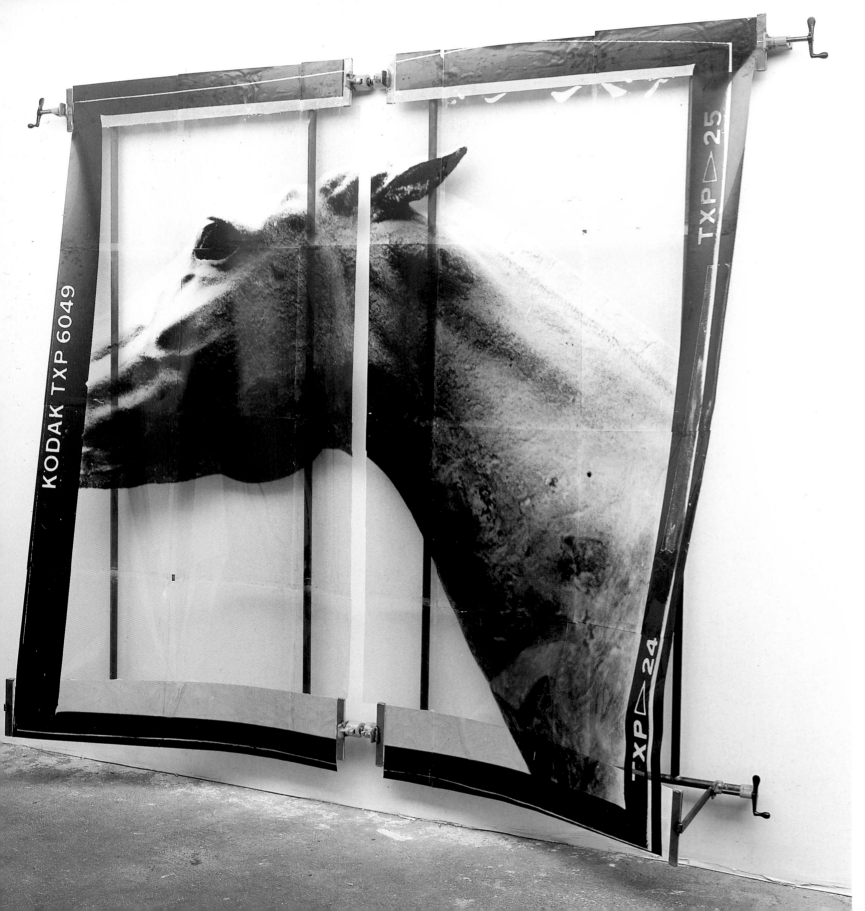

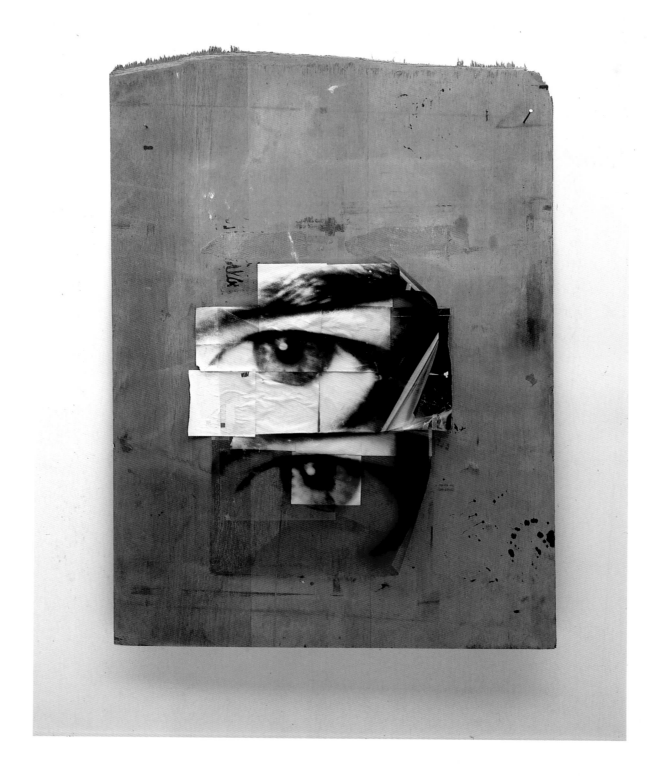

EYE WITH FILM AND PLYWOOD. 1989–90

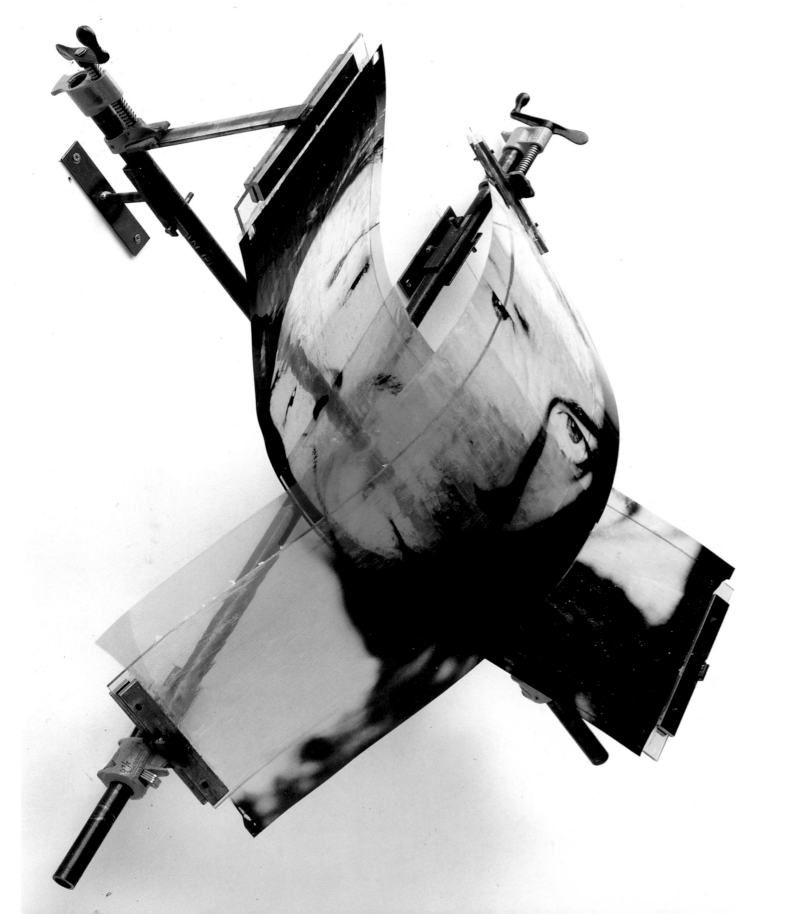

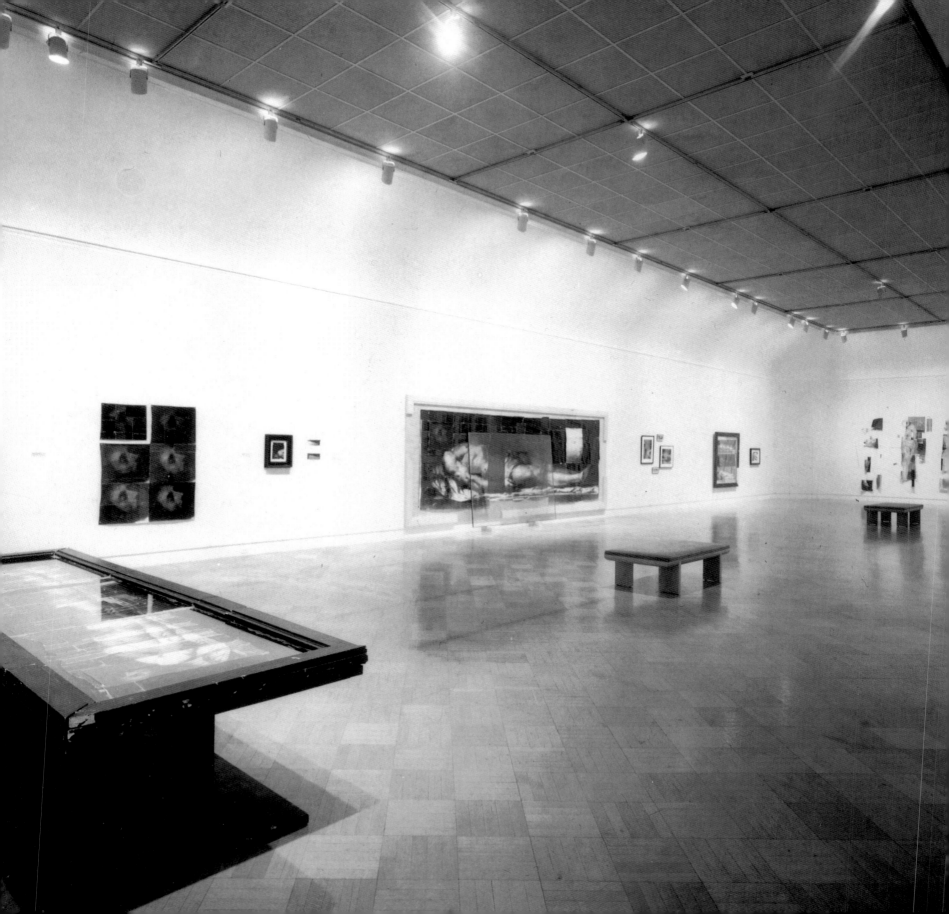

Born 1961, Absecon, N.J.

EDUCATION

1984–85
School of the Museum of Fine Arts, Boston, 5th Year Certificate

1980–84
School of the Museum of Fine Arts, Boston, Diploma

SOLO EXHIBITIONS

1990
Contemporary Arts Center, Cincinnati; traveled to Akron Art
 Museum, Ohio; Baltimore Museum of Art, The Sarah Campbell
 Blaffer Gallery, University of Houston
Fred Hoffman Gallery, Santa Monica, Calif.
Stux Gallery, New York
Mario Diacono Gallery, Boston
1989
Akira Ikeda Gallery, Tokyo
"Anne Frank Group," Leo Castelli Gallery, New York, and Stux
 Gallery, New York

1988
Stux Gallery, New York, and Leo Castelli Gallery, New York
"The Christ Series," Museum of Modern Art, San Francisco
"Mike & Doug Starn: Selected Works 1985–1987," Honolulu
 Academy of Art, Hawaii; traveled to University Art Museum,
 University of California, Berkeley; Wadsworth Atheneum,
 Hartford, Conn.; Museum of Contemporary Art, Chicago

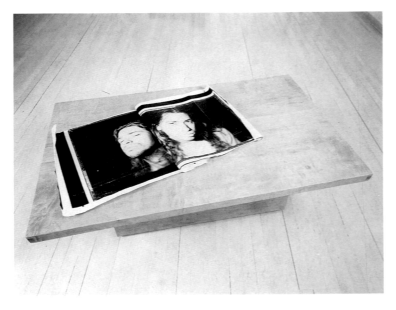

MAGAZINE. 1989

1987
"The Christ Series," The John & Mable Ringling Museum of Art,
 Sarasota, Fla.
Stux Gallery, New York
Stux Gallery, Boston

1986
Stux Gallery, New York

1985
Stux Gallery, Boston

SELECTED GROUP EXHIBITIONS

1990

"Recent Acquisitions," The Israel Museum, Jerusalem

"Primavera Fotografica," Center of Contemporary Art of Santa Monica, Barcelona, Spain

"Photographic Appropriation," Leo Castelli Gallery, New York, and Gallery, Milan, Italy

"Group Photography Show," Fernando Alcolea, Barcelona, Spain

"On the Edge of Sculpture and Photography," Cleveland Centre for Contemporary Art, Cincinnati, Ohio

"All Quiet on the Western Front?" Antoine Candau, Paris

"Five Artists from New York," Mayor Rowan Gallery, London

"With the Grain: Contemporary Panel Painting," Whitney Museum of American Art, Stamford, Conn.

1989

"L'Invention d'un Art," Centre George Pompidou, Paris

"Invention and Continuity in Contemporary Photography," The Metropolitan Museum of Art, New York

"Selections from the Collection of Marc and Livia Straus," The Aldrich Museum of Contemporary Art, Ridgefield, Conn.

"Self and Shadow," Burden Gallery, Aperture Foundation, New York

"Summer Group Show" and "Anne Frank Group," Leo Castelli Gallery, New York

"Anne Frank Group" and "Gallery Artists," Stux Gallery, New York

"The Photography of Invention: American Pictures of the 1980s," The National Museum of American Art, Smithsonian Institution, Washington, D.C.; traveled to Museum of Contemporary Art, Chicago; Walker Art Center, Minneapolis

"Wiener Diwan: Sigmund Freud Heute," Museum des 20 Jahrhunderts, Vienna, Austria

"Pre-Pop Post-Appropriation," Stux Gallery, New York

"Photography Now," Victoria & Albert Museum, London

1988

"Binational: American Art of the Late 80's," Museum of Fine Arts & The Institute of Contemporary Art, Boston; traveled to Städtische Kunsthalle & Kunstsammlung Nordrhein-Westfalen, Düsseldorf, West Germany; Tel Aviv Museum of Art, Israel; The National Gallery of Greece, Athens; Art Museum of Atheneum, Helsinki, Finland (1990); The National Gallery of Art, Warsaw, Poland (1990)

"Art at the End of the Social," The Rooseum, Malmö, Sweden

"2 to Tango," International Center of Photography, New York

"Photography On The Edge," The Haggerty Museum Of Art, Marquette University, Milwaukee, Wis.

"Art of Our Time," The Saatchi Collection, London

"First Person Singular: Self-Portrait Photography, 1840–1987," High Museum of Art, Atlanta·

1987

"Whitney Biennial," Whitney Museum of American Art, New York

"New York New Art," Mayor Rowan Gallery, London

"Primary Structures," Rhona Hoffman Gallery, Chicago

"Photomannerisms," Lawrence Oliver Gallery, Philadelphia

"Invitational," Michael Kohn Gallery, Los Angeles

"Invitational," Annina Nosei Gallery, New York

"Portrayals," International Center of Photography/Midtown, New York

"The New Romantic Landscape," Whitney Museum of American Art, Stamford, Conn.

"Invitational," Curt Marcus Gallery, New York

"Post Abstract Abstraction," Aldridge Museum, Ridgefield, Conn.

"The Big Picture: The New Photography," John & Mable Ringling Museum of Art, Sarasota, Fla., and "Fragments," San Francisco Cameraworks, Calif.

"The Antique Future," Massimo Audiello Gallery, New York

1986

"Adam Fuss, Mark Morrisroe and The Starn Twins," Massimo Audiello Gallery, New York

"Apparitions and Allusions: Photographs of the Unseen," San Diego State University, Calif.

"The Joe Masheck Collection of Contemporary Art," Rose Art Museum, Brandeis University, Waltham, Mass.

"Inaugural," Stux Gallery, New York

1985

"Boston Now: Photography," Institute of Contemporary Art, Boston

"Invitational," Stux Gallery, Boston

"Museum School Travelling Scholars," Museum of Fine Arts, Boston

"Fifth Year Travelling Scholarship Competition," Cyclorama Center for the Arts, Museum of Fine Arts, Boston

"New Work from New York," Carpenter Center for the Visual Arts, Cambridge, Mass.

"#2. Smart Art Too," 55 Mercer gallery, New York

1984

"The Little Train That Could . . . Show," Revolving Museum, Boston

AWARDS

1986

National Endowment for the Arts Grant

Massachusetts Council for the Arts, Fellowship in Photography

1985

Fifth Year Travelling Scholarship Award Recipients

MUSEUM COLLECTIONS

The Baltimore Museum of Art

The Bibliothèque Nationale, Paris

The Chicago Art Institute

The Everson Museum of Art, Syracuse, N.Y.

The Israel Museum, Jerusalem

The Los Angeles County Museum of Art

The Metropolitan Museum of Art, New York

The Mito Arts Center, Mito, Japan

The Museum of Fine Arts, Boston

The John & Mable Ringling Museum of Art, Sarasota, Fla.

The Wadsworth Atheneum, Hartford, Conn.

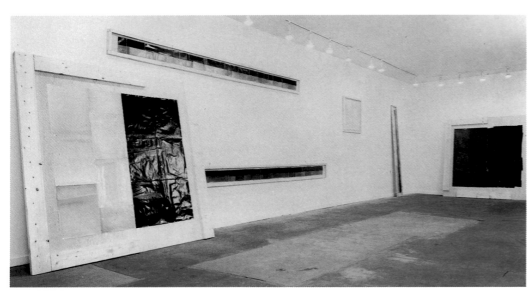

INSTALLATION VIEW, MASSIMO AUDIELLO GALLERY, NEW YORK, 1987

Addams Allen, Jane. "Chilly Cynicism a Portent of Trouble." *Insight*, June 15, 1987, pp. 58–59.

Altabe, Joan. "The Starn Twins, Brothers Turn Photography Inside Out." *Sarasota Herald Tribune*, November 15, 1987, p. 68.

Ames, Katrine. "The Art of Double Exposure." *Newsweek*, June 29, 1987, p. 68.

Audiello, Massimo & di Casadio, Mariuccia. "*Introspezioni Fotografiche*" (Photographic Inspection). *Vanity*, November/December 1986, pp. 66–72.

Bailey, Rosemary. "Starn Quality." *British Elle*, Summer 1987.

Bankowsky, Jack. "Mike and Doug Starn." *Artforum*, January 1989, p. 109.

———. "The Starn Twins." *Flash Art*, Summer 1987, pp. 109–110.

Bonetti, David. "Rising Starns." *The Boston Phoenix*, October 30, 1987, p. 4.

———. "Double Vision." *The Boston Phoenix*, November 12, 1985, pp. 4–6.

Boodro, Michael. "Dynamic Duos." *House & Garden*, August 1988, p. 23.

Brenson, Michael. "Art: Whitney Biennial's New Look." *The New York Times*, April 10, 1987, p. C24.

Cameron, Dan. "NY Art Now." The Saatchi Collection, Giancarlo Politi Editore, 1987, p. 173.

———. "The Whitney Biennial." *Flash Art*, Summer 1987, pp. 86–87.

Frick, Tom. "Boston: Starn Twins at Stux." *Art in America*, November 1985, p. 168.

Gefter, Philip. "The Starn Twins." *Shift*, vol. 2, #4, 1988, pp. 19–25. Interview.

Graham-Dixon, Andrew. "Double Exposure." *British Vogue*, March 1988, pp. 329, 372.

Giuliano, Charles. "The Starn Twins." *Art New England*, September 1987, p. 14.

———. "New Photographs: The Starn Twins, Doug and Mike." *Views*, Winter 1986, p. 17.

Giuliano, Mike. "Twin Photographers with One Focus." *The Evening Sun*, October 12, 1989, p. D12.

Grundberg, Andy. "The Year's Best: 1988 in Review." *The New York Times*, December 25, 1988, pp. 33, 39.

———. "A Pair Of Shows For A Pair Of Trendy Twins." *The New York Times*, October 2, 1988, pp. 31, 41.

———. "The Year's Best—New Breed Challenges Realism." *The New York Times*, December 27, 1987, p. 35.

———. "Where Blurred Focus Makes Sharp Statements." *The New York Times*, December 20, 1987, pp. 39, 42.

———. "Photography." *The New York Times*, July 5, 1987.

———. "Prints That Go Beyond the Border of the Medium." *The New York Times*, May 3, 1987, p. H27.

———. "A New Breed Puts Its Own Stamp on the Medium." *The New York Times*, December 28, 1986, p. H27.

Handy, Ellen. "The Starn Twins." *Arts*, Summer 1987, p. 108.

Hasegawa, Yuko. "Hope For Double Visions Power, Starn Twins." *Japanese Cosmopolitan*, October 1989, p. 200–201.

———. "Power of Double Visions." *Atelier*, September 1989, #751, pp. 2–28.

Haworth-Booth, Mark. "Photography Now." London: The Victoria & Albert Museum, 1989. Exhibition catalogue.

Haus, Mary Ellen. "Catch A Rising Starn." *New York Woman*, October 1988, p. 53.

Heartney, Eleanor. "Combined Operations." *Art in America*, June 1989, p. 140.

———. "The Starn Twins." *Art News*, September 1987, p. 135.

Henn, Ulrike. "The Starn Twins." *Art Das Kunstmagazin*, May 1988, pp. 72–78, 80.

Huffhines, Kathy. "In the Fen Country." *The Boston Phoenix*, October 28, 1986, p. A3.

Indiana, Gary. "Another View of the Whitney." *The Village Voice*, April 26, 1987, pp. 87–88.

———. "Imitation of Life." *The Village Voice*, April 29, 1986, p. 87.

———. "The Starn Twins." *The Village Voice*, April 22, 1986, p. 71.

Jacobs, Joe. "Doug & Mike Starn: The Christ Series." Sarasota: The John & Mable Ringling Museum Of Art, 1987. Exhibition catalogue.

———. "The Starn Twins." *Splash*, November 1987.

Kachur, Lewis. "Chicago: Lakeside Boom." *Art International*, Spring 1989, pp. 63–65.

Kenner, Hugh. "The First Photo." *Art & Antiques*, May 1989, pp. 69–79.

Koslow, Francine. "New Life For Old Masters." *Contemporanea*, September 1989, pp. 72–75.

———. "Doubling Photography: The Starn Twins." *The Print Collectors Newsletter*, vol. XVII, no. 5, November/December 1986, pp. 163–167.

Larson, Kay. "The Starn Twins." *Vogue*, September 1987, p. 459.

Lovelace, Carey. "The Whitney Gets It Right, Almost." *New Art Examiner*, Summer 1987, p. 24.

Mahoney, Robert. "Doug and Mike Starn." *Arts*, January 1989, p. 100.

———. "Art Against Aids." *Arts*, September 1987, p. 108.

Mantegna, Gianfranco. "Starn Twins." *Teme Celeste*, January–March 1989.

———. "Fotografia = Oggetto." *Fotografare Magazine*, August 1987, pp. 68–69.

Masheck, Joseph. "Joe Masheck On Art." *Boston Review*, June 1987, p. 30.

———. "Of One Mind: Photos By The Starn Twins of Boston." *Arts*, March 1986, pp. 69–71.

Miller, John. "Whitney Biennial." *Artscribe*, Summer 1987, pp. 5–8.

Neugroschel, Joachim. "Review of: Summer Group Show at Stux." *Cover Magazine*, Summer 1988, p. 11.

Ottmann, Klaus. Interview with Doug and Mike Starn, *Journal of Contemporary Art*, vol. 3, no. 1, Spring/Summer 1990, pp. 66–79.

———. "Reviews—Boston: Doug and Mike Starn," *Flash Art* 138, January/February 1988, p. 126.

———. "Photomannerisms." *Flash Art* 137, November/December 1987, pp. 70–71.

Pincus-Witten, Robert. "Being Twins—The Art of Doug and Mike Starn." *Arts*, October 1988, pp. 72–77.

Salvioni, Daniela. "Doug and Mike Starn." *Flash Art*, November/December 1988, #143, p. 120.

Sanada, Ikkan. "New Progressive Artists In New York." *Now '89*, February 1989, vol. 2, no. 161, pp. 136–138.

Smith, Joshua P. "The Photography of Invention: American Pictures of the 1980's." Washington, D.C.: National Museum of American Art, Smithsonian Institution, 1989. Exhibition catalogue.

Smith, Roberta. "Singular Artists Who Work in the First Person Plural." *The New York Times*, May 10, 1987, p. H29.

Solnit, Rebecca. "Through A Glass Murkily." *Artweek*, April 9, 1988, vol. 19, no. 14, p. 1.

Staniszewski, Mary Anne. "The Museum and Marketplace." *Manhattan Inc.*, April 1987, pp. 174–77.

Stapen, Nancy. "Still Rising Starns." *Art News*, February, 1988, p. 110–113.

———. "The Starn Twins." *Esquire*, December 1987, p. 127.

———. "The Starn Twins." *Bottom Line*, September 15, 1987, p. 5.

Taylor, Robert. "Whitney Biennial Takes A Step Forward." *The Boston Globe*, May 10, 1987, p. A1.

Temin, Christine. "Romance is in the Galleries." *The Boston Globe*, March 23, 1989, p. 87.

———. "Double Exposure." *The Boston Globe Magazine*, October 4, 1987, p. 5.

———. "Boston's Starn Twins An Art World Sensation." *The Boston Globe*, May 10, 1987, p. A4.

Tsuzuki, Kyoichi. "The Starn Twins." *Japanese Esquire*, June 1988, pp. 206–211.

Weiley, Susan. "150 Years of Photography: The Darling of the Decade." *Art News*, April 1989, p. 146.

Wilson, Beth. "The History of Decay." *Fad Magazine*, Summer 1988.

Wilson, William. "Pristine Anarchy." *Los Angeles Times*, April 19, 1987, pp. 93–94.

Wise, Kelly. "The Starns Break New Ground." *The Boston Globe*, October 15, 1987, p. 77.

———. "The Unconventional and the Brooding." *The Boston Globe*, December 17, 1986, p. 76.

Woodward, Richard B. "Mike and Doug Starn." *Art News*, December 1988, p. 146.

———. "It's Art, But Is It Photography?" *The New York Times Magazine*, October 9, 1988.

Wooster, Ann-Sargent. "Starn Twins." *Cover*, November 1988, p. 18.

Zimmer, William. "Photos By Twins: A Double Illusion." *The New York Times*, August 7, 1988, p. C24.

All works are by Mike and Doug Starn. Numbers preceding
each entry refer to page numbers.

2 *Blue Rose.* 1982–88.
Toned ortho print with Plexiglas, glue, frame, 11 × 14″.
Courtesy Anne R. Pasternak, New York

3 *Large Fern.* 1988.
Toned silver print, tape, wood, 94 × 88″. Courtesy Barbara
Guggenheim Associates

4 *Large Mona with Plexi.* 1985–88.
Toned silver print, tape, Plexiglas, wood, 115 × 100″. Courtesy
Thomas Ammann, Zurich

5 *Large Copper Rembrandt.* 1989.
Toned silver print and ortho film, wood, silicone, tape,
96 × 84 × 12″. Collection Marc and Livia Straus

6 *Film Acropolis with Pipe Clamps.* 1989.
Toned ortho film, wood, clamps, silicone, 52 × 48 × 15″.
Collection Dr. and Mrs. Claude and Christine Fain, Paris

7 *Half Concave Athenian Horse Head.* 1989.
Ortho film, silicone, wood, pipe clamps, 96 × 96 × 20″. Courtesy
Anne R. Pasternak, New York

12 *Crucifixion.* 1985–88.
Toned silver print, wire, ribbon, wood, tape, 10 × 15′ 10″.
Collection the artists

17 *Self-Portrait with Metal and Ribbon.* 1985–89.
Toned silver print and ortho film, tape, wood, ribbon,
aluminum, 61 × 109″. Courtesy Leo Castelli

18 *Two-Headed Swan.* 1988–89.
Toned silver print, tape, metal, 43 × 50″. Private Collection,
Vienna

24 *Little Money.* 1988.
Toned silver print, felt marker, 15 × 13″. Collection Stefan and
Linda Stux

41 *Rembrandt Head Details.* 1989.
Toned silver print, wood, 24 × 42 × 11″. Collection Jack and
Sandra Guthman

49 *Horses.* 1986.
Toned silver print, tape (Institute of Contemporary Art,
Boston), 55 × 108″. Collection Randolfo Rocha, New York

50–51 Installation view, *Horses.* 1985–86.
Toned silver print, tape (Edition of 100, Institute of
Contemporary Art, Boston), 10 × 16′.

52–53 *Horses.* 1985–86.
Toned silver print, tape (#65 from an edition of 100, Institute
of Contemporary Art, Boston), 35 × 120″. The Metropolitan
Museum of Art. Promised gift of Barbara and Eugene Schwartz

53 *Horses.* 1985–86.
Toned silver print, tape (Edition of 100, Institute of
Contemporary Art, Boston), 14 × 24″. Collection Randolfo
Rocha, New York

53 *Horses.* 1985–86.
Toned silver print, tape (#68 from an edition of 100, Institute
of Contemporary Art, Boston), 14 × 24″. Collection David and
Margaret Ross, Cambridge, Mass.

54 *Macabre Still Life.* 1983–85.
Silver print, tape, 66 × 51″ unframed. Private Collection

55 *L.* 1986.
Toned silver print, steel, tape, wood, 48 × 48″. Collection Philip
C. Manker, Boston

56 *Mark Morrisroe with Chair* (detail). 1985–87.
Toned silver print, tape, 12 × 12″ detail. Saatchi Collection, London

57 *Mark Morrisroe with Chair*. 1985–87.
Toned silver print, aluminum, tape, 87 × 87″. Saatchi Collection, London

58 *Mark Morrisroe*. 1985–86.
Toned silver print, tape, 100 × 100″. Collection the artists

59 *Ian Churchill*. 1985–87.
Toned silver print, tape, 82 × 83″. Collection the artists

60 *Lisa on Metal*. 1988.
Toned silver print, tape, wood, steel, 35 × 27″. Collection Gabriel Stux, Düsseldorf, West Germany

61 *Ian's Eyes*. 1987.
Toned silver print, 22 × 53″. Saatchi Collection, London

61 *Tears with Metal and Plexi*. 1987.
Toned silver print, tape, metal, Plexiglas, 72 × 55″. Collection Paul J. T. Sinclair, New York

64 *Bleached Rose*. 1982–86.
Toned silver print, tape, 10 × 13″. Collection Marcie Lee, New York

65 *Rose with Christ*. 1982–86.
Toned silver print, tape, 66 × 104″. The Rubell Collection, New York

66 *Plant Details #3*. 1988.
Silver print, tape, wood, 66 × 73″. Lambert Art Collection

67–68 *Stretched Christ*. 1985–86.
Toned silver print, tape, wood, Plexiglas, 28 × 142 × 45″. Collection Stefan and Linda Stux

69 *Triple Christ*. 1986.
Toned silver print, wood, glue, glass, aluminum, tape, 65 × 65″. Collection Randolfo Rocha, New York

71 *Plant #3 Detail*. 1988.
Silver print, tape, 67 × 56″. Lambert Art Collection

72 *Plant #1*. 1988.
Silver print, tape, 90 × 77″. Courtesy Thomas Ammann, Zurich

73 *Intertwined Detail*. 1988.
Toned silver print, tape, 53 × 41″. Collection Bob and Sandy Pittman

73 *Curly Leaf*. 1988.
Silver print, wood, tape, 24 × 21″. Collection Barbara and Eugene Schwartz, New York

74 *M. with Slate*. 1984–87.
Toned silver print, slate, 14 × 11″. Collection Stefan and Linda Stux

74 *Rose Petals with Black Tape*. 1985–87.
Toned silver print, tape, 31 × 29″. Collection Emily Galin, New York

75 *Plant #3 Detail*. 1988.
Toned silver print, tape, 33 × 28″. Courtesy Thomas Ammann, Zurich

75 *Kauai*. 1988.
Toned silver print, Plexiglas, glue, wood, 33 × 28″. Collection Bunny and Jeff Dell, New York

76 *Rose*. 1982–88.
Toned silver print, tape, wood, 55 × 76″. Courtesy Thomas Ammann, Zurich

77 *Double Stark Portrait in Swirl*. 1985–86.
Toned silver print, tape, 99 × 99″. Collection Randolfo Rocha, New York

78 *Double Stairs.* 1987.
Toned silver print, 38 × 29″. Collection Adler/Frasca, New York

79 *Double Chairs.* 1985–87.
Toned silver print, Plexiglas, tape, glue, wood, 96 × 84″.
Collection Fumi International, Tokyo

80 *Lake Michigan Steps.* 1987.
Toned silver print, tape, wire, wood, 66 × 37″. Collection
the artists

81 *Double Rembrandt with Steps.* 1987–88.
Toned silver print, toned ortho film, wood, Plexiglas,
108 × 108″. Collection the artists

82 *Blue Hands.* 1982–87.
Toned silver print, tape, 64 × 76″. Courtesy Everson Museum of
Art, Syracuse, N.Y.

83 *Blue Hands with Black.* 1982–87.
Toned silver print, tape, 92 × 56″. Courtesy Stux Gallery,
New York

84 *Terrace Jeu de Paume.* 1987.
Toned silver print, tape, 92 × 96″. Collection Randolfo Rocha,
New York

85 *Vertical Christ with Black.* 1985–87.
Toned silver print, tape, 94 × 100″. Collection Thomas
Ammann, Zurich

86 *Nipples.* 1985–87.
Toned silver print, tape, 56 × 87″. Saatchi Collection, London

87 *Jagged Mona.* 1985–88.
Toned silver print, tape, wood, metal, 90 × 51″. Collection Fumi
International, Tokyo

88–89 *Double Mona Lisa with Self-Portrait.* 1985–88.
Toned silver print, tape, 107 × 160″. Museum of Fine Arts,

Boston. Gift of Charlene Engelhard, Vijak Mahdavi, and
Bernardo Nadal-Ginard

89 *Yellow Mona Lisa with Plexi and Wood.* 1985–88.
Toned silver print, Plexiglas, wood, tape, 51 × 36″. Collection
Barbara and Eugene Schwartz, New York

90–91 *Yellow and Blue Louvre Floor.* 1985–88.
Toned silver print, tape, metal, 84 × 192″. Fredrik Roos, Zug

92 *Rembrandt.* 1987.
Silver print, 23 × 19″. Courtesy Stux Gallery, New York

92 *Mater Dolorosa with Rookery and Frame.* 1987.
Toned silver print, tape, wood, 12 × 9″ unframed. Courtesy
Anne R. Pasternak, New York

93 *Mater Dolorosa.* 1987.
Toned silver print, tape, metal, wood, 60 × 54″. Collection Mr.
and Mrs. Gerald Fineberg

94 *Rembrandt (Head Details).* 1989.
Toned silver print, tape, steel, wood, glue, 88 × 51″. Courtesy
Photographers + Friends United Agaist Aids

95 *Green Mater Dolorosa.* 1987.
Toned silver print, 94 × 74″. The Art Institute of Chicago.
Gift of Cooperfund

97 *Self-Portrait with Plexi and Wood.* 1987.
Toned silver print, tape, metal, Plexiglas, wood, 85 × 69″.
Collection Cooperfund, Inc., Oakbrook, Ill.

98 *Yellow Seascape with Film and Wood Blocks.* 1989.
Toned silver print and ortho film, wood, nails, glue, 70 × 93″.
Wadsworth Atheneum, Hartford, Conn. Gift of Mike and Doug
Starn in honor of the marriage of Anne Pasternak and Mike Starn

99 *Yellow Seascape with Film and Wood Blocks* (detail). 1989.
Toned silver print and ortho film, wood, nails, glue, 25 × 15″.
Wadsworth Atheneum, Hartford, Conn. Gift of Mike and Doug
Starn in honor of the marriage of Anne Pasternak and Mike Starn

100–101 *Film Seascape.* 1988–89.
Ortho film, glue, 100×216″. Collection the artists

102–3 *Film Tunnel with Man.* 1987–88.
Silver print, ortho film, tape, glue, wood, 106×216″. Collection the artists

104 *Watson with Ribbon.* 1988.
Toned silver print, plywood, ribbon, glue, 41×21″. Collection Milton Fine, Pittsburgh

105 *Rembrandts on Seascape.* 1987.
Toned silver print, tape, wood, ribbon, 88×144″. Courtesy Thomas Ammann, Zurich

106 *Large Blue Film Picasso.* 1988–89.
Toned ortho film, glue, Plexiglas, wood, 102×104″. The Baltimore Museum of Art. Frederick R. Weisman/Mid-Atlantic Toyota Contemporary Art Fund. BMA 1989.52

107 *Large Copper Picasso.* 1989.
Toned ortho film, wood, silicone, acrylic, 97×80″. Los Angeles County Museum of Art. Gift of the Grinstein Family, Sheila and Wally Weisman, and Anita and Julius L. Zelman, through The 1989 Collectors Committee

108 *St.-Michel Claw.* 1985–87.
Toned silver print, tape, Plexiglas, wood, 30×37″. Collection the artists

109 *Place St.-Michel with Lead and Plexi.* 1985–87.
Toned silver print, lead, Plexiglas, wood, glue, 108×84″. Saatchi Collection, London

109 *Rookery with Wood Block.* 1988.
Toned silver print, tape, wood, 79×66″. Collection Milton Fine, Pittsburgh

110 *Corona.* 1987.
Toned silver print, tape, 78×60″. Collection Scott Spiegel, Santa Monica, Calif.

110 *Sol.* 1988.
Toned silver print, tape, wood, 108×88″. The Beckman Collection, New York

111 *Corona Extra.* 1987.
Toned silver print, tape, 51×82″. Collection Vijak Mahdavi and Bernardo Nadal-Ginard

112 *Black Group #2.* 1987.
Toned silver print, tape, 96×41″. Courtesy Stux Gallery, New York

112 *Kandinsky.* 1988.
Toned silver print, tape, 48×38″. Collection Blake Byrne

113 *Red and Black Square.* 1986.
Toned silver print, tape, wood, 96×96″. Fredrik Roos Collection, Zug

114–15 *Black Piece.* 1986.
Toned silver print, tape, wood, 45×120″. Saatchi Collection, London

116 *Lack of Compassion.* 1987–88.
Toned silver print, glue, wood, 103×8″. Saatchi Collection, London

116–17 Installation view. *Lack of Compassion.* 1988. Collection The Israel Museum. Gift of the artists

118 *Small Portrait of Anne Frank.* 1989.
Toned ortho film, Plexiglas, wood, glue, 20×18″. Collection Stefan and Linda Stux

118 *Anne Frank Grave Marker.* 1989.
Toned ortho film, metal, wood, glue, 20×24×1″. Anne Frank Fund, Basel

119 *Anne and Margot Frank on the Beach.* 1989.
Toned ortho film, tape, 11×14″. Private Collection, New York

120–21 *Crucifixion.* 1985–88.
Toned silver print, wire, ribbon, wood, tape, 120 × 192″.
Collection the artists

122–23 *Rain Forest with Ciba and Wood.* 1989.
Toned silver print and ortho film, wood, tape, glue. cibachrome,
70 × 126″. Galerie Langer Fain, Paris

124 *Concave Bull Jumper.* 1989.
Ortho film, wood, silicone, iron pipe, pipe clamps,
92 × 139 × 11″. Collection Akira Ikeda Gallery, Tokyo

125 *Convex Bull Jumper.* 1989.
Ortho film, wood, silicone, iron pipe, pipe clamps,
97 × 117 × 13″. Collection Akira Ikeda Gallery, Tokyo

126–27 *Concave, Convex Bull Jumper.* 1989.
Ortho film, wood, silicone, iron pipe, pipe clamps,
97 × 130 × 12″. Collection Tsurukame Corporation, Nagoya,
Japan

128 *Horse Spit.* 1989–90.
Toned ortho film, silicone, Plexiglas, pipe clamp, 96 × 84″.
Courtesy Mario Diacono Gallery, Boston

129 *Half Concave Athenian Horse and Neck.* 1989.
Ortho film, silicone, wood, pipe clamps, 96 × 96 × 20″.
Collection Stefan and Linda Stux

130–131 *Horse + Rider of Artemision (Large).* 1989–90.
Toned ortho film, silicone, wood, pipe clamps, 92 × 192″.
Private Collection. Courtesy Barbara Guggenheim Associates

132 *Eye with Film and Plywood.* 1989–90.
Toned silver print, toned ortho film, glue, 66 × 48″. Courtesy
Leo Castelli/Stux Gallerey, New York

133 *X.* 1989–90.
Toned ortho film, silicone, pipe clamps, 42 × 42 × 12″. Courtesy
Stux Gallery, New York

135 *Magazine.* 1989.
Toned silver print, wood, 19 × 54 × 32″. Collection the artists

PHOTOGRAPH CREDITS

Doug and Mike Starn wish to thank the following
photographers for their kind cooperation in supplying various
photographs: Benjamin Blackwell, Doug Cooke, Peter Muscato,
Clive J. Ross, Dan Soper, Patty Wallace, Tom Warren.